sanford biggers
iona rozeal brown
patty chang
y. david chung
david diao
sean duffy
ellen gallagher
rico gatson
luis gispert
david hammons
david huffman
arthur jafa
michael joo
glenn kaino
clarence lin
kori newkirk
paul pfeiffer
cynthia wiggins
roy williams

christine y. kim

black belt

the
studio
museum
in
harlem

This publication was prepared on the occasion of the exhibition

Black Belt

The Studio Museum in Harlem, New York
October 15, 2003 –January 4, 2004

"Black Belt" is made possible, in part, by the Peter Norton Family
Foundation. Additional support has been provided by MTV Networks.
The exhibition catalogue is funded, in part, by Rebecca and Martin
Eisenberg.

MTV NETWORKS
A VIACOM COMPANY

Operation of The Studio Museum in Harlem's facility is supported, in
part, with public funds provided by the New York City Department of
Cultural Affairs and the New York State Council of the Arts, a state
agency. Additional support is provided by The Carnegie Corporation of
NY, the Peter Jay Sharp Foundation, the Andrew W. Mellon Foundation,
and by corporations, foundations, and individuals.

Library of Congress Cataloging-in-Publication Data
Black Belt/Christine Y. Kim with Vijay Prashad, Latasha N. Nevada Diggs
[et. al.].
IBSN 0-942949-26-9

The Studio Museum in Harlem
144 W 125th Street
New York, NY 10027
www.studiomuseum.org

For CG

table of contents

Director's Foreword & Acknowledgments
Lowery Stokes Sims

Roundtable Conversation
Blake Bradford, Deborah Grant, Glenn Kaino, Peter Kang,
Christine Y. Kim and Dominic Molon

Afro as am...
Christine Y. Kim

Artists:
Sanford Biggers David Huffman
Iona Rozeal Brown Arthur Jafa
Patty Chang Michael Joo
Y. David Chung Glenn Kaino
David Diao Clarence Lin
Sean Duffy Kori Newkirk
Ellen Gallagher Paul Pfeiffer
Rico Gatson Cynthia Wiggins
Luis Gispert Roy Williams
David Hammons

Kung Fusion: Organize the 'Hood Under I-Ching Banners
Vijay Prashad

The Black Asianphile
Latasha Natasha Nevada Diggs

Artists' Biographies

Contributors' Biographies

Works in the Exhibition

Selected Bibliography

Since its founding in 1968, The Studio Museum in Harlem has proudly presented cross-cultural, inter-generational exhibitions that have challenged and ultimately redefined the prevailing paradigms in contemporary art. In 1990, the Museum presented "The Decade Show" with our colleagues at New Museum of Contemporary Art and the now defunct Museum of Contemporary Hispanic Art. This exhibition proposed significant, parallel discourses on race, identity, sexuality and gender as a new way to understand the 1980s. This museum has always drawn the undeniable lines of reference and influence between artists of African descent and their peers worldwide. "Black Belt" takes us a step further.

Powerfully based on the idea of cross-cultural influence, "Black Belt" fully exemplifies the shrinking world and the effects of multiculturalism on popular culture and art practice. With 1970s martial arts icon Bruce Lee as the center of reference, and the complicated history of the co-existence of Asians and African Americans in this nation's inner cities considered, this exhibition takes bold steps to understand the collision and collusion of this profound encounter. Using this intersection as a starting point and contemporary art practices as the language, the artists in "Black Belt" explore the continuum of cultural exchanges between eastern tradition/philosophy and the evolution of polyethnic and transcultural American culture and identity.

This exhibition would not have been possible without the intellectual vision and commitment of its curator, Christine Y. Kim. With this project Christine has boldly opened a new chapter in the Museum's exhibition history. She was assisted in this task by her colleagues Marc Bernier, Head Preparator; Rashida Bumbray, Curatorial Assistant; Ali Evans, Public Relations Manager; Sandra Jackson, Director of Education and Public Programs; and Shari Zolla, Registrar. She also had the able assistance of curatorial interns Samantha Contis, Naima Keith, Dalila Scruggs, and Catherine Serrano.

This volume was edited by Franklin Sirmans, and I would like to thank him for his insight and tenacity. We are grateful to Brian Hodge for his innovative designs for our various exhibitions and projects. We are indebted to the contributors to the catalogue, Latasha Natasha Diggs and Vijay Prashad, and their publishers, Broadway Books (a division of Random House, Inc.), New York, and Beacon Press, Boston, respectively, for granting The Studio Museum in Harlem reprint permissions. The lively and illuminating contributions of the roundtable discussion participants, Blake Bradford, Deborah Grant, Glenn Kaino, Peter Kang, and Domonic Molon, make this exhibition catalogue an invaluable resource and historic document. Finally, I would also like to acknowledge the essential contribution of Thelma Golden, Deputy Director for Exhibitions and Programs.

This exhibition would not have been possible without the support of our funders. I thank the Peter Norton Family Foundation for its generous support of this project. I would also like to thank MTV Networks and Rebecca and Martin Eisenberg for their committment to this endeavor.

We are also grateful to the institutions and individuals who have lent work to this exhibition: The Broad Art Foundation, Santa Monica; Larry Sanitsky, Los Angeles; and Calum Stephenson, New York. And finally, I would like to thank the artists, Sanford Biggers, Iona Brown, Patty Chang, Y. David Chung, David Diao, Sean Duffy, Ellen Gallagher, Rico Gatson, Luis Gispert, David Hammons, David Huffman, Arthur Jafa, Michael Joo, Glenn Kaino, Clarence Lin, Kori Newkirk, Paul Pfeiffer, Cynthia Wiggins and Roy Williams, and their respective collaborators and technicians, for allowing us the honor of presenting their work at The Studio Museum in Harlem.

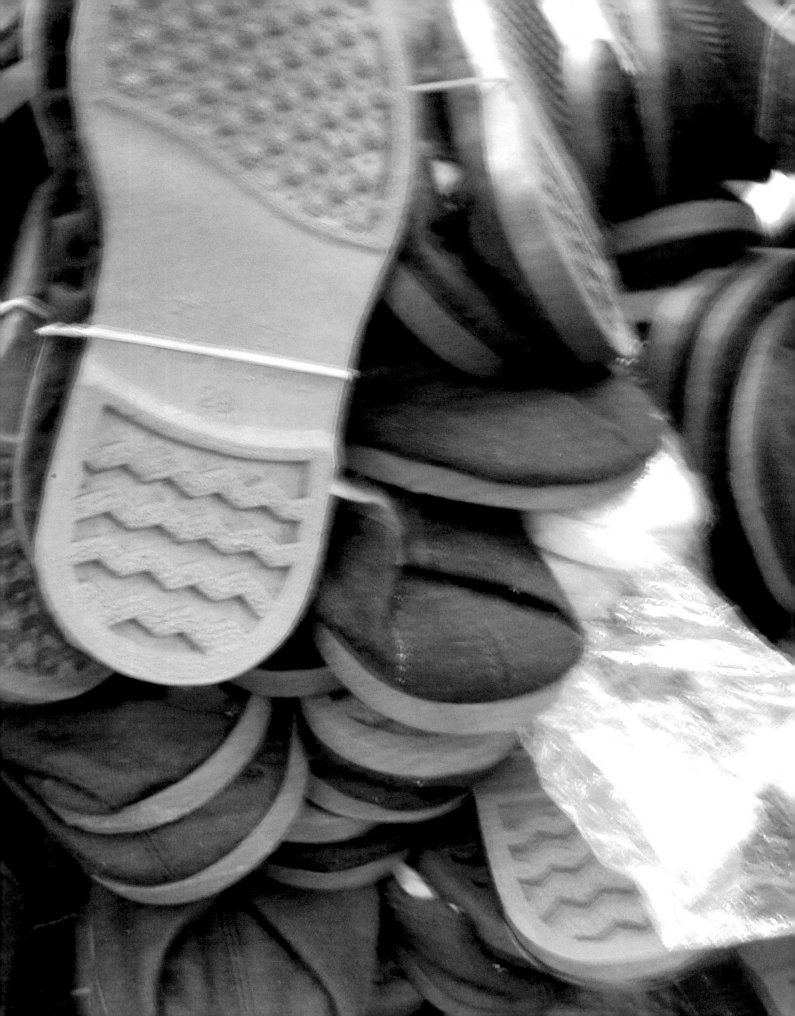

CHRISTINE Y. KIM: First of all, thank you all for agreeing to participate in this roundtable. "Black Belt" features over forty works of art by nineteen living American artists whose work has been influenced by African- and Asian-American intersections, specifically in relation to popular culture, martial arts and spirituality from the 1970s. My inspiration and intention for bringing together a group of thinkers to discuss the topic is reflective of my curatorial approach to the content as topical, polyvalent and transcultural.

One voice or even two or three could not adequately describe or discuss this "phenomenon," this moment—and evolving moments—in American history. Through the exhibited works of art, many ideas and thoughts emerge, and I hope that, in part, this conversation provides several windows, of varying sizes, shapes and shades, to view and reflect on the art and concepts of "Black Belt."

I've had a long-standing obsession with the year 1974. I was only two, so my fascination is not rooted in my own nostalgia, but rather in the investigation of 1974 as a pivotal moment in American history that would inform me as an adolescent and as an adult. Everyone seems to have something to say about 1974. Artist Sean Duffy describes it as "the moment when the hippies were long gone and disco hadn't yet caught on." Curious hybrid genres and styles were hitting the airwaves. Carl Douglas' hit song "Everybody Was Kung Fu Fighting" spent months at the top of the charts, selling nearly nine million copies, while Olivia Newton-John won the Country Music Association Award for Female Vocalist of the Year. The most popular men's cologne in 1974 was *Hai Karate*, which had an entire ad campaign around the onomatopoeic sound of a karate chop, "Hai-Ya!" *Hai Karate* claimed to empower "men who otherwise feared feeling like sissies sprinkling non-scented talc." The popularity of martial arts in the media stimulated an explosion of product development and marketing.

For most Americans, I suppose, Watergate stands out. President Nixon resigned and Gerald Ford took the Oath of Office in 1974. The Cold War reached hypothermic temperatures. The Cultural Revolution in China was foundering, followed by Mao's death three years later. Patty Hearst, granddaughter of publishing tycoon William Randolph Hearst, was kidnapped by the Symbionese Liberation Army, and within two months, joined forces with her captors in a bank robbery in San Francisco. It was a year of many things to many people.

It was an interesting time in the art world as well. James Turrell started *Roden Crater* in Northern Arizona (due to be completed this year), and in New York, the Robert and Ethel Scull Collection hit the auction block. With crowds fighting to get into Sotheby's—the way they would a few years later to get into Studio 54—the fifty works of art by artists such as Andy Warhol, Jasper Johns and Willem DeKooning, sold for an unprecedented $2,242,900. and set the stage for a market of booming proportions. For those with cash, irony could be bought, sold and traded.

Never mind the bollocks, the entertainment industry was also thriving. This golden era in American cinema produced classics like Peter Bogdonavich's *Paper Moon* (1973), Roman Polanski's *Chinatown* (1974), Sidney Lumet's *Dog Day Afternoon* (1975), *Foxy Brown* starring Pam Grier (1974), and *Mahogany* starring Diana Ross (1974). Francis Ford Coppola's *The Godfather II*, starring Al Pacino and Robert DeNiro, won the Oscar for Best Picture in 1974. Two classic T.V. shows debuted: *Happy Days* in the U.S., and *Monty Python's Flying Circus* in the U.K. And, as a testament to the burgeoning kung fu craze in mainstream America, *Kung Fu*, starring David Carradine, playing a role Bruce Lee originally developed and was cast in but looked "too Asian" for, was the top rated television show. The faces of Hollywood were changing or at least beginning to change.

On the baseball diamond, Hank Aaron hit home run number 715 in 1974, breaking the life-

PARTICIPANTS

Blake Bradford, Curator of Education, Fabric Workshop and Museum, Philadelphia
Deborah Grant, Harlem-based artist, current SMH Artist-in-Residence
Glenn Kaino, Los Angeles-based artist
Peter Kang, Executive Producer, X-Ecutioners
Christine Y. Kim, SMH Assistant Curator
Dominic Molon, Associate Curator, MCA Chicago

time mark set by Babe Ruth, but it was in the boxing ring that sports fans recall one of the most exciting moments in sports history. The charismatic and enigmatic Muhammad Ali (né Cassius Clay) confounded and captivated the public even before his conversion to the Muslim faith in 1964, followed by his refusal to fight in the Vietnam War. He argued that he had nothing against the Vietcong, comparing the oppression of the "brown people in Vietnam" with the "so-called Negroes" in America. In 1974 Ali outsmarted champion George Foreman in the highly anticipated "Rumble-in-the-Jungle" in Zaire. The publicity from this event granted Ali a larger political platform. In line with the Nation of Islam's long-standing relationship with various Asian groups and organizations, Ali stated on a Louisville radio show, "I am not a Negro. I am Muhammad Ali...and I am an Asiatic black man."

The Asiatic Asian man of the day was Bruce Lee, who died while filming *Game of Death*, in 1973. Throngs of fans, consisting mostly of young black men, who had been flocking to theaters on 42nd Street in New York and other venues around the country for years, studying films such as *Chinese Connection* (1972), *Fists of Fury* (1972), and *Enter the Dragon* (1973) mourned the death of the first Asian male hero in American history. Films such as *Game of Death* (1978) (with the aid of stuntmen and body-doubles), *Touch of Death/The Real Bruce Lee* (1981), and *Bruce Lee: The Legend* (1984), released posthumously were a testament to Lee's ongoing appeal. And, as Amy Abugo Ongiri speculates, "images of Bruce Lee were at least as popular in many black homes as were images of Martin Luther King, possibly even more so." Organizations such as the Black Karate Foundation (BKF) and dojos such as USA Shaolin Temple in New York were sprouting around the country and accepting new students by the dozens. Paradoxically, while athletes and entertainers of color were gaining popularity and commercial success, it did not come without new permutations of oppression.

In the wake of the passage of the Civil Rights Act of 1964 and the assassinations of Martin Luther King and Malcolm X, urban rebellions and disillusionment among black nationalists fueled an abandonment of the slogan "Black is Beautiful," and an adoption of "Black Power," brought on by Stokely Carmichael and members of the Student Non-violent Coordinating Committee (SNCC) and the Congress on Racial Equality (CORE) in 1967. Robin D. G. Kelley encapsulates the evolution: "high expectations begot the civil rights movement; the movement's failure to achieve all its goals and to deal with urban poverty begot Black Power." Former Black Panther leader Kathleen Cleaver observed that, "between 1969 and 1973, the incendiary mixture of external repression, internal dissension, and police infiltration prompted an escalating reliance on 'purges' to keep the organization intact. That policy resulted in several highly publicized expulsions that shattered the Black Panthers into opposing factions, and ultimately led to the organization's precipitous decline." This fragmentation had an enormous effect on the Party's nationwide supporters and collaborators such as the Brown Berets, a Chicano group in Southern California; the Red Guard, a Chinese group in the San Francisco Bay Area; the Puerto Rican Young Lords in New York; and the White Patriot Party in Chicago. The Black Panthers' broad anti-racist and anti-oppression mission had attracted people of many colors and cultures, and the decrescendo proved to have multiple repercussions for a variety of groups and individuals.

Internationally, Afro-Asian connections had strong political foundations based on notions such as "the enemy of my enemy is my friend," throughout the sixties. The Black Panther coalition had supporters in China, Japan, Cuba, Mozambique, South Africa and Israel. As early as 1957, under Mao Tse-Tung, China formed the Afro-Asian People's Solidarity Organization, which supported the mission against colonial oppression. W.E.B. Du Bois spent his ninetieth birthday in China with Mao.

Back in the United States, between 1965 and 1974, 75,000 foreign-born physicians entered the country in response to a sudden increase in the need for medical services resulting from the establishment of Medicare programs. After newspapers in Korea published articles and advertisements on the subject, over 13,000 Korean medical professionals, a majority of them female nurses, entered the United States. My mother was one of them. With a record high number of Vietnamese

refugees after the fall of Saigon in 1975, the United States immediately accepted 130,000 Vietnamese immigrants. The racial landscape of the country was rapidly transforming.

I too grew up idolizing both Muhammad Ali and Bruce Lee. It is fascinating that these two men of color, icons of masculinity, heroes of the (not so) free world, alive and kicking (ass), had such polyethnic and transcultural transcendence. I remember that the white kids had James Bond, who was personified by his sports cars, Bond girls and high-tech gadgets, luxuriating in the Swiss Alps swinging a full martini glass and never spilling a drop. Vijay Prashad recalls, "Our heroes of color occupied a new space of clear identity and specific interchangeability that had always previously been intercepted and perforated by the White European trope or model." People of color were questioning and challenging the redundant representations of the "other," and their distance from access, agency and status. Ali and Lee found brilliant ways to navigate the terrain. "Bond was the agent of international corruption manifest in the British MI-5, while Bruce stood his ground against corruption of all forms. With his bare fists and his *nanchakus*, Bruce provided young people with the sense that we, like Vietnamese guerrillas, could be victorious against the virulence of international capitalism." This passage in Prashad's book, *Everybody was Kung Fu Fighting: Afro-Asian Connections and the Myth of Cultural Purity*, pulled together thoughts of 1974 for me. It marked a moment of interchangeability, possibility and cross-pollination of ideas and identities previously unavailable... or at least inaccessible, and entirely fantastical, for younger generations.

Christine Y. Kim

Shifting gears to urban life, art and music production, as my investigation of 1974 narrowed, I began to think about diverse metropoli around the country. Kool Herc (aka Clive Campbell), father of hip hop, took his turntables outdoors to the first block parties in the Bronx in the early seventies, playing soul, old funk, and R&B, the same year that fellow Jamaican Jimmy Cliff released *The Harder They Come*, (1972), co-produced by Korean-Jamaican Leslie Kong. By 1974 Grandmaster Caz, Afrika Bambaataa and Grandmaster Flash, influenced by Kool Herc, were playing at block parties, house parties and in parks in various Bronx neighborhoods. "Influenced by the Caribbean style of 'toast' and 'boast,' the pioneers began taking their turntables and speakers to parks and lightly rhyming over records, 'to the beat y'all,' or 'and ya don't stop.'" Expanding from graffiti on buildings and bridges, tags appeared on New York's subway cars, stimulating a subculture of identity, performance and territorialism. Pollination and hybridization were more than just science-class vocabulary words used for bees and fruit.

And, so here we are at this roundtable today, thinking about 1974 as a metaphor for history as layered and uncentered. By placing the African-American fascination with kung fu, Bruce Lee, Eastern martial arts and spirituality on the table, the constellations of histories take a curious shape, informing us on the dynamic sources of our experiences today, generically and specifically, conditionally and consciously. Hybrids exist everywhere, most definitely in urban cultures, vernaculars and dialects, art forms, and even polymorphic identities...and sometimes it isn't until we trace the multiple lineages and their intersections that we see how cross-pollination is the norm, and singularity or purity is really the blip on the radar screen.

dominic molon: Hip hop is perhaps unique among mainstream musical genres for its astonishing tendency towards novelty and cultural appropriation. The former quality is manifested in the striking turnover in styles and "artists of the moment" due to an incessant emphasis on the new—something I first learned in college when my tastes were dismissed as *"last month!"* The latter is exemplified by the radical range of musical or verbal citations that may be made in many hip hop songs, for example, the use of the "Dies Irae" from Mozart's *Requiem* (1791) in the opening track on Ludacris' *Word of Mouf* (2001) album or Busta Rhymes' sample of Bernard Hermann's theme from *Psycho* (1960) on "Gimme Some More" (1999). One of the most intriguing forms of cross-cultural appropriation has been the application of Asian motifs, sounds and religion in hip hop to the present. What I am offering today is not a comprehensive or exhaustive analysis of Asian influences on hip hop, but more the observations of a fan who's been lucky or maybe

Dominic Molon

unlucky, depending on your perspective, to have had a background in cultural studies.

I wanted to start with two examples from the late-1980s/early-90s hip hop era as a way to set the stage for the transformation in attitude towards Asian Americans and Asian cultural forms. The first is Spike Lee's landmark film *Do The Right Thing* (1989). Of the many interracial conflicts that form the crux of the film are those that transpire between Asian merchants and two sets of African-American characters: Radio Raheem, an imposing character defined by his constant "broadcast" of Public Enemy's "Fight the Power," (1989), on his boom box, and three middle-aged black men who alternately profer bits of "man-in-the-street" wisdom, opinion and humor. While Raheem's confrontation is based on an inability to communicate, the seething resentment of the middle-aged trio is first articulated in a discussion about the efficacy with which the recent immigrants created a flourishing business and later in the near trashing of the merchant's store towards the end of the film, after the racial tensions have exploded into murder, riot and vandalism. When the same violence visited upon Sal's Pizzeria (a displaced symbol of white culture and economy) is threatened upon the Korean grocer's store, the spectacle of his wild pleas of "I no white" and "me black too" eventually seems to subdue the would-be looters (led by the three older men). One assumes that Lee was aware of a similar incident encountered by Malcolm X in the 60s, in which the leader and his friends were amused to see a Chinese restaurant unscathed by urban riots and featuring a sign in the window reading 'Me Colored Too.'

While the Asian merchants in the film were eventually perceived as part of a collective of transracial community, those who are the subject of rapper Ice Cube's incendiary "Black Korea" from his album *Death Certificate* (1992), are offered a less generous impression of Asian merchants in the 'hood. (The song not unsurprisingly starts with Radio Raheem's angry dialogue from *Do the Right Thing*.) Characteristic of the lyrics are: "So pay respect to the black fist/or we'll burn your store/right down to a crisp/and then we'll see ya!/Cause you can't turn the ghetto into "Black Korea." While the promise of violence is indeed shocking, perhaps more troubling is the position of the song in the context of the album itself. *Death Certificate* is divided into two sides (a nod to the formerly dominant album or cassette formats)—the "Death Side" 'the vision of where we are today' and the "Life Side," 'a vision of where we need to go.' While the "Death Side" glorifies allusions to casual violence and cheap sex, the "Life Side" preaches, to some degree, about a sense of racial self-awareness and identity. That "Black Korea" should have been featured on the "Life Side" is telling, for it suggests that an affirmative sense of black identity could be attained (in one instance) by an aggressive rejection of a racialized economic "Other." *Death Certificate*, like *Do The Right Thing*, was produced during a moment when hip hop culture was defined by a determination to articulate a powerful sense of black self and community through more politically self-aware forms of expression.

This emphatically confrontational ethnocentrism in hip hop was substantially mediated by a shift in emphasis away from a broader cultural sense of purpose toward the celebration of a socially transgressive lifestyle (aka gangsta rap) and a subsequent cult of the self that came to define much of hip hop in the mid-90s (the Dre, Snoop, Biggie, and Tupac prospect, if you will.) The genre became focused on the positioning of the self as the primary subject above all else, a result, perhaps, of the staggering commercial success of rap and its increasing acceptance in mainstream culture. By the mid-90s the Beastie Boys had already achieved both commercial success and mainstream acceptance while, importantly, retaining a sense of credibility within the hip hop community. More pertinent to this discussion is the influence of member Adam Yauch's devotion to Buddhism

on the group's music (in songs like "Bodhisattva Vow" from *Ill Communication* (1996) and in their efforts on behalf of the liberation of Tibetan Buddhists from Chinese persecution.

1997 marked the ascendance of Staten Island's Wu-Tang Clan with their double album *Wu-Tang Forever*. Featuring a dense interweaving of sound bites and string sections from kung fu films and the assumption of a fictionalized identity of kung fu-inspired "Shaolin warriors," the Wu-Tang Clan's project was radical in its shift from a sense of identity that began and ended with an inherent Afrocentricity and suggested an expansion of hip hop's language to incorporate a strangely multifaceted polyculturalism. The content of their songs, however, remains rooted in African-American culture, with the assumption of the Wu-Tang identity more consistent with the construction of an exotic image rather than a deeply felt ethos. Sincere or not, this globalization of the hip hop vernacular was given further and more poetic representation in the film *Ghost Dog: The Way of the Samurai* (1999). Featuring a soundtrack produced by the Wu-Tang Clan's RZA, the film centered on a black hit man (played by Forrest Whitaker) whose adherence to the focused code of the Japanese Samurai warrior underscored his solitary presence outside of the more hectic and culturally schizophrenic urban society swirling around him.

The current (or at least more recent) nature of exchange between Asian cultural motifs or figures and hip hop culture seems driven more by the expansion of the "cult of the soloist" to embody more nuanced productions and the explosion of a new-style kung fu "buddy picture" (exemplified by *Rush Hour I* (1998) and *II* (2001) starring Jackie Chan and Chris Tucker). One of the more significant rap moments of the past few years, Missy Elliott's "Get Ur Freak On" (2001), featured a sonic backdrop composed of a distinctly Asian sound as opposed to the more de rigueur P-Funk and James Brown samples of Snoop Dogg and Dr. Dre. Her videos also seemed heavily informed by the dynamic style of Japanimation in the use of cartoonish, exaggerated body parts and bright, superflat colors. The shift in cinematic relationships between hip hop and Asian cultures seems embodied by the film *Romeo Must Die* (2000), in which a battle between two rival families, one black American, one Chinese, is complicated by the romance between characters played by R&B songstress Aaliyah and Hong Kong action star Jet Li. The formula of the Americanized Hong Kong action style film has enjoyed an incredible amount of mainstream popularity and success, due to various rather obvious factors—the typical combination of an already marketable rap star like DMX with an equally proven figure like a Jackie Chan or a Jet Li, a ready-made (and seemingly inexhaustible) subtext of diametrical personality opposites (the wisecracking street smart hip hopper who gains a sense of depth from the sagely cunning and principled Asian kung fu master, who gains a bit of levity from the other), and of course a soundtrack ready to sell and filled with both established and emerging hip hop icons. Black and Asian now mostly figure together on the silver screen not as inner city combatants but in the cinematic fantasy world of car chases and cartels. Hip hop music, always fascinatingly opportunistic and cannibalistic, now inflects rhymes and attitudes with a more worldly sound rather than cultivating a more aggressively entrenched position of Afrocentricity.

Hip hop culture's elasticity has thus served to reflect the similarly changing boundaries between cultural production and the far-ranging effects of increased globalization and exchange. It seems to point to the kind of postracial dialogue characteristic of the writing of Paul Gilroy in its ability to, in the span of a decade, move from a racially essentialist position of a declaration of black identity, to a more open-ended and polycultural combination of styles and attitudes that are driven more, perhaps, by an individual artist or producer's tastes and inclinations than a political sense of urgency and activism. It is hardly curious and altogether appropriate that this institution, The Studio Museum in Harlem, which fostered an understanding of how the notion of a "black aesthetic" is being questioned and changed by cultural shifts, should acknowledge this moment of the further stretching of a current generation of artists beyond their own particular ethnic identities with a show like "Black Belt."

deborah grant: What I originally discussed with Christine for this roundtable was based on a narrative I wrote called "Broomsticks, Garbage Can Lids, and Num-Chucks." It was derived from a childhood memory. I remember my brother and his friends, after seeing the movie *Revenge of the Dragon* (1983), sport "num-chucks," which were *nanchakus*. They would take their mothers' broomsticks, cut them in half, and then take garbage bag chains and connect them to the sticks with a nail on the top, wrapping them with a bit of tape. The best way to wrap them was with colored fabric or plastic bike tape. What made them good was the look of them...more red or black was very important. The clothing was important too. In the mid-70s it was all about the Pro-Keds. I remember the most popular pair of black and white Pro-Keds had the light stripe on the side.

　　I lived in Coney Island, West 36th Street, to be exact. It was a mixed neighborhood. On one side there was Seagate, which was a gated community, and on the far end a predominantly German community with high-rise condominiums. Our neighborhood was poor, poor black, and poor white, poor Asian. Asian Americans with visas were supposed to live within a 40-mile radius of an English-as-a-Second-Language (ESL) Center. So most of these ESL Centers were in the center of the poorest areas in the U.S. The Centers were supposed to employ white Americans, but they would end up with Asian Americans. The dynamics amongst races and cultures were layered. There was a sort of camaraderie, especially when *Return of the Dragon* came out, notably at the candy stores, laundromats, and Chinese food restaurants...safe havens. It became popular to be around Asians. Bruce Lee represented the underdog in his films. He was the David fighting against the white male Goliath who had privilege and position. My brother and his friends attached themselves to the idea of Bruce Lee and what he represented. Our own neighborhood was broken-down: a building and then rubble, a building and then rubble, block by block. "Speculation" determines where it's more important to keep a building unoccupied than to keep it occupied. So, in *Return of the Dragon*, Bruce Lee's showdown with world-champion karate artist Chuck Norris in the Roman Colosseum littered with paper, detritus and rubble, witnessed only by a cat, represented possibilities to numerous young blacks and Hispanics in these neighbor-

Deborah Grant

hoods. My brother and his friends would go see the movie over and over again. It reminded them of their own neighborhoods and ultimately of themselves. Bruce Lee's character made an impact because he represented change in the social order. Norris was one of Lee's best opponents and a marvelous physical contrast: big and hairy, representing the white ruling class, using power and blunt karate moves, while svelte, yellow, underdog Lee countered with speed, gymnastic prowess and the grace of a ballerina. He was not only a brilliant fighter, but also a strong, articulated representation of an educated man of color.

　　I had a friend whose parents couldn't speak English. She spoke English for everybody in the family. They had a candy store. When I was young we hung out and watched my brother and his friends screaming bragging rights about the next *Kung Fu Magazine* issue and betting on the next top black belt artists. They would discuss Bruce Lee's TV series with David Carradine. Bruce Lee actually created that character and show. That was his. *They* stole it. I could never partake because I was a girl. But I remember so clearly seeing my brother and his friends in tight black jeans and white t-shirts or tank tops over rippled washboard stomachs, conversing about who was better than whom.

　　The "num-chucks," as they called them, were makeshift weapons that they couldn't really swing. They would hit themselves in the head instead. That was where the concept of the "numb" came from. The main idea of the *nanchukus* for them was really about having them in their back pockets, to be seen with them, and what they symbolized. At the time, it was a felony in most states to have them, but these 12-inch sticks were made from mom's broomsticks (because most kids couldn't afford them at $12.95 each). It became a tool for them to meet young women...and to socialize. It was related to the formation of a gang because at that time any kind of gang situation,

unless there was a gun, a homemade gun, or a zip gun, was about fighting fist-to-fist. These "num-chucks" was the closest thing to getting a real weapon.

GLENN KAINO: I wanted to talk about some of the things I'm currently considering about the construction of identity. And, in the process, reference black and Asian relations as part of what allowed me to formulate these ideas and give some insight into how I came to some of these hypotheses. I've been thinking a lot about the construction of history. It's interesting that you started this conversation, Christine, with timelines, because a lot of my work and what I think about are timelines and how, if we look at several overlapped, we often see very interesting matrix points, places where they intersect. One of the things I've come to understand over time is that to me, the way we construct history, in general, is flat—flat, meaning the length of time between any two specific events and their causal significance in relation to each other. Flattened by the way we learn history from reading about it in books.

Vietnam, World War II and Hannibal all happened at the same time for me. I'm a fourth-generation Japanese-American whose family is from East L.A., whose grandparents spoke Spanish, whose uncles were from the East Side, who grew up with my dad saying "*orale*!" Those are the building blocks of who I am. One of my best friends growing up was a black kid named Sal who was about a foot-and-a-half taller than me. I was a scrawny little Asian boy, but I was the only one who could do windmills in my elementary school. He used to watch Japanese cartoons, so we'd hang out. I began as a total hybrid.

I've been considering, in my artwork, how, within this postmodern culture of recycling, referencing and sampling, we can actually be progressive. How can we create new ideas and meanings in a way that doesn't fall back to an old cycle, where we repeat our past mistakes at the price of giving old, bankrupt ideas a second run? Perhaps it's my "Life Side" of the CD that Dominic mentioned, asking this.

To me, we sit here in this room together to develop a narrative for the future. Instead of running through linear timelines, commonly illustrated with a straight pencil line with cross-hatch marks at the events, I'd like to propose a three-dimensional timeline of scattered, diffused points, or perhaps a four-dimensional model where the points all move. Different reference points become more like a shifting star-field of history, where we each position our own constellations and determine our own pasts. History can only repeat itself if it can recognize its former self.

The star-field would have to behave like quantum objects. In quantum theory, there is a concept of wave/particle duality, in which really small objects function as both waves and particles, meaning that they have two entirely different ways of existing. Only the act of observation collapses them into an observable state where they then "choose" to either be a wave or a particle for us to see. That's just the nature of quantum physics. If that's how everything from the building blocks of the universe works, why shouldn't it make sense that our memories, our histories and our identities, perhaps in some way, work like that? Therefore, we could all act in different ways, and at the points when we actually call ourselves on the carpet and decide to throw ideas down, whether it is in an art project, in a book, or for a show like "Black Belt," at that point, we have to choose what side of which fence we're on, and have to say something to someone. I don't have a problem with contradiction.

Glenn Kaino

One of the opinions I've heard about the exhibition is that it has problems because it celebrates the way martial arts and stereotypical images of kung fu fighters have been exploited by American popular culture at the expense of more positive and complex Asian-American representation. Being packaged within the context of African-American art both revives and validates an oppressive tactic within an institutional discursive structure. Another critical view is that having an Asian-influenced show with a very multicultural group of artists somehow neglects to recognize the history of this museum as an African-American venue. Each

time I hear something like this, I view it as an old-school way of thinking about identity. It doesn't trust the intention of the show or the space. It's troubling to think that in this day and age we're still basing notions on singular racial boundaries in the interpretation of culture. If we're going to do that, then we are counter-productively working from a fixed position, and we're not actually talking about making anything new, or even trying. It's all too safe and boring.

I was in Mexico City for a show called "Five Continents and One City: Second International Salon of Painting" (1999) and attended a panel discussion. A group of artists from Africa was there. Clive Kellner from South Africa was the curator for the African section. The artists who he had brought were Fernando Alvim, Kendell Geers, and Owusu-Ankomah. They were all mostly from different parts of the world but a few had taken residence in Johannesburg. At one point during the Q&A, someone in the audience said something to the effect of, "You're curating from Africa, but you're white and your artists are white. What's up with that?" Owusu-Ankomah is black and from Ghana, and I believe he lived and worked out of Germany. Frédéric Bruly Bouabré is black and in the show but was not present. Fernando, who had just downed a bottle of tequila on stage, pointed to the audience member and said something like, "Look, this is the new way of thinking. This is a new type of identity. All my friends, my wife and family, my doctor and my lawyer are all black. I'm as black as them. We're all black and white at the same time." They argued this point for several minutes.

I still can't tell what I thought about that. On the surface, there are many problems with this argument, sure. But if you get into it a few layers deeper, unpacking his statement on several levels and adding a little bit of trust, you get something very complex. Trust is a key part of this, (so too perhaps the tequila), because without the trust, you could easily fall back into accusation and contempt, citing hegemony, privilege, and several different other problematic concepts that come along with the negotiations of the boundaries of identity across races. I really don't know where I fall in regards to that statement, but it had an impact on me. Later that evening we extended to their group the trust to see where we could get in a conversation, and it ended up being very interesting. I left feeling that, as a curator, Clive really put himself out there and took a chance. It paid off.

BLAKE BRADFORD: When I was young, my parents, brother and I lived in Trenton, New Jersey. There were no Asians. It was a pretty homogenous environment. When I was about five or six I spent a lot of time indoors, watching TV. On Channel 17 out of Philadelphia, I watched *Johnny Sacco*, I watched *Ultra Man*, and I watched *Speed Racer*. I wanted to be Japanese...but it was twisted. I didn't actually know what that desire was about. It was like, you know, this guy, he's Japanese, and he's got a cool car, or he's got a flying robot. Looking back, as an adult, I consider

how these cultural products enter into the American mainstream. This heterogeneous culture doesn't even realize how heterogeneous it is, or where things are coming from. Yes, in response to Glenn, yes, let's get away from a linear sense of history and into a more three-dimensional model. Let's get away from notions of cultural purity and recognize how much cultural hybridity is in everything. Let's take commercial culture, which is by nature omnivorous and opportunistic. In addition to the Wu-Tang and their appropriation of their version of Chinese culture to Shaolin, there are also Wu-Gambinos, you know, Capadonna. It's an attitude, as much as anything that they adopted. Before I discovered O.J., Reggie Jackson and Muhammad Ali, it was a choice between the Fat Albert Gang, Fonzie and J.J. Walker. They were fine, but what I really identified with were the Anime characters. So, now I look back on it and wonder where

Blake Bradford & **Glenn Kaino**

that stuff came from, and what was informing my views as a six year-old, and what…in 1974, '75, '76, was going on way before the tensions exposed in *Do The Right Thing*, in Ice Cube, and the 1992 LA riots. This was a really interesting and exciting time, for black people, post-World War II, post-Korean War, post-Vietnam War. Looking at black culture, there is always, even with hip hop culture, an element of finding something that's authentic and bound in it, that's both inclusionary and exclusionary. And looking at that post-civil rights moment and the African-American search for an authentic space, essential and original, we factor in the mutating relationship between black social and political culture and the Asian presence in America.

In some ways those questions go back to the turn of the century and the Sino-Soviet War. The Japanese beat the Russians, and African-American political and social thinkers at the time were looking at Asians—as you mentioned, Christine—with an ideology of "the enemy of my enemy is my friend." Other "others" were fighting against European hegemony, oppression and colonialism. We have this American, romantic view of the 60s, but it's way more layered. It's already twenty-five years after Indian independence. All the European powers are leaving Africa in parallel lines and processes. Communism is a really powerful influence. You have black Maoists. In response to Christine and Dominic's discussions, how do we think about black Maoists in the 60s and even in the early 70s in relation to Ice Cube's "Black Korea" and the Wu-Tang Clan?

Bruce Lee represented something with social symbolism. He predated Arnold Schwarzenegger and Sly Stallone who were equipped with western technology and power. Bruce Lee had his hands and his will. *Rambo* and *Commando* could take on three hundred opponents only when equipped with a huge gun, banana clip, bombs and grenades. There was a certain righteousness to Bruce Lee. He never just broke something, or kicked somebody who didn't deserve it. When I think about what I was exposed to as a child in terms of Asian culture via TV, there were only a handful of paradigms. Anime Speedracer was sort of a James Dean character, or maybe Racer X was more James Dean. It was the same. It was very American. *Ultra Man* was sort of a subtle fight against techno- and biological mutation, post-World War II.

And then the kung fu movie, especially with recent ones, but even going back to the Shaw Brothers, it's always the Han dynasty, the descendents of the Han, the Chinese, fighting against the Manchus. If you watch tournament movies, it's the Chinese kung fu masters beating the Okinawans, or beating the Indian, Burmese or Thai boxers. It's always a superiority of Chinese culture, which seemed to stand for ancient tradition and philosophy. And I think that one of the things that black people saw in the 60s and 70s was that the Asian nations had a different kind of relationship with the West. They had never really been conquered. Asian cultures and walls persisted. I mean they had been occupied, but in Africa, for example, in Angola, they speak Portuguese, or French in West Africa. But in China, they speak Cantonese and Mandarin. In Japan, they speak Japanese. I think for black people there was an envy of the resistance that was ongoing from the Sino-Soviet War through World War II. It was with conventional weapons that they beat the Germans and the Russians, or more, the Germans and the Italians. Then it took a leap of technology, a super-human cruelty, to beat the Japanese. The Korean War never really ended. And in Vietnam, too, from 1968 the Tet Offensive was basically a stalemate. I perceive a sort of collective envy of how Asians were able to beat back colonialists and oppressors.

I don't want to oversimplify things. It's of course infinitely more layered. Now when it's convenient, mostly commercially convenient, Jay-Z raps over Indian *davali* tracks. It gets complex from there because it also relates to the late-capitalist era we live in. The interest and fascination in Asia becomes tied to exoticism on the part of African-Americans through western networks channeling the information. You rarely see black people learning Chinese, or that kind of depth of cultural interest. Like Glenn, I'm not troubled by this contradiction. Cultures give and take from each other. Coming back to the three-dimensional model, these things don't really feel like contradictions when you have a more layered structure of time and history. I have always known that, or at least felt it. It's when we classify and historicize it that space gets pushed out.

peter kang: One of the interesting things about working in the hip hop business from the 1980s through today is that there has always been a lot of respect between me and the artists, from Fat Joe, to the Beatnuts, to Common, and I never seemed to have the issues that I noticed a lot of them had with other executives in the company who were white. I always wondered why that was. Of course that may be my personality, but there is more to it. If we choose to trust each other enough, the contradiction is not hypocrisy, it's entirely progressive.

About two years ago, I became interested in working with young Asian-American artists who were expressing similar ideas to what had originally attracted me to hip hop. In the beginning, when I first came up, it was very much about originality, excitement, and progressiveness. I grew disillusioned with the hip hop industry towards the mid-90s when appropriation, determined by corporate America, started taking over. The move toward gangsterism turned me off. It was so clearly about oppression all over again. Around the same time, I started working with the

Peter Kang

X-Ecutioners. They are not lyrical; they're turntablists. They work with turntables as their instruments; they speak with their hands. I was very excited because, to me, it was all about revolution, doing something progressive and different, which was what attracted me to hip hop in the first place.

In 2001 I was invited to the East Coast Asian Students Union conference at Columbia University to speak on a panel about Asians in the music industry. Afterward, there was a showcase of hip hop artists and spoken-word performances given by Asian-American kids. I was absolutely floored by the stuff I was hearing. It was moving, and socially and politically conscious. They found an arena and a vernacular to talk about issues like the murder of Vincent Chin, and drew comparisons to hip hoppers talking about Yusuf Hawkins. They discussed histories such as the "comfort women" of Korea, or Sah Eeh Gu 429, the race riots in LA in 1992. This experience made me think about the commonality of oppression and how Asian Americans were embracing hip hop culture, taking it and giving it their own voice. In relation to Blake's discussion, it overlaps with and extends the three-dimensional timeline further. Asian Americans are taking a form born out of envy and exoticization and bringing it into a new fold, more organically than consciously, with harmony and not oppression. The title of Duke Ellington's record *The Afro-Eurasian Eclipse* (1971), originally from the fifties, described his perspective on Asianization. In it, he composed jazz suites that were all influenced by Asian culture. Sure there's a commercial thrust that one can read into, but it was his...ours. I'm working on an album now and a documentary film on the kids. Right now, I'm compiling the material, documenting their shows, doing interviews with them, finding out what their influences were growing up, musically and socially, and what their home lives were like. They actually grew up with hip hop, unlike my generation, our generation. We were raised in the early seventies, and experienced a sort of birthing, in 1982, hearing two guys listening to "Rappers' Delight" (1979), pushing grocery carts down the streets of Manhattan. These kids grew up in the era of Public Enemy and KRS-ONE, and they were moved by the struggles of African Americans. They translated it into their own thing, which really moved me, and really made me understand myself, that I went through the same thing these kids went through.

BB: One of the things I was going to ask you was about working with the X-Ecutioners, who are black and Latin, and their teams of individuals... So many of the other DJ crews, like Scratch Pickles and Beat Junkies, a lot of the West Coast DJs especially, are Asian, and, it's an interesting thing, like turntablism, like DJs from the Bronx, like Caribbean DJs, Latin DJs, black DJs. Do people talk about that at all—the ethnicity behind the music?

PK: Yeah, I did an interview with the Triple Threat DJs, who are the original members of the Invisible Scratch Pickles. And they were probably the most prominent Asian-American DJ crew. They basically told me that their roots come from the Bay Area in the early 1970s, their fathers

and uncles were in DJ crews playing disco music.

GG: I mean like from Vallejo, like Q-Bert on the....

PK: Yup, yup. And they just kind of continued on the tradition.

GG: They didn't know that it wasn't *their* tradition.

PK: When I asked them what was the moment that awakened them, they said it was watching Herbie Hancock on the Grammy Awards with D.ST, doing "Rock It" (1982).

GK: I grew up with some of those guys in LA. We would ride our bikes in the sixth grade to DJ Curse's house, and were like, "oh, man, Ray's a good DJ!" And when the transformer scratch came out, it was like, "oh man, we gotta learn to do that!" You know, we all had our Radio Shack mixers, and we used to put a little dime with a piece of tape on it to make the fader shorter, it was like a toggle-switch before there was a toggle-switch. These experiences have had an enormous effect on my art practice. Growing up going to the record store, getting the new "Roxanne," looking for another copy of "Alnayfish" because we broke the last one. It's related to the constant quest for something new, something *ours*. I mean I don't remember any ownership issues. We would roll down and obviously realize that we were not black, but there would be some black people, some Asian people, we would all just roll down to the store together. We all made our own little business cards in seventh grade after we had saved up some money. Some of my friends were in rap crews, and some of them in a graf crew called NASA. We were all breakers. Most of my friends were Filipino and Korean. I was the only Japanese kid. The first time the ownership issue ever came to mind was when someone was going to go to New York. We were like, "man, you're gonna go to New York, shit! That's where it all started!" And when he came back from New York, everyone was askin' "oh, tell me some stories! You were in the Bronx, you were in Brooklyn, what's going on?" And he said, "I don't know. Wherever I went, they were like, 'what's up, Chinaman?'" He would respond, "'yo, man, I'm Filipino!' They don't even know the difference between a Filipino and a Chinaman!" Innovation seemed so inclusive from the get-go. We attached ourselves to it. It was going to be our proxy into American pop culture, this assembling of other bits. I remember on weekends, we'd watch *Ultraman*. My grandmother used to translate from Japanese to English the ninja show for my little breaking crew and me. There was a show called *Kage No Gundan* (Shadow Warriors), which was a ninja show, and then we'd watch *Breaking and Entering*, which was a documentary. It was the first time Ice-T ever appeared on tape, and he was a clown, and of course, the *Fantastic Five*. Then, Shabba Do moved to our neighborhood. We would ding-dong ditch Shabba Do's house. You know, we'd be sayin', "that's Shabba Do's house!" And he'd yell, "get the fuck out of here!" It was stuff like that. You'd see a half-Japanese, half-white kid, one black kid, one white kid, two Japanese kids (me and my younger brother), and a few other kids on the couch in my living room, watching TV, and deciding what we're going to do after that, were we going to play ninja, or were we going to break?

GG: As a kid, like Glenn and Deborah, I never felt the sense of "I'm not..." It was more like "if I want to go and claim Bruce Lee, I claim Bruce Lee." Nobody's like, "I'm not Chinese, I know I'm not from Hong Kong, I know I'm not from New York." It was about claiming not negating. You don't really think of asking until somebody else says, "you're not hip hop" or "you can't do martial arts because you're at a genetic or a cultural disadvantage." Fortunately, in baby steps, history and cultural theorists are moving away from that model of litmus tests and impermeable boundaries.

CWK: "Black Belt" artist Patty Chang, who, like me, grew up in the San Francisco Bay Area in the seventies, remembers the conflict and contradiction of extreme attraction and repulsion, of being excited about a hero but having to respond to another kind of stereotype and marginalization. While America began to accept an Asian icon, the extant hegemony grew determined to tap into

its commerciality. Returning to what Glenn and Dominic were saying about something new and original, one of the things I wonder about is what kinds of issues of trust we are talking about. Does "we're all black and we're all white," depart from a pragmatic or a romantic point? Audiences crave association with something that's different, something that's new, something that's clandestine, progressive, or pertaining to an underground, a non-commercial entity or idea, especially in this day and age of the mach-3 speed travel to mainstream status. If a beat, a look or idea hasn't been tapped into, someone's going to figure it out sooner rather than later and turn it into a profitable situation. So is the game then about rejecting society, controlling your own marginalization, or insisting on being the one who profits from it? One of the problems lies in the constant and evolving reinforcement of the exoticized "other," whose subjects begin to reform and regenerate new ideas even when confronted with the negations and limitations, only to be marketed and mass produced, reifying and perpetuating the objectification and exoticization.

GK: Obviously, historical analysis will prove that with the notion of trust, sometimes you get burned. People are skeptical, and I think that perpetuates the attraction to the underground. For me, the conversation ends up similar to how I unpack the rhetoric of the marginal, in terms of the analysis of marginalization of ethnic cultures. I use the same analysis when people talk about underground culture. I don't like thinking about the high and the low, or spaces demarcated by these sorts of regions. I think of the tactic often invoked in recent history to reposition the center to the margin in order to create an alternative cultural discourse that ends up recognizing the marginal position as central, and allows itself to analyze its own place relative to the mainstream. For me, the margin is the mainstream because, again, with this sort of obliterated model, where everything is about configuration, not originality, I think there is no difference. So that is a conversation that I don't necessarily have. I understand the issues with trust, and I understand why, perhaps at the risk of sounding naïve, I say these things about trust. But I know that the reaction to that is to be sheltered into the underground, or to create protected spaces. I think everybody has a cultural practice, and we should try to figure out and analyze each instance as a custom-made history. I don't think that you can't be underground. I think you can, and I think that it's a very successful strategy. But as opposed to saying you're underground to resist the mainstream, I prefer the position to say people are building tactical positions whereby they can develop ideas further, before they want to affect change, and develop ideas privately. Private space is equally important as public space. For me, it all comes down to configuration, where instead of learning originality, we learn how to configure. It has to do with things like lowered cars, custom radios, and sticker-science. Sticker-science is putting stickers on your skateboard or stickers on your thing. It's like collage, as opposed to data accumulation.

DG: Also, I think about Tristan Tzara's concept of mirroring, that we shouldn't be concerned with society's interpretation of ourselves—that we have to look to our inner self. John Singleton used one of The Last Poets in his film *Poetic Justice* (1993), where you see him sort of singing, "Niggaz are just plain…" and that is the final point of the poem where he ends on this positive note after beginning with all these phrases about how white people see black people. It's more than just a sample. It is an interpretation of "us," not through "them" but through our own eyes. It's not like Cornel West being sampled in *The Matrix Reloaded* (2003).

I remember something that Bruce Lee said in an interview with Pierre Burton in 1971. Bruce Lee became very fed up with Hollywood and felt totally ripped off. So he went back to Hong Kong and asked one of the elders for his blessing. He needed it to be able to use certain moves within his dojo in California. His elder said to him, "If you are going to go on and spread, understand that *it* is going to be spread." Bruce Lee felt, as he said, "raped by the system." If anyone's going to call it something and make money off it, it should be *you.*

Last year, I worked on a project with Gang Zhao, Franklin Sirmans, Lilly Wei, and Brett Cook-Dizney. Gang, who grew up in China, was telling us how, in the seventies, black culture was

hugely popular in China. He said everyone wanted an afro. He said it was about the recognition of a commonality between the Black Panther movement and Mao Tse-Tung. All of these things were progressive and exciting. He said there was also a backlash in China. Everything black in China wasn't necessarily in. Just as within black culture, not everything Asian was or is in. Towards the late 80s, a let's-try-and-get-our-own attitude prevailed. That was when everyone was into Afro-centricism. Trying to find one's own meant being resourceful and pragmatic. I also think about Joseph Campbell's discussion about searching for one's identity: where is the source? Is it how people perceive you or how your perceive yourself? Yet, I can't overlook the fact that the commonality seems to be money; I mean that's how we live.

CWK: From the moment Warner Brothers previewed the Shaw Brothers' film *Invincible Boxer* (1972) in Cannes and subsequently bought and released it in the U.S. as *Five Fingers of Death* (1973), to more recent movies like *Romeo Must Die*, the seventies kung fu movie, or more generically, Hong Kong action cinema has become one of the most commodified objects of Asian culture in the U.S. I wanted to read you a passage from a recent essay by Tzarina T. Prater entitled, "Old Man your Kung Fu is Useless: African American Spectatorship and Hong Kong Action Cinema," that relates to some of those issues of ownership, and money as the commonality:

> *Romeo Must Die*, starring world-reknowned Chinese martial artist Jet Li, is an example of how the centrifugal motion created by global capitalism and the Hollywood machine create a flattening of signification. The film was conceived by the producer Joel Silver (of *The Matrix* and *Lethal Weapon* series), after he conducted market research that profiled his audience as "urban" (read: lower class and pigmented). Based on this research Silver decided to create a film that would combine martial arts and hip hop, clearly aiming to capitalize on the mass-marketed aspects of the two "subcultures." To that end, the film also stars rap artist DMX as Silk, a machine-gun-toting entrepreneur (who appears, like the movie's R&B singer Aaliyah, on the soundtrack). Fascinating in its articulation of capitalism's ability to flatten and commodify cultural production as sheer surface, this film subordinates and obscures the very real complexity of transcultural exchange. *Romeo Must Die* enacts to social inequities and disruption that the free market engenders, without really questioning the inevitable economic crises created by *laissez-faire* business policies.

Prater's argument suggests that the very nature of capitalism, or at least where we are in the history of capitalism today, opposes the multi-dimensional model or methodology that Glenn introduced by design. Because of the channels and modes of exchange that people traffic in, globally, namely Hollywood and the media, our individual narratives of cultural exchange do not really manifest in a wider trajectory. In other words, the white veil between us (Asians, blacks, Latinos, et al.) is more opaque than transparent, and we'll continue to understand other cultures through movies, TV programs, music videos, magazines, etc. Now, as a few of you have stated, I too am unafraid of these kinds of contradictions and actually enjoy them. We, as individuals, may understand that the nature of urban cultural hybridization is a three-way street, but if, as Deb suggested, money is the lowest common denominator, where does this place the history of our own lives, work and experiences in relation to ownership and control? As Peter explained, hip hop producers are going to push gangsta rap and commercial shit, but leave folks like dead prez behind because their complexity is not palatable or marketable to the American public.

DG: This is always going to happen, and the critique of this perpetuation is a big part of my work as an artist.

GG: The strategy goes both (and many) ways, and I think all of us, generationally perhaps, know that this does, did, and will, happen. This is America. An interesting thing about Bruce Lee is that his style, Jeet Kune Do as opposed to Wu Shu or kung fu, is a hybrid style. He said, 'fuck all the

traditional forms and other stuff; those things are important, and they have a place and a history, but I'd rather incorporate a fighting style that is pragmatic.' He caught a lot of backlash about his ideas of authenticity.

ɢᴋ: That's why notions of authenticity need to be redefined as well.

dm: Wasn't it *Game of Death* where he had to go through the various continuums, each one represented different hybrid roles and possibilities? In this documentary, the discussion of the yellow jumpsuit, which was very untraditional, was about a representation of formal breakdowns. Bruce was trying to get away from rigorously confined notions, through western pragmatic fashion and style.

ʙʙ: Especially when traditional martial arts or kung fu forms might have been attached to a more monastic tradition, again, going back to the Han Dynasty, as if it were an essential component of Chinese culture. I think there was a lot of opposition to wearing the *gi*, not having the Jeet Kune Do gloves and all that other stuff.

ᴄʏᴋ: Recently I read an article about a thirty-fourth generation *Sifu* (teacher) who has a dojo on Broadway in lower Manhattan. He listens to hip hop at temple. He says, "It's good music to train to." I thought that this was an appropriate example of the continuum of cultural exchange and multi-directional cross-pollination.

ʙʙ: In the late 1980s when everyone was wearing medallions and kente cloth, you couldn't say that "Planet Rock" was based on a song by the band Kraftwerk, which is German kraut-rock-machine music. And you can't say that other people weren't bothered. Like, "it's a black thing, you couldn't understand." In 1982, it was one thing, like you throw on the Kraftwerk record, and then you throw on the Afrika Bambaataa version of it. Afrika Bambaataa talks about that kind of cultural hybridity, but at different moments in the present, the past takes on these different shapes. When Dominic was talking about "Black Korea," it was like, "weren't we down with kung fu movies, like ten years ago?" Like, "no, no, that never happened."

dm: I was thinking about that time when even in visual arts culture, for me it was when I was in grad school, the Whitney Biennial in 1993 took place while these things had been going on in hip hop. I think that put out some very strong, identity-based works and revisionist politics. It was very much a sign of that time.

ɢᴋ: I think to the credit of that Biennial, though, it broke down doors. They broke through a door with a battering ram that none of us want to use now, but that was the ram they had to use, and they used it. It's complex the way people, even with that show, that being representative for like an entire era… it's still a piece of art history.

dm: To me, it was the most appropriate museum show of that decade.

ᴄʏᴋ: That was exactly ten years ago. It's curious to perceive where we are going now…

The exhibition "Black Belt" brings together nineteen artists of diverse backgrounds whose works comment on the layered and complex ways in which a particular cultural nexus in twentieth-century American history has influenced their art. While the majority of the works in the exhibition are new, the selected artists have been making work inspired by Afro-Asian connections and notions of cultural hybridity throughout their careers. Through forty-four works in painting, sculpture, drawing, video and mixed-media, the resonance of what is typically seen as merely a subcultural pop phenomenon is reconsidered as an immense and immeasurable genre that evokes various creative and critical discourses. While many of the artists in "Black Belt" explore the private sphere of sexuality, gender and personal politics, the exhibition also embraces the multiplicity of cultural exchange characterized by universal pop culture.

I have developed the context for "Black Belt" in part as a platform on which to understand how specific transcultural experiences translate into contemporary artistic practices and processes. It is impossible to effectively categorize or chart the range and depth of influences and concerns implicit in these works of art. However, by fusing artistic concerns and critical voices in consideration of a cultural intersection in American history—the mid-1970s—"Black Belt" visually explores a structure and methodology reflective of the hybrid nature of culture—not as it is perceived but as it is formed. The African-American fascination with Asian culture through martial arts, Bruce Lee and kung fu and the Asian fascination with black culture are two of many topical trajectories of discourse on identity and culture in contemporary art today.

The roundtable conversation in this catalogue reflects how a divergent group of artists, producers and curators respond to this moment through their personal experiences. The connections between that era and today are perhaps most apparent in the found-image-based work of several artists including Rico Gatson, Glenn Kaino and Paul Pfeiffer who manipulate film and video footage. Using sources from popular entertainment, including *Menace II Society* and Michael Jackson, these artists deconstruct the contemporary seduction of violence. Those concerns are also shared by Sanford Biggers and Iona Brown, whose sculptures and drawings point to global vernaculars in style and a tenuous mutual exoticization between cultures.

Some of the more abstract aspects of Eastern philosophy are evidenced in the work of Ellen Gallagher, David Hammons, Arthur Jafa and Clarence Lin, who are engaged in theories associated with absence, Zen philosophy and mythology. Adding another topic to the conversation, Patty Chang's and Cynthia Wiggins' works consider some of the paradoxes of racism and sexism in intrapolycultural spaces. The Asian male stereotype is dissected through notions of obsession, fandom, and the cult of personality in the work of David Diao and Michael Joo. Through the work of all the artists in the exhibition we are invited to reflect on the reverberations of time and consider our collective cultural future.

Harlem-based **SANFORD BIGGERS** works in mixed and hybrid media reflective of the many sources and processes from which he draws in his sculptures and videos such as handsewn sneakers and altered fake jewelry. Biggers appropriates commodities and icons that refer to global markets and international trade, while locating intersections of economy and society in culture. Kung fu "knit kickers," for example, are placed on an extended, gold-plated "bling, bling" chain. They mimic the practice of sneakers throwing over telephone wires or lampposts. Whether in Brooklyn, San Juan, Tokyo, or Manchester, this practice exemplifies a global urban vernacular.

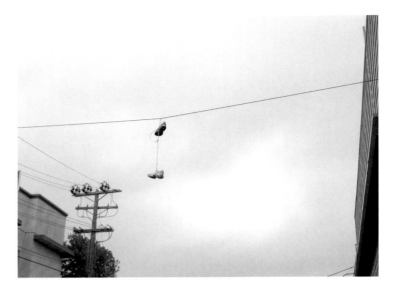

Studies for Untitled, 2003

Phat Gold Chains, 2003

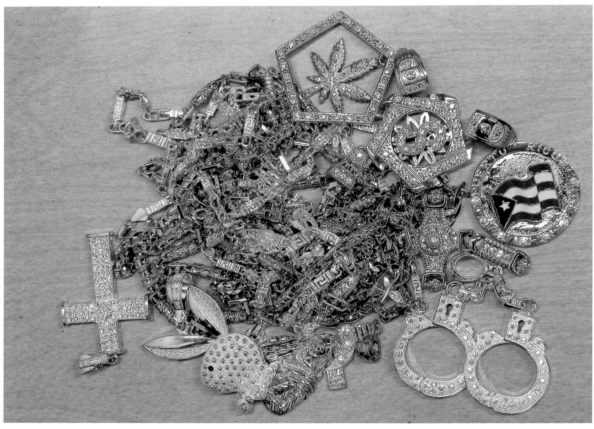

I grew up watching "Kung Fu Theatre" on Channel Five on the weekends and "Kung Fu" during the week. My friends and I would imitate our favorite fighters and practice their signature skills. I was the Master of the Flying Guillotine. Around 1983, we all started breakdancing, which was a continuation of the same ritual though with different moves. What made my crew, Ground Motion, stand out, was that we wore karate shoes. We used to save up some money, go to the swap meet in LA, where they were sold by the bunch, and have enough to equip the whole crew.

To me, Jim Kelly was kung fu soul brotha #1, way before Bruce Leroy and the Wu. He was the purveyor of the 1970s notion of Black international cool. Not only did he lay it down in *Enter the Dragon* (1973) with Bruce Lee, he was also one-third of *Three the Hard Way* (1974) and the star of *Black Belt Jones* (1974). He was to martial arts what Dr. J was to basketball...There was something about the whole thing that seemed so packaged and manufactured, but it didn't matter... I draw him in black rice.

Black Belt Jones, 2003

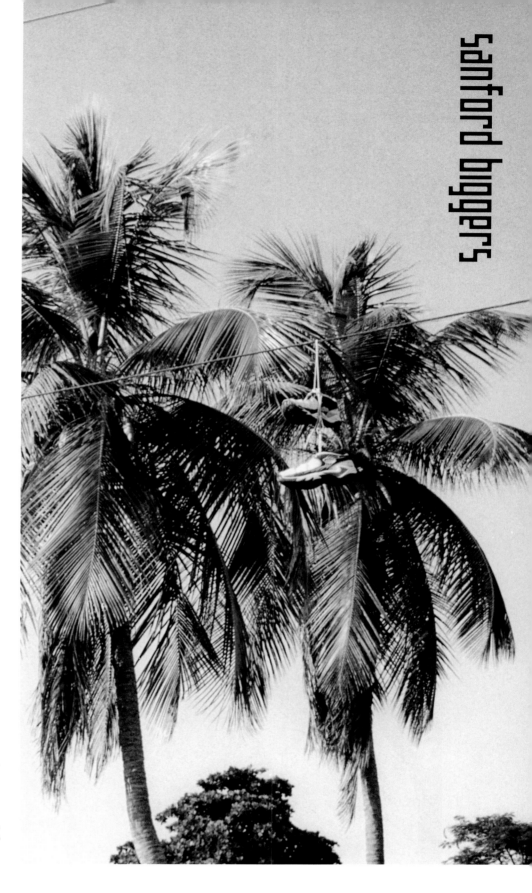

Study for Untitled, 2003

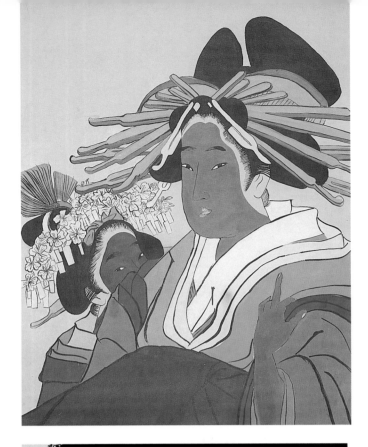

The paintings and drawings of **IONA ROZEAL BROWN** investigate Asian art historical and cultural practices, specifically *ganguro* in Korea and Japan. Her work also examines the contemporary "cross-cultural" adaptations of black youth culture in Asia and the influence of Eastern philosophy and style on black America. The works on paper are painted in the Japanese *Ukiyo-e* (pictures of the floating world) style of the late Edo period, associated with the urban pleasures of teahouses, theaters, geishas and courtesans. While they illustrate stylistic appropriation and mutual exoticization between black and Asian cultures, they are also representations of cultural objectification and stylization of non-Western cultures and subcultures in the U.S. and in Europe.

Of course one of the most obvious connections of black popular culture and the martial arts can be witnessed in the music group, the Wu-Tang Clan. The name is derived from the sword fighting school of the Shaolin Temple. They refer to their home of Staten Island as Shaolin and make continuous references to the various Wudan schools of thought in their music.

Expanding on the theme of *a3* (afro-asiatic allegory), the newest portrait is a visage painting of the Qing Dynasty emperor, Qinlong, or more specifically, it is the Qing emperor's *shenrong* (emperial visage). Official in status and ceremonial in function, a visage portrait employs a pictorial style that rejects any depiction of physical environment, bodily movement or facial expression. The basic codes of the genre are that it must present the emperor in a perfect frontal view, wearing the Manchu-style hat, and donning the robe with embroidered imperial dragons, which serve as symbols of his ethnic and political identity. See, Emperor Qinlong had inherited a vendetta from his grandfather, Kan Lin, against the Shaolin Temple as it was in support of the former ruling Ming Dynasty. The Shaolin Temple would finally be destroyed under the rule of Qinlong.

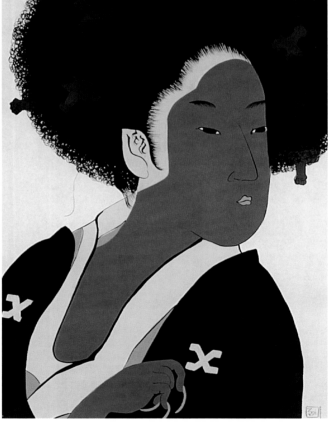

a3 blackface #0.50, 2001

a3 blackface #3, 2002

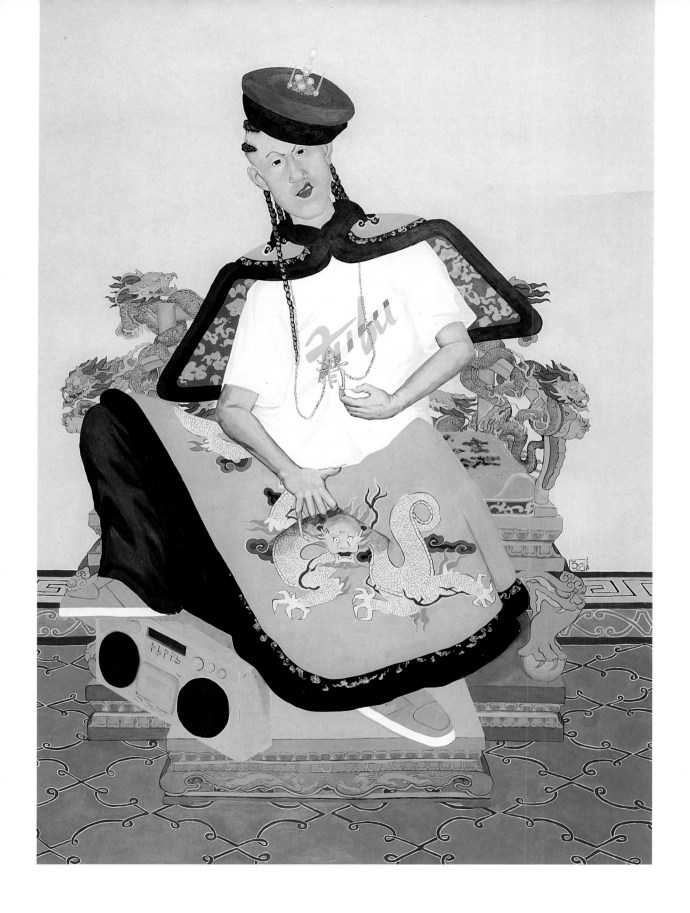

a3 #10 (down-ass emperor Qianlong), 2003

PATTY CHANG's videos and performances are enigmatic and seductive critiques of and responses to desire in American culture. Her reenactment of the famous fight scene between Bruce Lee and Kareem Abdul-Jabbar from *Game of Death* (1978) speaks to the fetishization, perpetuation and proliferation of combat between non-whites in an otherwise white Hollywood. By highlighting specific aspects of the choreography, theatricality and special effects from the signature scene, Chang and her collaborator insert themselves as stand-ins for the larger-than-life and, paradoxically, pathetic heroes who have played out and shaped stereotypes over the decades, while catering to a mainstream audience. While agency resides in the accessibility of the material, a feeling of fatality through linearity and self-marginalization is evoked with humor and irony.

 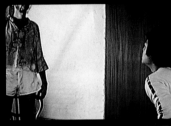
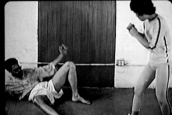 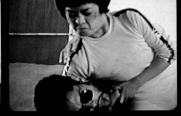
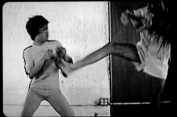 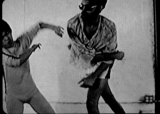
 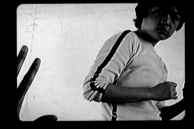

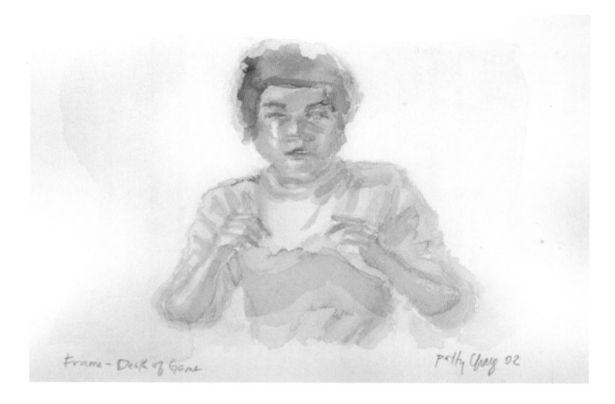

Frame—Death of Game Patty Chang 02

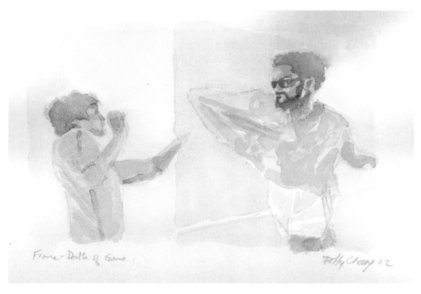

Frame—Death of Game Patty Chang 02

When I was young, within my circle of peers, kung fu was sort of a dirty word. The idea of Bruce Lee embodied a kind of self-loathing that, now that I look back, took years of discipline and training to understand and correct.

Sitting in front of the TV on weekday afternoons watching "Dialing for Dollars," followed by the afternoon movie and then the cartoons, the one movie scene I always think of is Bruce in the yellow jumpsuit fighting Kareem. When something inspires the level of quizzical awe that this scene elicited in me, it becomes interesting material to dissect...The watercolors bring the video stills back into a tactile, low-tech, nostalgic form. It also allows me to enhance my Bruce-like resemblances.

Y. dAVId CHUNG's videos and installations recite narratives of urban conflict and racial barriers in America, such as the 1992 Los Angeles riots and the polemics of black youth and Korean merchants nationwide. This new wall drawing is based on the final battle scene from *Black Belt Jones* (1974), considered the first martial arts AND black action film. Compressing over ten minutes of film footage into one still image, Chung depicts Jim Kelly fighting a throng of opponents in a flurry of soap bubbles. (The original scene takes place in an auto body shop.) In the film, he and Sidney, played by Gloria Hendry, defend their karate studio against the mobsters who want to demolish the building and erect a shopping mall in its place.

Study for *Black Belt Jones*, 2003

I am interested in how kung fu has permeated street life. It has created a new hybrid identity fusing ancient Asian traditions with contemporary inner-city ideas, derived from both the pragmatic need for self-defense and battle, as well as in response to people of color being pitted against one another by the government and in the media...and not only falling victim to the stereotypes but also fueling their propagation.

The paintings of **dAVId dIAO** rarely come without a feeling of unrequited longing. They are a commentary on the relationship between triumph and tragedy in western civilization and art history. The first and most obvious readings of the silkscreened figures address notions of masculinity, idolatry, sexuality and race. Implicating cultural legacies such as Jackson Pollock and Bruce Lee in his portrait-cum-self-portrait-cum-portrait canvases, he critiques "the sources and subjects of art-making in the aftermath of modernism." Pollock's gesture of throwing the paint is compared to Bruce's Lee's kung fu slice. The smiley face over Lee's face emphasizes masking and minstrelsy…a sort of futility in seeking originality within the social reliance on reproduction for cultural understanding.

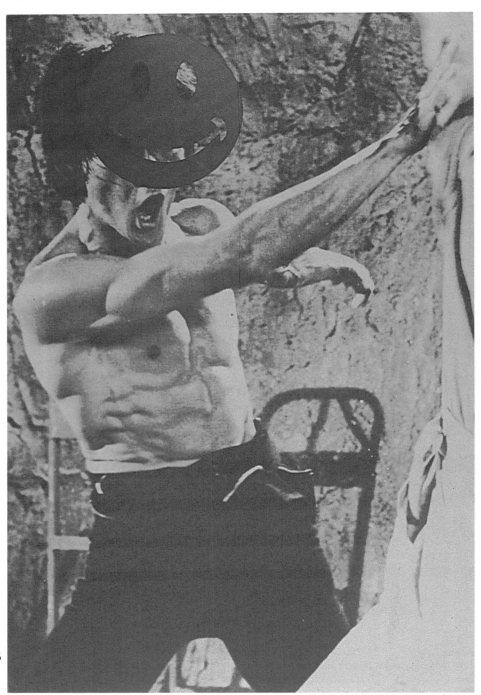

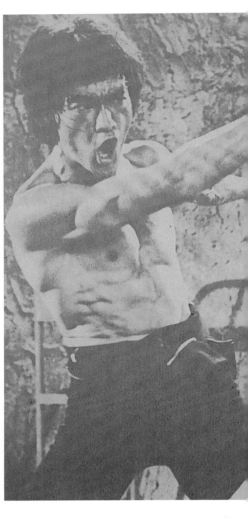

Hiding, 2000

The smiley face is deliberately sinister and comical… the so-called "Oriental" man is giving face and saving face…I have no heroes. I find the notion of the hero problematic.

To some extent, the late film star [Lee] has risen before us as within a dream. Diao offers up Lee as a kind of alter ego, raising the possibility of a fantasy relationship with Lee as a more aggressive Chinese icon and also as a shamanistic culture hero. Lee's ferocious and ritualized kung fu pose brings to mind that atavistic physicality of grandly gestural expressionistic painting as well as a fantasy of the powerful and mysterious racial other. Close examination of Diao's painting reveals that behind Lee one finds a background highly suggestive of a painterly text, a rough-hewn monochromatic play on texture thick with brush strokes. Through this Bruce Lee fantasy, the 'action painter' of Abstract Expressionist myth has been reborn for the post-Greenbergian, post-modern era of mass culture and the "new cultural politics of difference."[1] In the fantasy scenario about Bruce Lee, Diao's provisional ideal ego substitute is found working with the pleasure of Lee's celebrated and intensely virile style. One can imagine the impossible fantasy figure refusing formal caution and regularity and responding directly to drives far more primal than those embraced in the self-reflexive procedures of Diao's actual practice of critical painting. Bruce Lee appears as a regressive fantasy double in the history of modernist painting: a famous and deceased mass culture hero is ironically appealed to and given free reign to paint again with the shameless sublimity of the Abstract Expressionists.[2]

Interested in the "sonic" intersections of pop culture and art, **SEAN DUFFY** constructs a single turntable unit out of two or more players with needles on a single record, creating rounds of sound. Formally, the dissected and cannibalized record players are exquisitely reconstructed to resemble modernist painting and design, most notably Mondrian. Conceptually, the sculptures are born from wordplay and music history. The polyphonic repetition of the "round" represents a McLuhanesque "Eastern" space of simultaneity, sphericality, and syncopation. Sound, as opposed to sight, is multidirectional and fluctuating. One of Duffy's theories about the early 1970s is that resulting from the new FM radio formatting, radio stations were trying to appeal to as wide an audience as possible, playing every type of music. "It wasn't uncommon for one radio station chart to have Neil Sedaka, followed by the Staples Singers followed by Steppenwolf, which represents an interesting fracture in systems of classification."

Study for Thank You, Ernest, JoJo and Leslie, 2003

Thank You Ernest, JoJo and Leslie is a sort of tribute piece to my favorite albums from my early years. It is backed by the soundtrack to Jimmy Cliff's *The Harder they Come* (1972), which was co-produced by Leslie Kong, and Dillinger's *CB200* (1978), which was made possible by Ernest, JoJo and the rest of the HooKim family. Jamaican music takes from Africa, Asia and the Americas and turns it into something that is new, yet wholly familiar because that is the design of the American sonic experience. Anytime we look back into the history of jazz, from Miles Davis to hip hop, we find the traces. The Pioneer turntables are period props, and the fake bamboo furniture refers to a sort of international set-design aesthetic of the "exotic" or the "primitive."

The paintings of **ELLEN GALLAGHER** resist and repel conventional critique. In the past decade, she has created canvases of enlarged, lined notebook and penmanship paper, suggestive of pedagogical writing frames or spatial guides for children. Within this structure, fractured blackface minstrels cluster and hover in nebulous, monochromatic spaces; and hair-product, wigs, and hairpiece advertisements from the 1940s through the 70s are carefully arranged in grids. The figures in these compositions resist both seeing and being seen—with their whited-out eyes and caked-on yellow hair (Gallagher uses yellow as a metaphor for hybrid skin)—they are like signs and symbols participating in an infinite cosmology of whimsy and erasure.

I really see the black paintings as a kind of refusal. Even when reading them, if you stand in front of them they go blank and then if you stand at the side you see only a little. They are also about memory in Bebop. And Miles Davis' omission of notes that leaves a ragged disembodied line...The black paintings are also physically like factory work, a purposeful, formal re-inscription of factory work. Hand cutting from sheets of rubber. I am always re-creating this labor. Once I start to get an efficiency or proficiency with what I am doing I have to complicate things so that there is this sense that the labor is growing and growing and could potentially overwhelm me. That possibility is so very important that I almost can't finish it...The black paintings are about re-inscribing that element of using your body into the work.[3]

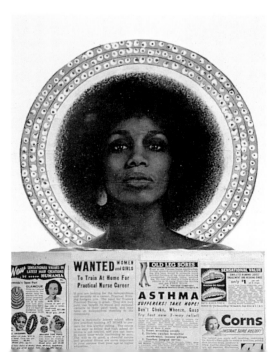

Murmur consists of five, separate 16-millimeter projections of claymation, stop-action-animation and scratch-animation films, each of which has its own independent yet interrelated narrative. *Kabuki Death Dance* is based on Gallagher's underwater "wig ladies," who are in part inspired by Eunice Rivers, an African-American nurse who, in 1932, began unknowingly ushering hundreds of black farmers from Macon County, Alabama, to participate in The Tuskegee Syphilis Study. Studying the infected men as human subjects, this government-funded project denied them an available cure and allowed for numerous deaths through 1972. In this animation, the figures form fractal compositions, transform into migratory flocks, and descend into Drexciya, Gallaghers mythical Middle-Passage Atlantis. The name, Drexciya, comes from a Detroit-based music group, which claims to channel aural hallucinations from the ever-descending depths of the Middle Passage. In these animations, fantastical realms of hybrid characters and abstracted narratives replace the social and racial histories from which they are derived.

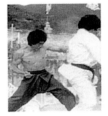

PICO GATSON's most recent works include video sculptures and installations where snippets of old Hollywood and blaxploitation films, music videos, documentaries and kung fu movies are subtly recognizable... to a degree determined by the cultural fluency of the viewer. Using high-tech editing software and tampering with the tempo, Gatson accelerates and decelerates the found footage as if "painting" in video. Figures, sounds, landscapes and narratives are either blurred or brought out to undermine or highlight the culturally-specific subtexts.

The nine monitors, set in an oversized, plywood, diamond-shaped structure, emit a soundtrack that emphasizes the "battle history" of rap music and breakdancing. The videos consist of a rapid succession of images, organized into four categories: Fights, Rappers, War and Racism, running at one to three frames per second. Each category addresses a different aspect of what Gatson calls "the male obsession with violence, fighting and aggression." These are the yang moments. The yin moments of the work are found in the more spiritual and meditative scenes, such as the two-minute, tightly framed loops of Muhammad Ali's and Bruce Lee's eyes. Diametrically opposed yet inextricably bound, the yin and the yang components inform one another. Collectively, these images speak to Gatson's belief in non-violence as the first form of resistance, based on Bruce Lee's perpetual semi-autobiographical film characters' vow of non-violence.

With this installation I am interested in creating a work that is unapologetically political, and still, I want to challenge commonly held notions of Political Art by focusing on the highly formal qualities of these images and sonic cadences.

LUIS GISPERT often talks about the rapidity and simultaneity of information in American television and film. Gispert's photographs and sculptures reflect hybrid spaces for the authentic and the artificial to interact in a non-hieratic manner. The curious collapse of elements, otherwise associated with the "high" and the "low," can inform structures of interpretation similar to the way children gather and understand information, especially for Gispert, who grew up in an exclusively Spanish-speaking household, learning English from watching TV.

I remember in the early eighties sitting in front of the television on Sunday afternoons with my female cousins in Miami. We would wait for "Samurai Sundays" to come on Channel Six. It was six straight hours of martial arts programming. Of all the movies, one stayed with me. Not that it was my favorite kick flick, but something about the final fight scene always struck me. *Enter the Dragon* (1973) ends with Bruce Lee fighting the villain with a razor claw hand in a hall of mirrors. The refracted images of Lee flying through the air, smashing mirrors in slow motion still has resonance with me.

My 37th Chamber is an enantiomorphic structure that a viewer can partially enter. He/she sees his/her own image both multiplied and cancelled out at specific points. This idea came from that final battle scene in *Enter the Dragon*. A motion sensor activates the low-frequency sound of a body-hit taken from a martial arts film, emitted from a hidden subwoofer within the chamber.

PLEXIGLASS

INTERIOR
GOLD MIRROR

SBWOOFER

MOTION SENSOR BEAM

...ERSON ENTERS MOTION SENSOR
...RIPS LIGHTS BEHIND PLEXIGLASS
...ND SUBWOOFER

MY 37 CHAMBER VERSION 2

4'

OUTSIDE COVERED
IN GREEN JERSEY

16'

12' 3' 7'

6'

RED JERSEY

MY 37 CHAMBER VERSION 2
TOP VIEW

16'

7'

Can It Be That It Was All So
Simple Then, 2000-01

Study Enter my 37th
Chamber, 2002-03

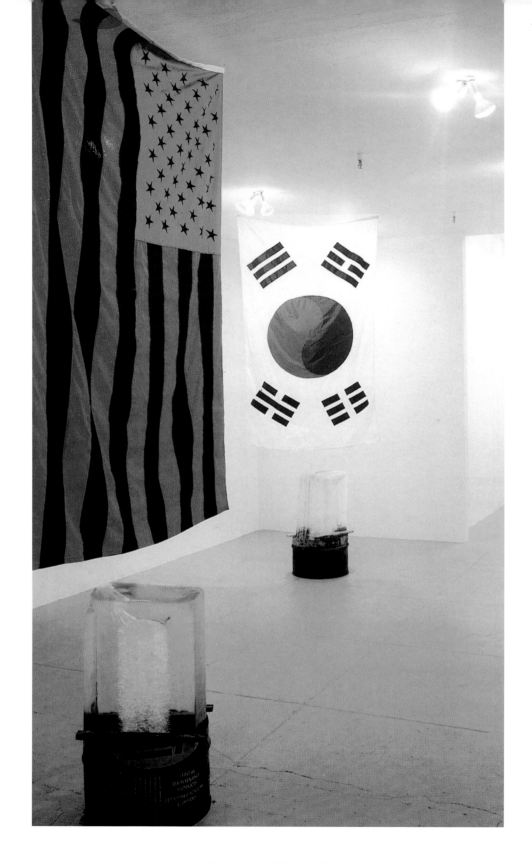

dAVId HAMMONS has had a long-standing interest in Eastern aesthetics and philosophy, specifically in notions of absence and negative space. Insisting on a rhetoric that contradicts those of other artists on the topic, Hammons interprets the 70s' African-American male fascination with kung fu and martial arts as centered around violence and entertainment. **Rap music and kung fu have the same level of madness to me. They're not about cultural exchange.** Discussing more poignant and poetic aspects of Asian culture, Hammons quotes artist On Kawara, "The Asianness is in the ritual."

Whose Ice is Colder? (detail), 1991 Homeplate, 1998

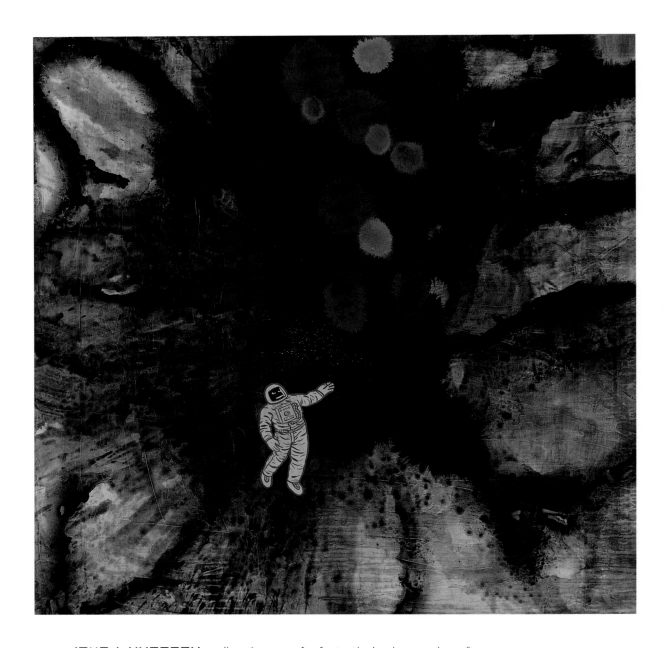

dAVId HUFFMAN realizes images of a fantastical universe where "trauma smile" characters exist in "dark matter," which, according to astrophysicists, occupies eighty-five to ninety percent of the universe's mass but is largely unstudied and/or invisible. "There is little known truth about dark matter because astronomers have concentrated on celestial bodies of light and have inadvertently disregarded other possibilities of the universe," explains Huffman. "This is politically very curious... terms like 'black hole,' 'low surface brightness' and 'dark matter,' give rise to racialized perspectives in science and in science fiction." His macabre, rich, painterly canvases depict moonscapes dotted with part-comic, part-hero, quasi-Afrofuturist, martial arts characters in fantastical spaces where Japanimation figures, blackface robots and superheroes of color abound.

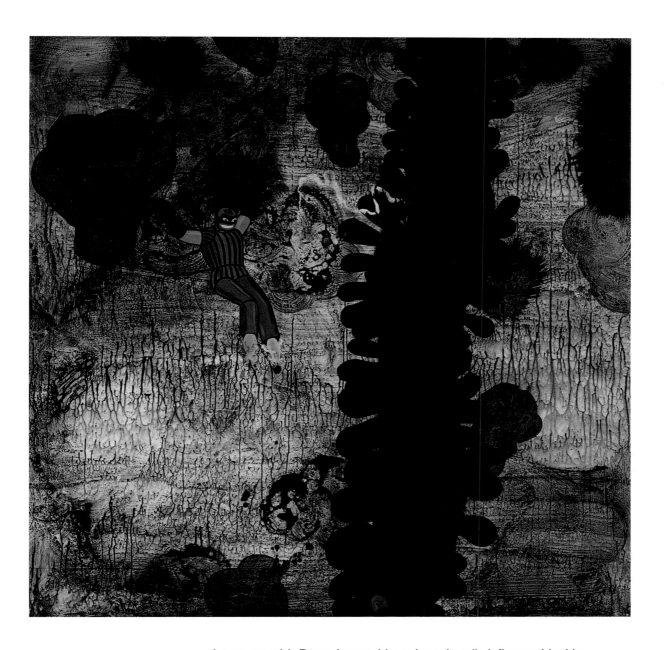

I grew up with Bruce Lee and have been heavily influenced by his presence in American culture. I used to watch him as Kato in "The Green Hornet." Even though he was only the driver and a servant, he was the star of the show. On a personal note, I tried to become a fighter and studied martial arts, but after a few years, I realized that I could not come close to Bruce's skills, and that it was better as a fantasy... That was when I turned to art. My cousin, who was training me to be a fighter, came to pick me up for a tournament one morning and I said to him "I've given up fighting for art." I wanted to kick some ass too.

ARTHUR JAFA works in sculpture, film and architecture. His collages consist of found images from photojournalism, fashion and travel magazines. Jafa is particulary interested in formal strategies within the politics of representation. *Untitled* is both a conversation piece and a shrine to black militancy. Formally, its composition is in accordance with what Jafa refers to as "the principles of black *feng shui*." Visible through a suburban glass sliding door—reminiscent of diverging vernacular architectural fragments, such as black storefront churches, International Style architecture and the glass enclosure at the Lorraine Motel (erected after the assassination of Martin Luther King, Jr.)—are elements such as a black-on-black flag and Black Panther decals, employed in the manner of red seals on Chinese landscape paintings and calligraphy. Throughout the course of the exhibition, Jafa will rotate, remove and add items to the installation. They include images such as Malcolm X in a window with a rifle, Bruce Lee with black *nanchukus* and Mao Tse-Tung with W.E.B. Du Bois.

Stanley Kubrick's obsession with a suppression of blackness is atypical of the genre only with respect to the elegance of its construction. And who could possibly fully disentangle the clusterfuck of racism (and sexism) that's typical of classic science fiction and its retarded offspring, science fiction films? 2001 [A Space Odyssey (1968)] is about fear of genetic annihilation, fear of Blackness. (Black rage, Black Power, Black Panthers, Black planet, Black dick, etc.) White phallic objects (starships) move through all encompassing blackness (space) from one white point to another (stars). This fear of space, this horror vacui, is a fear of contamination, a contamination of white being by black being which, by the very nature of the self-imposed and fragile ontological construction of white being, equals the annihilation of white being.[4]

Untitled, 2003

As their titles indicate, numerous past works by **MICHAEL JOO**, such as *Yellow, Yellower, Yellowest* (1991), *Nature vs. Nature* (1997), *Chia* (1999), and *Miss Me-gook* (1993-2000) reference racial aphorisms and plays on double entendres. Joo's sculptures and videos often manipulate visual or linguistic puns and racial and/or sexual stereotypes, reconstructing critical narratives around extant tropes. *Chasing Dragons* implicates as its main character Topper Headon, drummer from The Clash, as portrayed in the documentary film *Rude Boy* (1980). Headon, a devout Bruce Lee fan, is shown kicking and punching both a workout bag and a friend. Joo fractures the original footage into vertical fan-like sections in human scale fragments, formally replicating the dizzying experience of Bruce Lee fighting in the hall of mirrors in *Enter the Dragon* (1973).

In title and in social discourse, *Chasing Dragons* refers to the legendary drummer's simultaneous obsessions: heroin and Bruce Lee. Less a commentary and more a tribute, the work is concerned with the idea of "the fan" and the status and behavior of a punk rock icon, an idol to many—including myself—and the attraction to destruction.

Chasing Dragons, 2003

si no, si kisha? she's at the party?
i'm getting dat poosey

hurry up an' git yo shit an'
git yo ass up on outta here.

what did you say about my nànay?

just shut the fuck up, punk.
just bone on out.

aye, aye. get tha monays, dude!

jacka-pot, man. like las begas

The Hughes Brothers' classic urban gangster movie *Menace II Society* (1993) starts with two young, African-American men walking into a liquor store in search of beer. Less than thirty seconds into shopping, they are followed and harassed by one of the owners, a middle-aged Asian woman. The two men confront her, asking, "I don't know why you always follow me around" to which they receive no reply, only a suspicious stare. They pay for their beer and begin to make their way to the door when the clerk, presumably the woman's husband, condescends to one of them, "I feel sorry for your mother." The customer gets angry; the scenario seems to justify his rage. He is presented as the stereotypical victim of the constant distrust of an Asian middle class whose arrogance towards their African-American neighbors has no bounds. He turns around and shoots the man dead, then grabs the man's wife. He takes her to the back of the store to eject the security camera tape before shooting and killing her. His friend freaks out, panics and runs away. This event sets the movie in motion and creates a roaring story engine.

The framing of the relationships in this film between African-American youth and working class Asians is constructed from essentialist views of racial formation and fails to provide any productive insight into the complicated nature of the impacted histories of the Asian diaspora and African-American oppression within the urban landscape. Rather, two groups of poor, ethnic people are shown to dislike each other and are put in a setting wherein they are provoked. The loaded histories of each group are invoked, leaving a scene filled with judgment, jealousy and hate.

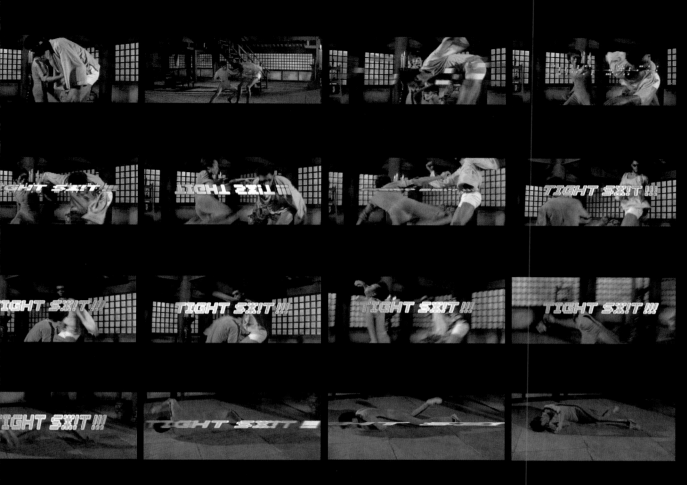

Society 2 Menace by **GLENN KAINO** is an attempt to draw new meaning from this same scene and create a heightened drama by restructuring the relationships between the characters in a way that subverts their dependency of classic racial archetypes. As if produced in a different dimension, the film looks the same but sounds different. New vocal tracks have been recorded for each character... The shooting, which felt somehow ironically justified in the original, now seems just raw and vicious. The scene can no longer rely on the master narratives of African-American oppression and Asian diasporic distrust as its back-story; rather it brings several interlocking histories into the mix. The owners' indignation no longer seems like the proverbial 'straw that broke the camel's back,' but rather a badly timed joke that leads to dire consequences. This sense of immediacy is what makes the violence seem wanton. The film begins to speak more to the obsession with violence and the phenomenon of urban and suburban shootings than to any specific racial relationships.

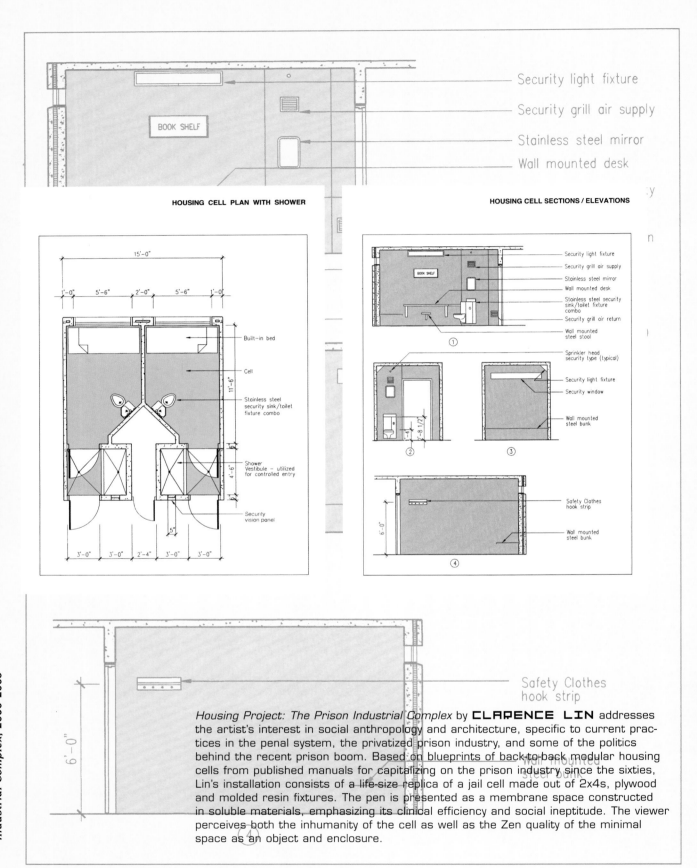

Security light fixture

Security grill air supply

Stainless steel mirror

Wall mounted desk

HOUSING CELL PLAN WITH SHOWER

HOUSING CELL SECTIONS / ELEVATIONS

BOOK SHELF

15'-0"

1'-0" 5'-6" 2'-0" 5'-6" 1'-0"

11'-6"

4'-6"

Built-in bed

Cell

Stainless steel
security sink/toilet
fixture combo

Shower
Vestibule - utilized
for controlled entry

Security
vision panel

5"

3'-0" 3'-0" 2'-4" 3'-0" 3'-0"

BOOK SHELF

Security light fixture
Security grill air supply
Stainless steel mirror
Wall mounted desk
Stainless steel security
sink/toilet fixture
combo
Security grill air return
Wall mounted
steel stool

①

Sprinkler head
security type (typical)

Security light fixture

Security window

Wall mounted
steel bunk

② ③

2'-8 1/2"

Safety Clothes
hook strip

Wall mounted
steel bunk

6'-0"

④

Safety Clothes
hook strip

6'-0"

Wall mounted
steel bunk

④

Housing Project: The Prison Industrial Complex by **CLARENCE LIN** addresses the artist's interest in social anthropology and architecture, specific to current practices in the penal system, the privatized prison industry, and some of the politics behind the recent prison boom. Based on blueprints of back-to-back modular housing cells from published manuals for capitalizing on the prison industry since the sixties, Lin's installation consists of a life-size replica of a jail cell made out of 2x4s, plywood and molded resin fixtures. The pen is presented as a membrane space constructed in soluble materials, emphasizing its clinical efficiency and social ineptitude. The viewer perceives both the inhumanity of the cell as well as the Zen quality of the minimal space as an object and enclosure.

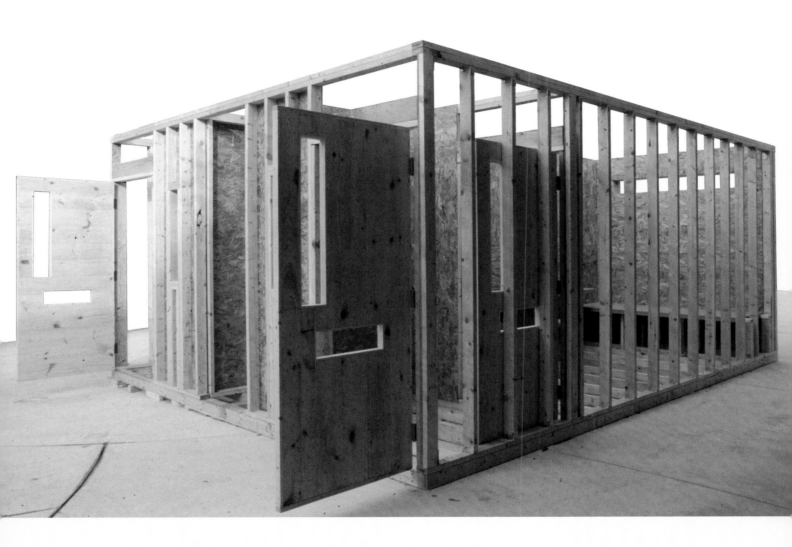

Whereas multiculturalism defines cultures as distinct and coexist-
ing, polyculturalism assumes that people live coherent lives that
are made up of a host of lineages (Prashad), and looks to under-
stand those cross-cultural influences. Martial arts has been a way
for people of color, for many living in these "new housing projects,"
to envision or meditate on a life beyond bars. This minimal sculp-
ture is a representation of the armed fortress of white supremacy.

KORI NEWKIRK's recent work has shifted toward minimal silhouettes. The Ninja throwing stars are site-specific neon sculptures that measure up to four feet in diameter. Instead of vicious, razor-sharp edges, however, the forms are illuminated and buoyant, reminiscent of the signage from 42nd Street theaters that Newkirk remembers fondly from the 1980s. The sculptures are embedded within the architecture of the exhibition space.

125th Street awash in the bright sunlight of an anonymous day. Long black lines vibrate with tenuous excitement as they wait to enter the cavernous theater. Mostly, boys to men... The babble inside is louder than outside. 42nd Street. The scene repeats itself after dark. Flashes of color as the car glides under brightly lit signs, one after another. Dressed for downtown, stimulated by the dazzle and dirt of the day. My people, my people.

The video works of **PAUL PFEIFFER** obscure and abstract media celebrities, such as Patrick Ewing, Muhammad Ali and Marilyn Monroe, and compress real-time and actual places found in film and television footage. *Live Evil*, whose title derives from a Miles Davis album, consists of a partially erased, silvery Michael Jackson, slithering on a dark stage. Jackson's body is vertically edited out and his body seemingly "morphs into a Rorschach pattern." Residing in a fluctuating space between the rituals of the "dance" and the "fight," *Live Evil* distills the identity of a famously infamous black entertainment icon and turns him into a minimal, robotic, pulsating, segmented, insect-like specimen, while alluding to agency and the hegemonic representation of identity in music and dance performance.

Live Evil, 2003

What pushes me to use certain found images is that they have left a deep impression on me, either a long time ago, or very recently. The way that images become burned into the memory shows how porous an individual identity really is. It makes me wonder how the boundary line around an individual is drawn. In a way, all my work is a study of that process. My approach is to take an image that has penetrated my consciousness, and then to manipulate it just enough to emphasize the qualities that have impressed themselves on me, regardless of whether I wanted them to or not.[5]

The work of **CYNTHIA WIGGINS** examines practices and behaviors of violence, in domestic spaces, sports and public environments. By installing extension cords and rope on plaques and altars, for example, she presents utilitarian objects used in acts of violence against women as objects of desire. One of Bruce Lee's signature lines from *Chinese Connection* (1972)—"I won't hide. I've made plans"—is the starting point for her installation, *Plays Well with Others/Bruce Lee Saved my Life*.

I have always been a very physical person, and, for some reason, I have always inserted myself into places and spaces where I was told I didn't belong. This habit led me to take up martial arts in 1998... Martial arts seemed like the logical place for me to begin to think about the nature of aggression and my own aggression. Physical aggression isn't something often associated with women as actors, but rather victims of. I wonder what creates and defines an aggressive personality. Is aggression nature or nurture? Can it be contained? Are aggressive personalities benign, or, like kinetic or potential energy, waiting to be ignited?

Plays Well with Others/Bruce Lee Saved my Life is part homage, part interrogation. While the altar invokes Bruce Lee, the *shuriken* (throwing stars) are about the more deadly involvement of weapons. The wisdom boards, made from wooden boards used for breaking during martial arts belt tests and tournaments, display proverbs culled from training journals as well as my own mantras, such as "He who conquers others may be powerful, but he who conquers himself is truly strong," and "To fight the instant one is provoked is to acknowledge defeat."

ROY WILLIAMS' found-object sculptures and installations are both dioramas and portraits. His use of quotidian materials, such as books, house paint, concrete blocks, photocopied newsprint and street signage, allow him to re-create situations of futility. *Losing Small Battles* consists of a stack of four philosophy books on a pedestal. A concrete weight holds them down, and a cable connects the brick to an electric guitar amplifier, emitting a low, hypnotic buzz or scratchy, yet even, hum.

Losing Small Battles involves artifacts that pertain to my own search for meaning... contemplating ideas about self-discovery, self-defense and self-definition. The cement block sits atop the books as a social weight, or maybe as an obstacle to retrieving the necessary information in the books. I guess it's also about a test of strength and discipline... as well as a representation of a book, or of knowledge, but embodied in a meditative object. The sound emanating from the amplifier is the only possible source of transfer for infor-

mation. Perhaps it represents the desire for amplification of the information contained in the books. It's information as a sound, a static hum, the texts abstracted... vibrations and energy as information. All these objects belong together. They remind me of Zen statements and riddles that the Zen Master uses to determine a student's level of enlightenment.

1. See Myung Ja Kim, "Across Races: Towards a New Cultural Politics of Difference; An Interview with Dr. Cornel West," *The Korea Society Quarterly*, Spring 2000, pp. 8-9.
2. See Paul A. Anderson, "David Diao: Critical Painting and the Racial Sublime," *Third Text* 33, Winter 1995-96, pp. 41-59.
3. See Ellen Gallagher interviewed by Jessica Morgan, in *Ellen Gallagher*, (Boston: Institute of Contemporary Art and New York: D.A.P., 2001), pp. 26-27.
4. See Arthur Jafa, "My Black Death" in Greg Tate, *Everything but the Burden*, (New York: Broadway Books, 2003), p. 255-256.
5. See "Paul Pfeiffer and John Baldessari in Conversation," in *Paul Pfeiffer*, (Cambridge, Mass.: MIT List Visual Arts Center, Chicago: Museum of Contemporary Art, and New York: D.A.P., 2003) pp. 36-37.

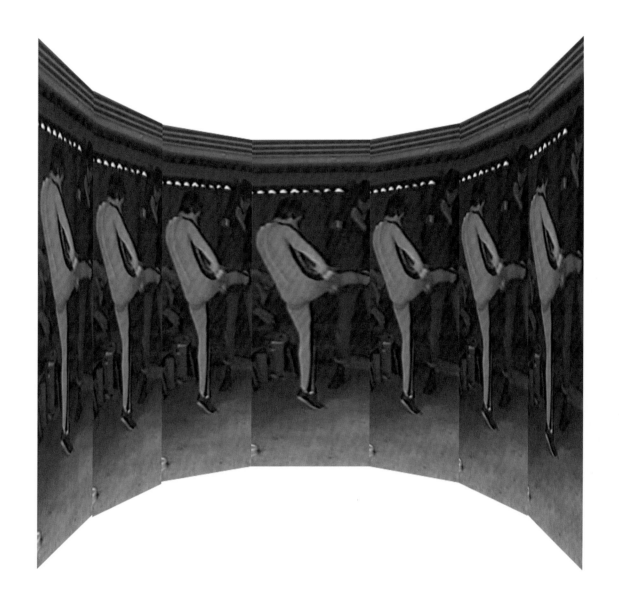

Although hot and humid as usual 1974 was not just another year for us in Calcutta. The railway workers across India had been on strike and their boldness worried the complacency of the elite. The short Maoist insurgency called Naxalism came and went like a whirlwind. The Communist movement grew apace and three years later would come to power over the state administration and stay there winning six separate elections. And, across from the New Market, Globe Cinema Hall showed *Enter the Dragon* starring Bruce Lee.

There was something extraordinary about Bruce Lee. He was the "foreign" version of our own Amitabh Bachchan, the Big B, who that year gave us such classics as *Benaam and Roti Kapada aur Makaan*, and who would in the next year star in the greatest spaghetti Eastern of all time, *Sholay*. As far as those foreign heroes were concerned (and *foreign* simply refers to English-language films), my friends and I supped on James Bond with some satisfaction. *Enter the Dragon*, however, was something else. I saw the movie several times, blown away by the beautiful acrobatics of the celluloid freedom fighter. Bond thrilled us with his gadgets, but we did not take kindly to his easy victories against his adversaries who seemed to be either Asian or Eastern European, straw figures standing in for Communists from Vietnam to Poland. Bond was the agent of international corruption manifest in the British MI-5, while Bruce stood his ground against corruption of all forms, including the worst of the Asian bourgeoisie, Mr. Han. With his bare fists and his *nanchakus*, Bruce provided young people with the sense that we, like the Vietnamese guerrillas, could be victorious against the virulence of international capitalism. He seemed invincible. We did not know that he was already dead.

Born in San Francisco on November 27, 1940, the Year of the Dragon, Bruce made his first U.S. film, *Golden Gate Girl*, at the age of three months. A child of Chinese opera stars (although his mother was a fourth German), he moved to Hong Kong in his childhood, where he starred in over twenty films, before returning to the United States as an undergraduate at the University of Washington. In Seattle, Bruce threw himself into the Asian American world, working in Chinatown as a busboy and as a teacher of his favorite art, kung fu in the sticking hands method. He left college to marry Linda Emery, a white American of Swedish English ancestry, against her family's wishes. They soon had a son, Brandon, and a daughter, Shannon. When asked about "racial barriers," he told a Hong Kong journalist in 1972 that "I, Bruce Lee, am a man who never follows those fearful formulas... So, no matter if your color is black or white, red or blue, I can still make friends with you without any barrier."[2] In fact, Bruce was one of the first martial arts *sifus* (masters) to train non-Asians, including people such as Chuck Norris, Roman Polanski and Kareem Abdul-Jabbar.

The anti-racism of Bruce was not matched by the world in which he lived. "I am a yellow-faced Chinese, I cannot possibly become an idol for Caucasians."[3] Since the late eighteenth century, when the first Asians arrived in the Americas, the white patriarchs found their presence foul. Deemed to be nothing but labor (as coolies), they came to be seen as fundamentally alien rather than as assimilable immigrants. Representations of these foreigners exaggerated certain attributes to render them not only strange, but also inferior. In the minstrel shows, Jim Crow and Zip Coon were joined by John Chinaman. As historian Robert Lee notes, "Unlike the minstrel characterization of free blacks, who were represented as fraudulent citizens because they were supposed to lack culture, the Chinese were seen as having an excess of culture."[4] What was this excess of culture? If the republic saw itself as virtuous and industrious, then it saw the Chinese, who themselves formed a crucial part of the working-class, as oozing cultural sloth mainly

through their language, food, and hair (the queue, or long ponytail). These cultural stereotypes enabled the mockery of a people by suggesting that they could never be part of the republic, since they had too much alien culture. This was to change somewhat in the 1960s, as social movements against racism and state management of these movements helped produce what we know today as multiculturalism. U.S. television with *The Green Hornet*, 1966-67, embraced Bruce to play the Asian, just as the state acknowledged the role of Asians in the creation of a cold war United States. The passage of the 1965 Immigration Act signaled a shift in U.S. racism from outright contempt for Asians, as evinced in the 1924 Immigration Act, to one of bemused admiration for their technical and professional capacity. In the throes of the Cold War, and burdened by the lack of scientific personnel, the U.S. state and privileged social forces concertedly worked to welcome a new crop of Asians whose technical labor was to be their crucial passport to this New World. This is not to say that Asians found life easy or that the U.S. state was the paragon of generosity. Nevertheless, the opening afforded by the U.S. state's needs allowed immigrant Asians to imagine ways to import elements from their diverse Asian societies into their new homes. The Asian American movement, in tandem with the civil rights and other minority movements fought for this cultural wedge. Yet, when Bruce's bravado took him to Hollywood in 1966 to play Kato in *The Green Hornet*, his role did nothing to challenge the legendary stereotypes of the alien "Heathen Chinee" within America.[5] As Kato, Bruce was welcome to be the mysterious clown, and sidekick. "Hollywood sure as heck hasn't figured out how to represent the Chinese," Canadian journalist Pierre Berton said to Bruce, who replied that "you better believe it, man. I mean it's always the pigtail and the bouncing around, chop-chop, you know, with the eyes slanted and all that."[6] *The Green Hornet* ended production in July 1967 with a special program in which the champion crime fighters teamed up with Batman and Robin. The script had the four heroes fight one another to a draw, then join efforts to defeat the villainous Colonel Gumm. Bruce, nonplussed, "maintained an icy silence, but his eyes burned through the holes in the mask he wore." With the cameras on, he menacingly stalked Burt Ward, who played Robin. Ward tried to plead that it was only a TV show, but Bruce ignored him, and only when he was disturbed by a noise off-stage did he back off and exclaim, "Lucky it is a TV show."[7] But of course it was more than that. Kato was still the Heathen Chinee. The Green Hornet, Batman, and Robin respected his martial skills, but still they could allow him neither to win nor be their equal. The cultural hierarchy of race set in place for over a hundred years was not to be swept away by the entry of a talented young Chinese American actor.

It is hardly a surprise then that in 1971, the studio considered Bruce to play Caine in the television show *Kung Fu* (then called *The Warrior*), but then rejected him as "too Chinese." The dismissal sent Bruce packing to Hong Kong and into history. *Kung Fu*, on the other hand, became all that Bruce disavowed. Set in the nineteenth century, the show has Caine (half Chinese, half white) taking on racism by his own individual, superhuman initiative; other Asians appear passive or as memories of a grand era long past and always exotic. The half-white man, a leftist Chinese American periodical argued, is guided by "the feudal landlord philosophies of ancient China," and even ninenteenth century China "is pictured as a place abstracted from time and place." The Taiping and Boxer revolts have no room in what is essentially a very conservative view of China and of social change.[8] Bruce would not have played Caine in this light. "It was hard as hell for Bruce to become an actor," remembers Jim Kelly, the African American kung fu star of *Enter the Dragon*:

> And the reason why was because he was Chinese. America did not want a Chinese hero, and that's why he left for Hong Kong. He was down and out. He was hurt financially. He told me that he tried to stick it out, but he couldn't get the work he wanted. So he said, "Hey, I'm gone." My understanding, from talking to Bruce, was that the Kung Fu series was written for him, and Bruce wanted to do that. But the bottom line was that the net works did not want to project a Chinese guy as the main hero. But Bruce explained to me that he believed that all things happened for a reason. Even though he was very upset about it, he felt that everything would work out. He wasn't going to be denied. I have so

much respect for Bruce, because I understand what he went through just by being black in America. He was able to find a way to get around all those problems. He stuck in there, and wouldn't give up. He knew my struggle, and I knew his.[9]

Bare Feet and Naked Hands

They say, Karate means empty hands,
So it's perfect for the poor man.[10]

In the early 1970s, every "Oriental" was a "Gook." Born in the U.S. mendacity against the Philippines and Latin America in 1898, the word gook was applied equally to the Vietnamese guerrillas and to those Asian Americans drafted into the U.S. army. During basic training, an instructor pointed to twenty-year-old marine corps recruit Raymond Imayama from Los Angeles and said, "This is what the Viet Cong looks like, with slanted eyes. This is what a gook looks like, and they all dress in black."[11] "Japs are the next lowest thing to niggers," one fellow U.S. army recruit said to twenty-year-old Marcus Miyamoto.[12] Miyamoto, born in the Manzanar internment camp in 1945, was in the U.S. Marines in Danang in 1965-66. Imayama and Miyamoto are two of many marines of color pushed to the front lines to fight a racist war. So the war was racist, then, not just in its virulent attack on the Vietnamese, but also in the way the United States Army used Asian and African Americans as cannon fodder.[13]

Steve Sanders, one of the founders of the Black Karate Federation (BKF) in 1968 and a co-star of *Enter the Dragon*, learned his art as a marine at Okinawa before being shipped off to Southeast Asia.

> I didn't enjoy being over there. Anybody who says he did is either a nut who enjoys seeing people killed or a liar. I really don't know why I was there in the first place. I didn't hate the North Vietnamese or the VCs. They looked the same as the South Vietnamese who we were supposed to be helping. How can you like one and hate the other? As far as I'm concerned, those people just want to be left alone to do their own thing.[14]

Sanders is not alone in this view. Certainly we all remember Muhammed Ali's public stance—I ain't got no quarrel with them Vietcong[15]—but less public figures also saw the irony and vigorously protested against serving the U.S. government. In 1966 three army privates associated with the Communist Party refused to ship out to Vietnam. James Johnson (African American), Dennis Mora (Puerto Rican) and David Samas (Lithuanian Italian), in a joint statement, noted that "Negroes and Puerto Ricans are being drafted and end up in the worst of the fighting out of proportion to their numbers in the population; and we have first hand knowledge that these are the ones who have been deprived of decent education and jobs at home." Furthermore, "We were told that you couldn't tell [the Vietnamese] apart -- they looked like any other skinny peasant," but "the VietCong obviously had the moral and physical support of most of the peasantry who were fighting for their independence."[16] Known as the Fort Hood Three, they represent many troops who felt, in their skin, the horror of the war.

In April of 1967, the year Bruce made his mark on television, Martin Luther King Jr. stood before a congregation at Riverside Church in New York City and broke his silence about Vietnam.[17] "We were taking the black young men who had been crippled by our society and sending them eight thousand miles away to guarantee liberties in Southeast Asia which they had not found in southwest Georgia and East Harlem," he said. "If America's soul becomes totally poisoned, part of the autopsy must read Vietnam. It can never be saved so long as it destroys the deepest hopes of men the world over."[18] To speak out against the Vietnam War, to kick it against international corruption -- this was what it took to be a worthy non-white icon. And Bruce did it without guns, with bare feet and fists, dressed in the black outfits associated with the North Vietnamese army. For

U.S. radicals, the Vietnamese became a symbol of barefoot resistance. Early issues of the Farm Worker's newspaper *El Malcriado* called President Johnson the "Texas grower" and the Vietnamese, "farm workers," to make the transcontinental links that would give the Mexican workers hope.[19] Frustrated by her contemporary social movements in 1968, Marilyn Webb of DC Women's Liberation applauded the "Vietnamese woman [who] has literally won her equality with a weapon in her hand and through the sheer strength of her arms."[20] The Black Panthers, of course, recognized this aspect of the Vietnamese struggle. Connie Matthews, a Black Panther from San Jose, was eloquent on this theme at the Vietnam moratorium demonstration in October 1969. "The Vietnamese are a good example of the people being victorious," she said. "Because with all of America's technology and her greatness she has been unable to defeat the Vietnamese. Every man, woman and child has resisted."[21]

The Vietnamese seemed like the only force capable of being brave before nuclear imperialism. As the "Man", imperialism appeared untouchable to millions of youth across the planet. How could the barefeet of the world trounce B-52s, Agent Orange, fleets of destroyers, nuclear bombs, the military-industrial powerhouse of the United States. Each time a people made the attempt, from the Congo to Chile, the CIA's technological sophistication put paid to their efforts. The cultural symbol of the CIA was James Bond, that overarmed agent of U.S.-UK imperialism, and he had to answer Bruce's *Enter the Dragon* with *The Man with the Golden Gun* (1974).[22]

U.S. imperialism was like a poison. Apart from napalm, the U.S. used its arsenal of finance capital to undermine the sovereignty of the nations of the Third World. From 1965 to 1973, aggregate manufacturing profitability in the advanced industrial countries began to decline, a phenomenon that was assisted by the oil shocks of this period. One of the strategies for recovery conceived by the managers of the Group of 7 nations was to export the crisis, to conduct the structural adjustment of the newly independent nations, and to subsume all the economies of the world under the Dollar-Wall Street regime.[23] Robert McNamara, fresh from his post sending B-2 bombers to Vietnam, went to the World Bank where he provided vast funds to bolster new authoritarian regimes such as Indonesia, Brazil and the Philippines.[24] The debt of the entire Third World has increased from $100 billion in 1970 to $1.3 trillion in 1990. Whatever limited sovereignty was produced by the newly independent nations (and their import substitution strategy) was usurped by multinational firms (who enjoyed the corporate welfare of the IMF) and by the parasites who ruled the new nations. From 1962 to 1974 the register of revolutions held only one entry, South Yemen, but "in 1974 the dam had burst." In the next six years revolutionary movements took power in at least fourteen states, from the overthrow of Haile Selassie in Ethiopia to the victory of the New Jewel Movement (Grenada) and the FSLN (Nicaragua), in 1979.[25] The dollar wars against the currencies of the poor increased the sense of powerlessness. Big Capital wrenched the reins of history from artisans and peasants, who saw technology as the enemy rather than as the puppet of financiers and plutocrats. Bruce, on the screen, seemed to be able to ward off the evil of iron and steel, of dollar and debt, with his bare hands.[26]

What appealed to many young people, men and women, was the "simplicity, directness and nonclassical instruction" of Kung Fu. "Ninety percent of Oriental self-defense is baloney," Bruce said, "It's organized despair."[27] Kung Fu, in Bruce's vision, revoked the habit of hierarchy that swept up most institutions. Frustrated with what his student Leo Fong called "chop suey masters" who created an art for recompense, Bruce eagerly developed his Kung Fu (in the wing chung style, which he called jeet kune do) against the style of his fellow teachers whom he described as "lazy. They have big fat guts. They talk about ch'i power and things they can do, but don't believe in."[28] Instead Bruce used weights and drank high-protein weight-gain drinks (blended with ginseng, royal jelly, and vitamins). His virtuoso approach to perfection, and culture, came across in his delicate fierceness on the screen. If the *sifu* rejected the authority that came with the *sifu's* position and instead fought for authority based on skill, then this was itself a rejection of the hierarchy of tradition. Bruce did not claim his power from his inherited kung fu lineage (his teacher, Yip Man, was

master of the "sticking hands" method of wing chung), but he wanted others to bow to his street-fighting prowess. When asked if he was a black belt, Bruce was forthright. "I don't have any belt whatsoever. That is just a certificate. Unless you can really do it -- that is, defend yourself success-fully in a fight -- that belt doesn't mean anything. I think it might be useful to hold your pants up, but that's about it."[29] In other words, anyone with dedicated tutelage can be a master, can be a *sifu*.

Kung fu gives oppressed young people an immense sense of personal worth and the skills for collective struggle. Kung fu, Bruce pointed out in his sociology of the art, "serves to culti-vate the mind, to promote health, and to provide a most efficient means of self-protection against any attacks." It "develops confidence, humility, coordination, adaptability and respect toward oth-ers."[30] Words like *respect* and *confidence* jump out at me immediately, for one hears the former from working-class youth and the latter from their hard working, but beleaguered teachers. These youth live within a calculus of respect and disrespect, wanting the former, but alert to challenge the latter. Their teachers want them to be confident. Kung fu allows for both and don't the kids know it. They are there on the weekends, for no "credit." And they fight not just for anything, but for righteousness.[31]

The notion that anyone can be a *sifu* was powerful, and it became the basis for the turn of many working-class youth to the martial arts. In the ghettos of the United States, dojos and kung fu schools opened to eager students. Cliff Stewart's dojo opened in Los Angeles in the late 1960s. Stewart, a founder of the BKF, set up the dojo for "the kids in our neighborhood. Most of them couldn't afford to travel to dojos in other parts of the city," nor could they afford the equipment required to participate in most sports except basketball.[32] Karate requires no fancy equipment, just a small space, bare feet and naked hands. The youth in the ghetto took refuge, said Steve Sanders, in "pills and pot for a long time. Some were stealing to keep up their habits. So I made a deal with them. I told them if they kept away from drugs, they could come to my classes and train for nothing."[33] Many came and excelled.

Fred Hamilton organized All-Dojo Karate Championships at places like the Manhattan Center in New York City or at the Fordham University Gymnasium in the Bronx, where, for a few dollars, entire families could sit and watch the Black Belts demonstrate their rough poetry in motion.[34] By then most young African Americans knew of the deeds of the BKF (and its founders, Steve Sanders, Jerry Smith, Cliff Stewart and Don Williams). Staff Sergeant George Harris was the first African American judo champion for the Air Force. In 1971, *jujitsu* artist Moses Powell was the first African American to perform at the United Nations and by 1973 became a featured performer in Aaron Banks's Oriental World of Self-Defense. That same year, Howard Jackson from Detroit, Michigan, took the world of kung fu by storm, winning the Battle for Atlanta and becoming the first African American to be ranked no. 1 in the sport's history. Tayari Casel, a student of Jimmie Jones of Chicago, later, experimented with *kupiganangumi*, a "rhythmical and acrobatic martial art developed by African slaves and their descendants and ch'ang ch'uan," when he won the Battle of Atlanta in 1976.[35] Each of these men continue to develop their martial arts skills to build communi-ty power. Powell has developed a style known as sanuces-ryu (he works with "ex-offenders, teach-ing them self-respect, self-control and honesty through the martial arts" and he works "with disad-vantaged youth and senior citizens").[36] Meanwhile, Mufundisi Tayari Casel trains young people in Maryland in the arts of *kupigana ngumi*, a Swahili phrase that means "way of fighting with fist." He urges the development of a healthy lifestyle, discipline and community values.[37] The Black Karate Federation continues to preach the path of karate as the path to a disciplined and just com-munity. It seeks to "facilitate a sense of unity among a diverse community, provide leadership and guidance for youth and their families, narrow the gap between cultures, gender and age groups, create a greater sense of awareness of both physical and mental health."[38]

What was astounding about the BKF and several other U.S. dojos was the openness to women. Bruce himself was not keen on women in the dojos. Of women fighters he said that "they are no match for the men who are physiologically stronger, except for a few vulnerable points. My

advice is that if they have to fight, hit the man at his vital points and then run. Women are more likely to achieve their objectives through feminine wiles and persuasion."[39] You can imagine what Pauline Short thought of these words. Called the "Mother of American Karate," Short opened her first karate school in Portland, Oregon, in 1965 which catered entirely to women. Or one can sense the fury of Ruby Lozano, the Filipina, who won one of the twelve awards for Outstanding Filipinos Overseas from the government of the Philippines in 1974 for her karate prowess. And what about the fiery reaction from Graciela Casillas, born in Bellflower, California in 1956 and karate champion by the late 1970s. And, finally, what of Judith Brown's suggestion that women should live in all-female celibate communes and practice karate, a weapon in the arsenal of a strong, liberated woman.[40] The BKF welcomed women into the schools, just as the black kung fu movies took pains to represent women as fighters in their own right.[41]

In addition to the master of the local dojo, there were black kung fu heroes like Jim Kelly, bigger than life on the movie screen, tangling with women just as fierce as he. Born in Paris, Kentucky in 1946, Kelly came to kung fu through karate, and by the 1970s Kelly cemented his place among the top rank of martial artists at Ed Parker's famous tournaments (where Bruce first did an exhibition in 1964). When they worked together on *Enter the Dragon*, Kelly's skills impressed. Bruce admired the soul that Kelly put into his *chi'i* and let him choreograph his own fights (others tended to make martial arts entirely mechanical if they were not supervised).[42] The ability to transmit "soul" was central to Kelly, whose mix of pleasure and skill had thrilled young aficionados in his day. Consider the famous act of bluster from Kelly (as Williams) in *Enter the Dragon*. When the evil Han asks Williams about his fear of defeat, he responds that "I don't waste my time. When it comes, I won't even notice. I'll be too busy lookin' good." You can imagine entire sections of the theater breaking into spontaneous applause. As writer David Walker recounts in his essay "Jim Kelly and Me,"

> I wanted to be Jim Kelly. Sure I wanted to be Bruce Lee too, but I wasn't Chinese and that seemed like an obstacle that I wouldn't be overcoming anytime soon. I promptly began growing my hair into an Afro. "Man, you come right outta some comic book" became my catch phrase. And once Halloween rolled around, I slipped into yellow pajamas, pencilled in some sideburns, and I hit the trick-or-treat trail decked out as my main man.[43]

With plots that revolved mainly around efforts to smash unjust power lords, Kelly's bare-fisted bravado was at its best. When a white supremacist organization plans to poison African Americans through the water supply, Kelly is onto them (*Three the Hard Way*, 1974). As Black Belt Jones, Kelly first takes on the Mob and a corrupt city government. Two years later, in *Hot Potato*, he goes after a corrupt wing of the U.S. military. In *Black Samurai* (1977), Kelly is Bond (*Goldfinger*, 1964) -- as he infiltrates a secret island get-away of a crime syndicate to rescue his girlfriend.[44] Of course in *Black Belt Jones*,[45] Gloria Hendry, who plays the lead, Sidney is a *sifu* in her own right. When Jones (Kelly) gets a message that the bad guys are on the move, he gets ready to leave Sidney to do the dishes as he goes off to do combat. Sidney, incensed by his sexism, borrows his gun and "does" the dishes with a round of well-aimed fire. This is the film of black liberation.[46]

Panthers and Dragons

Liberation wasn't restricted to the screen. From 1968 until the late 1970s, the terrain of left political struggle in the U.S. was populated by energetic organizations formed to combat the problem of racism and its effect on communities. In 1967, Stokely Carmichael and Charles Hamilton's manifesto *Black Power* argued that just coalitions can be built only if each party within the compact is empowered -- *before a group can enter an open society, it must first close ranks*"[47] -- Oppressed groups were to form their own organizations to hold discussions that could not be held before the eyes of all people, and to forge the strength for mutual respect in broad coalitions.[48] While some

activists in the late 1960s took the position that the most oppressed must lead the movement, most of those among the oppressed, as a prelude to a united front, created organizations under the banner of the Third World. Inspired in part by the struggles of others in China, Vietnam, and Africa, the Black Panther Party for Self-Defense, formed in 1967, led the way, but right on their heels came groups such as the Young Lords Organization (which began in 1956 as a gang before being rectified by Cha Cha Jiminiz in 1967), the Brown Berets (a Chicano formation in 1968), the American Indian Movement (formed in Minneapolis in 1968), the Red Guard Party (a group of Chinese Americans in San Francisco, in 1969) and the I Wor Kuen (from New York's Chinatown in 1969).[49] Poor white folk formed the Patriot Party. In 1968 Bernardine Dohrn of Students for a Democratic Society was of the view that "the best thing that we can do for ourselves, as well as for the Panthers and the revolutionary black liberation struggle is to build a fucking white revolutionary movement."[50] Against the liberalism of support, came the revolutionary instinct of self-interest politics here in the guise of the Weather Underground. Four other women of the SDS sounded the clarion call for an autonomous women's organization when they wrote in mid-1967 that "we find that women are in a colonial relationship to men and we recognize ourselves as part of the Third World."[51]

If the Panthers inspired the multicolored Left, they in turn had been inspired by the Chinese Communism.[52] When Bobby Seale and Huey P. Newton formed the Black Panthers in October 1966 they took much inspiration from Mao's radical critique of imperialism. The Chinese Communists, during the Yenan period (1937-1946), learned that the party must harness the strength of the people and allow creative popular energy to determine social organization. "Our culture is a people's culture," noted Mao in 1944. "Our cultural workers must serve the people with great enthusiasm and devotion, and they must link themselves with the masses, not divorce themselves from the masses."[53] Such values motivated Bobby Seale and Huey Newton, and they also had an impact on Amiri Baraka, who knew of the Panthers during a teaching assignment at San Francisco State in 1967. Baraka founded the Congress of African Peoples on Maoist principles; in 1978, as the Revolutionary Communist League [Marxist-Leninist], it merged with the I Wor Kuen and the Chicano August Twenty-Ninth Movement to create the ill-fated U.S. League for Revolutionary Struggle.[54] For Seale and Newton, furthermore, Maoism provided a way to raise easy cash: they went to Chinatown, ordered and bought boxes of Mao's Red Book, took them over to the UC Berkeley campus, and sold them for a profit. This money enabled them to buy guns and other equipment for the Party. Mao was in the Black Panthers, just as the Panthers opened themselves up to other organizations.

And each of these organizations did more than just recognize an affinity. They worked closely with one another in a piecemeal coalition. The Young Lords worked in close concert with I Wor Kuen, and in 1971, Central Committee member Juan Gonzalez traveled to San Francisco's Chinatown to meet with Asian revolutionaries and others.[55] When Native American radicals took Alcatraz in 1970, a detachment of Japanese American radicals unfurled a huge banner that read Japanese Americans Support Native Americans, painted signs that said This is Indian Property and Red Power and brought them food.[56] The Palestine Liberation Organization offered their solidarity with Native Americans too; Stokely Carmichael offered the key-note statement at the Arab Student Convention in 1968; the Black Panthers took up the cause of the forty-one Iranian students set for deportation from the United States because of anti-shah activities; and the Wei Min made liberation struggles of the Ethiopian Students Union of Northern California their common cause. It was a vibrant world of internationalism through nationality, in other words, of a *particular universalism*.[57] When DeAnna Lee asked Bobby Seale in 1970 if he had a message for Asians, he said that "I see the Asian people playing a very significant part in solving the problems of their own community in coalition, unity and alliance with Black people because the problems are basically the same as they are for Brown, Red and poor White Americans -- the basic problem of poverty and oppression that we are all subjected to."[58] Amy Uyematsu at UCLA had an even larger worldview, declaring in 1969 that "yellow power and black power must be two independently-powerful, joint forces within the

Third World revolution to free all exploited and oppressed people of color."[59] These movements acknowledged the strategic importance of unity, but they knew that unity could not be forged without space for the efflorescence of oppressed cultures and the development of their leadership.

Of course, an alliance of blacks and Asians was sometimes resisted. Moritsuga "Mo" Nishida was raised in Los Angeles, joined a gang (the Constituents from the westside on Crenshaw), and moved into the orbit of black radicalism. But he was not welcomed: "We ain't black so we get this, especially from non-California bred blacks who don't understand the Asian oppression and struggle, so to them, if you're not black then you're White. So we getting all kind of bullshit like that."[60] Yet, the complexity of segregated neighborhoods in the United States meant that the idea of an exclusive nation could not always be actively sustained. Asians along the west coast of the United States lived among blacks, so that when the Black Panther Party was formed, Asians gravitated to it (in much the same way as Asians of another generation worked within the civil rights ambit). Yuri Kochiyama had already made contact with Malcolm X, and in the late 1960s, several Asians joined the Panthers, including Richard Aoki (made immortal by Bobby Seale as "a Japanese radical cat," who "had guns for a motherfucker"[61]), the Chinese-Jamaican film-maker Lee Lew-Lee and Seattle activist Guy Kurose.[62] Aoki, raised in the Topaz Concentration Camp and then in west Oakland with Huey Newton and Bobby Seale, was a charter member of the Panthers and its field marshal, who went underground into the Asian American Political Alliance at UC Berkeley. Three decades later, Aoki said that "if you are a person of color there's no other way for you to go except to be part of the Black liberation struggle. It doesn't mean submerge your own political identity or your whatever, but the job that has to be done in front, you got to be there. And I was there. What can I say."[63]

One of the classic examples of this alliance is the relationship between the Red Guard and the Black Panthers. According to former Red Guard member Alex Hing, Asian women from San Francisco's Chinatown made the Panthers in Oakland aware of the disaffected young people from their neighborhood, many of whom assembled at a pool hall owned by a cooperative called Leway (or Legitimate Ways).[64] The Panthers visited them, and worked alongside some of them to create a radical nucleus that would, in 1969, emerge as the Red Guard.[65] In Los Angeles, similar developments among lumpen Asian youth led to the creation of two formations, the Yellow Brotherhood and Asian Hardcore,[66] while in New York City the I Wor Kuen emerged as a Maoist outfit of Chinatown.[67] Radical Chinese youth on both coasts renamed 1969 (the Year of the Rooster) the Year of the People Off the Pigs, a salute to the style of the Black Panthers and against the oppression within Chinatown. Always restricted to not more than a few hundred youths, the Red Guard tried to develop some programs to reach out to the community in a manner similar to the Black Panthers. The Guard attempted to make commercial street fairs into community fairs. They tried to dethrone the dominance of the right-wing leadership within Chinatown, they created a Breakfast for Children program and when this did not work began to feed elders in Portsmouth Square Park. They fought against the oppressive police and worked hard to undercut the racism of the white teachers and tourists. They fought to maintain a tuberculosis center and a Buddhist temple, and set up a legal clinic (Asian Legal Services). At the same time the Guard publicized the efforts of other politicized communities and distributed propaganda on behalf of the Cultural Revolution in China, against the Vietnam War and in favor of the Black Panthers.[68] The Red Guard, unlike many of the campus-based groups, "was born out of the poverty and repression of the ghetto,"[69] which enabled them to make connections with the other antipoverty, anticapitalist organizations that struggled among the working class and working poor in their communities.

The milieu of the Red Guard, the Brown Berets and the Black Panthers was one of an enchanted solidarity against capitalism. Since the economic system was prone to crisis, Alex Hing of the Guard told Asian students at UCLA in 1970, that Asians must prepare for its eventuality. Since Asians are only a small population in the United States, and since "most Asians don't know the front end from the back end of a gun," an alliance with the oppressed working class seemed

the only avenue for the "survival of Asians."[70] If ethnicity was not sufficient in tactical terms for survival, in strategic terms to bind around ethnicity would make it hard to be critical of "Uncle Charleys" like Dr. S. I. Hayakawa, President of San Francisco State, as well as of the right-wing Chinatown leadership. Jack Wong, of Chinatown, said that Hayakawa's obdurate stand against the students of color during the 1968 strike at the school was "just another instance of a yellow man being used by the whites."[71] A critique of the Asian Right from within the Asian community facilitated Black Panther David Hilliard's comment that "we can run Hayakawa not only off this campus, but we can run him back to imperialistic Japan. Because the man ain't got no motherfucking power. He's a bootlicker." Not only could Hilliard make this statement thanks to the opening afforded by the Red Guard's critique of Hayakawa, but in response to Kim Il Sung's call to combat imperialism and the "ideological degeneration" among the oppressed peoples.[72] The Guard produced a space for the Left to undertake a clear distinction between an antiracist nationalism and one that protected the Right from any criticism on the grounds of national assertion. But, as many people have said in retrospect, the Guard failed to create a mass base, perhaps mainly due to its views of the Guard as an army, but also because of the tendency among the Chinese Americans to withdraw from engagement with the state -- in New York and in San Francisco, the Asian Left had to deal with the military formations of the police as well as of the Asian middle class, such as the right-wing Chinatown elite's gangs, the Flying Dragons and the White Shadows).[73]

Army machismo came in part from the Black Panthers, but also from the widespread sense of wonder that the Vietnamese forces could penetrate the defenses of the U.S. army during the famous 1968 Tet offensive. With Tet, young Asian Americans ceased to feel the burden of a stereotypical submissiveness, and many of them refashioned themselves around the symbols of Asian resistance to imperialism particularly those of the Cultural Revolution -- the Mao jackets, the Red Book, the slogans. The U.S. army's attempt, after Tet, to retake control over the war led to a genuine moral failure (in the village of Ben Tre a U.S. Major provided the famous line, "It was necessary to destroy the city in order to save it"). Disgusted by this, many young Americans turned to the struggles within that omnibus category the Third World to find the agent of revolutionary struggle (Cuba, Vietnam, Algeria), and they drew upon that category to create the tentative united front for their own struggles at home. In 1970, the U.S. People's Anti-Imperialist Delegation traveled to North Korea and Vietnam under the leadership of Elridge Cleaver, minister of information of the Black Panther Party. Two Asians made up the ten delegates, Pat Sumi, a member of the Movement for a Democratic Military, and Alex Hing, of the Red Guard. Writing of their experiences in Asia, Sumi and Hing noted that the struggle in the United States had to be moved from being antiwar to antiimperialist, from one that wanted to "bring the troops home" to one that opened "up the resources of Amerika to the rest of the world."[74]

Two years later, Bruce would give us the perfect allegory both of Asian American radicalism and of the Vietnam War with *The Way of the Dragon* (also called *Return of the Dragon*). Here Bruce (as Tang Lung or China Dragon) works at a Chinese restaurant (the ultimate stereotype of skillful servileness), but in the back alley he trains the waiters in martial arts to repulse the thugs whose harassment has hurt business. The godfather of the thugs hires a few heavies to deal with Bruce, a *hapkido* expert (Wong In Sik) and two U.S. karate champions (Bob Wall and Chuck Norris, now Walker-Texas Ranger). He dispatches both Wall and In Sik, representatives perhaps of the ordinary U.S. soldier and of the South Korean army. With Norris, (named Colt -- 45 perhaps?), Bruce takes his time, but as he demolishes him, the fight, set in the Coliseum in Rome, becomes a battle between Western civilization and Chinese civilization, between the paper tiger of U.S. imperialism and the rising tide of the Red East.[75] Bruce, in the context of the Red Guards and of the Northern Vietnamese army, appeared on the screen to young Asian Americans as "the brother who showed [America that] Asian people can kick some ass."[76]

From Baku to Bandung: Third World Solidarity

When Bruce planned *Way of the Dragon*, he told his mother that "Mom, I'm an Oriental person, therefore, I have to defeat all the whites in the film."[77] At the time, the United States had dropped eight hundred thousand tons of bombs on Cambodia, Laos, and Vietnam. Bruce's victory over Norris/Colt would be an act of solidarity with the army in black pajamas. In June of 1972, in Bombay, in another show of unity, a group of Dalits formed the Dalit Panthers. Named in honor of the Black Panthers, they hoped to celebrate and emulate the ethic of the panther, who, as they argued, *fights without retreat*. The Dalit Panther manifesto offers an immense sense of political comradeship:

> Due to the hideous plot of American imperialism, the Third Dalit World, that is, oppressed nations, and Dalit people are suffering. Even in America, a handful of reactionary whites are exploiting blacks. To meet the force of reaction and remove this exploitation, the Black Panther movement grew. From the Black Panthers, Black Power emerged. The fire of the struggles has thrown outsparks into the country. We claim a close relationship with this struggle. We have before our eyes the examples of Vietnam, Cambodia, Africa and the like.

When representatives of the Black Panther Party (David Hilliard and Elbert Howard) met the representatives of the National Liberation Front of Vietnam in Montreal, the Vietnamese said "He Black Panther, we Yellow Panther!" and the Panthers replied, "Yeah, you're Yellow Panthers, we're Black Panthers. All power to the people!"[78]

To appreciate the vitality of the idea of Third World solidarity, we will need a detour into its modern history. That Ho Chi Minh once hung out in Garveyite halls in Harlem should perhaps be part of this story, as should the Maoist inflections in both the National Liberation Front (of Vietnam) and Black Panther politics. In 1965, Ho Chi Minh and the black radical Robert F. Williams spent an evening together at which they "swapped Harlem stories; Ho recounted his visits to Harlem in the 1920s as a merchant seaman and claimed that he had heard Marcus Garvey speak there and had been so inspired that he 'emptied his pockets' into the collection plate."[79] The story could very well be about the conversations between Nkrumah of Ghana and Stokely Carmichael or any other black radical who visited the Ghanian leader, who had also spent a formative period of his life in Harlem and Philadelphia.[80] The radical visions that emerged in the 20th century enabled the sense of enchanted comradeship of the 1960s and 1970s, a legacy worth revisiting in this new century.

Talk of Ho Chi Minh and Robert Williams leads me toward Lenin's famous articles from the early 1900s that exalted the Asian rebellions, this in light of Japan's defeat of the Russians in the 1904 war. "There can be no doubt that the age-old plunder of India by the British, and the contemporary struggle of all these 'advanced' Europeans against Persian and Indian democracy, will *steel* millions, tens of millions of proletarians in Asia to wage a struggle against their oppressors which will be just as victorious as that of the Japanese. The class conscious European worker now has comrades in Asia, and their number will grow by leaps and bounds."[81] The internationalism of the world Communist movement produced several institutions dedicated to building solidarity across the world, the First Congress of the Peoples of the East in Baku (1920), the Indian School at Tashkent which became the Institute of the Study of the East (1921) and then the University of the Toilers of the East, the League Against Imperialism (1924), the Conference of the Oppressed People in Brussels (1927), and then into the 1940s, the various peace and youth festivals.[82]

Intellectuals of the Afro-Asian world found immense political, moral and intellectual resources in the tradition of Marxism and Communism, something that has been wonderfully catalogued in recent years.[83] The depth of this connection is forgotten or else minimized by the example of George Padmore's resignation from the CPUSA or Aimé Cesaire's celebrated letter to Maurice Thorez resigning from the Communist Party of France. Cesaire wrote in that letter "What I want is that Marxism and Communism be harnessed into the service of colored people, and not colored

people into the service of Marxism and Communism." There is a falseness to this statement because Marxism and Communism both emerged from the labors of "colored people" (whether as the materials for Marx's analysis of the world system or at the debates in the Comintern between the Indian Communist M. N. Roy and Lenin or else in the developments of communisms outside Europe whose heritage continues till this day). But what those who quote from Cesaire fail to reveal is that in the very same letter he wrote that "There exists a Chinese communism. Though I have no first hand acquaintance with it, I am strongly prejudiced in its favor. And I expect it not to sink into the monstrous errors that have disfigured European communism."[84]

"Black Maoism," whose contours we traced earlier, was enabled by the strong antiracist position taken by Mao's China: as the Communists took power over China, the Party abolished the idea of "race," suspended anthropology departments (which had a propensity toward a racist form of physical anthropology) and proscribed them until 1952. In 1963, at the urging of his guest Robert Williams, Mao offered a strong statement in favor of the black liberation movement to call on "the workers, peasants, revolutionary intellectuals, enlightened elements of the bourgeoisie, and other enlightened personages of all colours in the world, white, black, yellow, brown, etc., to unite to oppose the racial discrimination practiced by U.S. imperialism and to support the American Negroes in their struggle against racial discrimination."[85] The Chinese Communist position reveals for us the centrality of political engagement over cultural history.[86]

During the onrush of anticolonial national liberation (which began with India and Pakistan in 1947), African and Asian leaders spoke in glowing terms of their need to cooperate. In late 1946, Nehru wrote to six East African leaders in solidarity with their struggles ("the voice of India will always be raised in the cause of African freedom") and he suggested that "African students should come to the universities and technical institutes of India."[87] Indeed, Nehru was instrumental in putting Indian resources at the service of African independence, whether these were economic or political.[88] In the 1940s and 1950s, Nehru was a regular speaker at historically black colleges in the United States, where in tribute his suit became the vogue (only when Nkrumah came to these colleges wearing the same suit was its name changed from the Nehru Jacket to the Nkrumah Jacket).

With the Communists in power from 1949, the new Chinese republic attempted to solidify its relationship with Africa. In the early 1960s, political scientist Immanuel Wallerstein noted that

> The Soviet Union is to Africans, particularly black Africans simply another part of the Western world. It is China, not the USSR, that fascinates. China is not a white nation. It is more militant than the USSR on colonial questions. It is a poorer country, and its efforts at economic development are more relevant to Africa's problems, the Africans think. Above all, China has been a colony of the West, or at least a semi-colony.[89]

From 1959, the Peoples' Republic of China began to offer technical assistance and cooperative market arrangements with a number of African nations (as well as military training to those who still fought colonial powers). Guinea was the first country to create close economic ties with the PRC through interest-free loans and instruction in rice-growing techniques.[90] The African reaction to Chinese Communism is best captured in President Julius Nyerere's 1965 speech to welcome Chou En-Lai to Dar es Salaam. After praising the Long March, Nyerere noted that both China and Africa are on a joint long march, "a new revolutionary battle -- the fight against poverty and economic backwardness." But the war is not only economic, because, said Nyerere, Tanzania had to defend against neocolonialism, and carefully take assistance from others, for "neither our principles, our country, nor our freedom to determine our future are for sale."[91] China was well aware of this, for when Chou and President Mobido Keita of Mali signed the "Eight Principles" of aid in 1964, point four specifically stated that "the purpose of the Chinese government's foreign aid is not to make the recipient countries dependent on China but to help them embark on the road to self-reliance and independent economic development step by step."[92] Assistance from India or China came only because, as Nkrumah made clear during his 1958 trip to India, the struggle for Indian

independence was longer and the people were able to prepare themselves for it. In Ghana "the change was comparatively sudden" and "we had to start from scratch to manage our own affairs."[93]

The links between Asia and Africa in the middle of the previous century came on the terrain of a sort of anticolonial solidarity. In 1955, representatives from twenty-nine African and Asian nations gathered together in the small Indonesia town of Bandung to celebrate that heritage.[94] There were also representatives from the United States. Flushed with success from the ongoing anticolonial movement, a community of leaders, behind whom stood masses of people, came together with a loose agenda, but with considerable self-confidence. President Sukarno of Indonesia noted that the participants are united "by a common detestation of colonialism in whatever form it appears. We are united by a common detestation of racialism." Furthermore, Sukarno pointedly noted that unity at Bandung was not one of race or religion, since "conflict comes not from variety of skins, nor from variety of religion, but from variety of desires." Therefore the anticolonial heritage and suspicion of neocolonialism was the principle ethic for unity.[95] Bandung left an impressive mark on peoples of Africa and Asia, despite the impossibility for such a platform to mean much in the intense suspicion of the cold war era. Ideological differences between countries (variety of desires) and the arrangements made by nations with the superpowers prevented any combined action, except occasionally at the United Nations (for crucial anticolonial votes, on world disarmament as a moral force, for aid to newly free countries, and decisively, through agencies to ameliorate or check the multinational corporations).[96]

At Bandung, Nehru remembered the centrality of the Middle Passage to any project to craft solidarity across the tide of color.

> There is nothing more terrible, there is nothing more horrible than the infinite tragedy of Africa in the past few hundred years. When I think of it, everything else pales into insignifi cance; that infinite tragedy of Africa ever since the days when millions of them were car ried away in galleys as slaves to America and elsewhere, the way they were treated, the way they were taken away, 50 percent dying in the galleys. We have to bear that burden, all of us. We did not do it ourselves, but the world has to bear it. We talk about this country and that little country in Africa or outside, but let us remember this Infinite Tragedy.[97]

Nehru's contribution continued the anticolonial relationship of Indian nationalism with the U.S. black left, one that was wiped out by the U.S. state in the 1950s.[98]

However, U.S. black representatives failed to grasp the depth of struggle as they perversely defended the U.S. record on civil rights and attacked China's communism. From the mid-1940s, the U.S. state department cultivated certain African American artists and writers to muddy the critiques of U.S. racism that mainly came from the USSR.[99] Several black artists and writers colluded with the U.S. government out of fear or to gain access to the world stage. At Bandung, African Americans such as Congressman Adam Clayton Powell, Jr., and Max Yergan vigorously praised the U.S. governmental system, perhaps to shore up their own political futures upon return. Even arch anti-communists among the Asians, such as Sir John Kotelawla of Ceylon, held their tongues as Chou En-Lai took a conciliatory position. But Powell and Yergan let loose much to the consternation of their Asian allies.[100] Richard Wright, like Yergan, had been a communist in his youth. In the 1950s he joined with the liberal anticommunist wing (and contributed to their celebrated collection *The God That Failed*), but, unlike Yergan, Wright was always an unpredictable political writer. At Bandung he was not taken by Powell and Yergan, yet he too seemed to miss the point when he claimed that Sukarno was "appealing to race and religion" or when he wondered how Chou felt "amidst the ground swell of racial and religious feeling."[101] But by the Vietnam war, a conflict with no foreseeable ending, black and Asian American activists would become more radical and more united than they had ever been, finally empowered by a sense of Third World solidarity.

Everybody Was Kung Fu Fighting, ca. 1974

As *Enter the Dragon* came to us in Calcutta, a song also broke through the tedium offered by Musical Bandbox, a Sunday afternoon program on All-India Radio. It was a rather trite song: Everybody was kung-fu fighting, hunh, Those cats were fast as lightning, hunh. Nothing to it, really. But Biddu, an exemplary Indian who lived in England and produced Tina Charles's *Disco Fever* and Nazia Hasan's *Disco Dewanee*, wrote the tune, hence its appearance on Indian radio. Sung by Carl Douglas, an African American, whose entire career was forged around the gimmick of kung fu music ("Dance the Kung Fu" and "Shanghai D"), the song belongs in my memory bank alongside an atrocious tribute to Muhammad Ali with that infectious line from the master, "Fly like a butterfly, sting like a bee."[102] Tripping on Carl Douglas and Biddu, we read the papers for news of the impending fight between Muhammad Ali and George Foreman in Zaire, the famous "Rumble in the Jungle" in the autumn of that year.[103] "From slave ship to championship," the promoters declaimed. "We were taken from Africa as slaves and now we're coming back as champions." Ali was only thirty-two, a year younger than Bruce. And Ali was as politically incensed about racism and imperialism as Bruce was. Bruce was trained to hate white supremacy in the hovels of Hong Kong. Ali's life in the U.S. South prepared him to strike tough jabs for the Black Power movement. It was Ali, after all, who denounced the U.S. imperialist engagement in Southeast Asia with the memorable line, "No Vietcong ever called me nigger." Although Bruce Lee was also a boxing champ in Hong Kong (and the 1958 Crown Colony Cha-Cha Champion), he spent much of the 1960s watching films of Ali boxing. "An orthodox boxer, Ali led with his left hand. Since Bruce was experimenting with a right lead stance he set up a mirror so that he could watch Ali's movements and practice them the appropriate way."[104] In an instance of classic cross-fertilization, the great boxer Sugar Ray Leonard told an interviewer in 1982 that "one of the guys who influenced me wasn't a boxer. I always loved the catlike reflexes and the artistry of Bruce Lee and I wanted to do in boxing what he was able to do in karate. I started watching his movies before he became really popular in *Enter the Dragon* and I patterned myself after a lot of his ways."[105]

So what are the implications of the world of polycultural kung fu? Color-blind capitalists wish to make a profit from its appeal, often by the opportunistic combination of ethnic niche markets (when Jackie Chan and Chris Tucker appear together in the 1998 *Rush Hour*, and soon in *Rush Hour II*, or else when Sammo Hung and Arsenio Hall did time in CBS's *Martial Law*, or the ultra-commodified Tae-Bo of Billy Blanks[106]). Primordialists (and "perfectionists") argue that the artistry originates in either Africa or Asia. "It was Africa and not Asia that first gave martial arts to the world," wrote Afrocentric scholar Kilindi Iyi, "and those same African roots are deeply embedded in the martial arts of India and China."[107] Iyi looks at ancient murals from Beni Hasan, Egypt, to make his claim, but he could equally make the point that the similarities between Capoeira Angola and kung fu can be traced to those enslaved Africans who created the Brazilian art in the 1500s, nurtured it in the *senzalas* ("slave houses") and developed it into a symbolic as well as a physical response to the atrocity of a racist slavery. The language of Capoeira, indeed, is replete with Bantu words, and the movements of Capoeira resemble the southern Angolan dance of *n'golo* ("zebra dance").[108]

If Iyi looks to Africa for the origins of martial arts, others do the same with Asia. Most histories of kung fu tell the story of Bodhidharma, an itinerant Buddhist monk who introduced the monks of the Shaolin Temple in China to the martial arts of his homeland, southern India. Bodhidharma may be the son of the King of Kancheepuram in the region of today's Tamil Nadu (as some Japanese manuscripts claim), and it is said that he imported the arts of Kalarippayattu to China from Kerala, in the southwest of India.[109] Bodhidharma's *Hseih Mai Lun* ("Treatise on the Blood Lineages of True Dharma") lays out a philosophy of the ch'i ("life force"), and how it must be kept active to ensure that monks don't sleep during meditation.[110] The desire to seek origins in what might be complex cultural diffusion or else independent creation is certainly not of much

help. However, we might say that the martial arts traditions such as kung fu developed in a mani-fold world that involved, in some complex way, Kalarippayattu of Kerala, Capoeira Angola of Brazil, and the various martial arts of Africa. Kung fu is not far from Africa, nor from the *favelas* ("slums") of Brazil.[111]

Iyi, along with Afrocentric historians Wayne Chandler and Graham Irwin, makes the mis-take of finding *racial* links when I am more tempted to avoid that complex soup of "descent," whatever that may mean. They argue, for instance, that Buddha, the man whose tradition pro-duces kung fu, was of African "descent."[112] The school of Kamau Ryu System of Self-Defense claims that Bodhidharma was "black with tightly curled knots of hair and elongated ear lobes which are traditional African traits."[113] The incessant interest in origins bespeaks a notion of culture as an inheritance that is transmitted across time without mutation, and is the property of certain people. There are numerous reasons to claim origins and to mark oneself as authentic if one belongs to an oppressed minority. Minority groups may mobilize around the notion of an origin to make resource claims, to show that despite the denigration of the power elite, the group can lay claim to an aspect of civilization and the cultural currency attached to it. Furthermore, to demarcate one-self from the repressive stereotypes, the oppressed frequently turn to their "roots" to suggest to their children that they have a lineage that is worthy despite racism's cruelty. These are important social explanations for the way we use both origins and authenticity (to protect our traditional forms from appropriation by the power elite). As defensive tactics these make sense, but as a strategy for freedom they are inappropriate. In a prosaic moment in 1919, W. E. B. Du Bois wrote of the "blood of yellow and white hordes" who "diluted the ancient black blood of India, but her eldest Buddha sits back, with kinky hair."[114] Du Bois's gesture toward Buddha was not necessarily a claim to the *racial* or *epidermal* lineage of Buddha, but it was a signal toward some form of solidarity across the Indian Ocean and between Asians and Africans in diaspora. In his 1928 novel *Dark Princess*, the Indian Kautilya seals her bond with the African American Matthew through a ruby that is "by legend a drop of Buddha's blood"; in time, their child, "Incarnate Son of the Buddha," will rule over a kingdom fated to overthrow British rule.[115] Matthew, for Du Bois, was a symbol of anti-imperialist solidarity, and the claim to Buddha indicated a search for the cultural roots of soli-darity not too dependent on the mysterious world of biology.

In our own day, community scholars like Q-Unique of The Arsonists come at kung fu from the lens of hip-hop. He believes that Bruce Lee should be remembered as "the first to teach non-Asians Martial Arts and to be the first big Asian actor," and "that right there is enough to tell me that you should be able to believe in yourself to be able to climb the highest mountain. Or just go against whatever is thrown your way. You should be able to look at adversity in its face and believe in yourself to get what you want. And that's what Bruce Lee ultimately taught me: What I do with my MCing skills is sort of like what he did with his Martial Arts. You study everybody's techniques and you strip away what you don't find necessary and use what is necessary and you modify it. You give it your own twist. He used Jeet Kune Do. Mine is Jeet Kune Flow."[116] The poly-cultural view of the world exists in the gut instincts of many people such as Q-Unique. Scholars are under some obligation to raise this instinct to philosophy, to use this instinct to criticize the diversity model of multiculturalism and replace it with the antiracist one of polyculturalism. Culture cannot be bounded and people cannot be asked to respect "culture" as if it were an arti-fact, without life or complexity. Social interaction and struggle produces cultural worlds, and these are in constant, fraught formation. Our cultures are linked in more ways than we could cata-log, and it is from these linkages that we hope our politics will be energized. The Third World may be in distress, where the will of the national liberation movements has put the tendency to anti-imperialism in crisis, and where the Third World within the United States has often been overrun by the dynamic of the color blind and of the desire to make small, individual gains over social transformation. Nevertheless, the struggle is on, in places like Kerala and Vietnam, but also within the United States as the Black Radical Congress greets the Asian Left Forum, the Forum of Indian

Leftists, the League of Filipino Students (among others), and as all of them join together against imperialism, against racism. History is made in struggle and past memories of solidarity are inspiration for that struggle. Indeed, the Afro-Asian and polycultural struggles of today allow us to redeem a past that has been carved up along ethnic lines by historians. To remember Bruce as I do, staring at a poster of him ca. 1974, is not to wane into nostalgia for the past. My Bruce is alive, and like the men and women before him, still in the fight.

This essay was originally published in Everybody was Kung Fu Fighting: Afro-Asian Connections and the Myth of Cultural Purity, *by Vijay Prashad (Boston: Beacon Press, 2001). Reprinted by permission of Vijay Prashad and Beacon Press.*

1. The quote is from dead prez, "Police State," *Let's Get Free* (New York: Loud Records, 2000).
2. Hsin Hsin, "Bruce's Opinion on Kung Fu, Movies, Love and Life," *Words of the Dragon. Interviews, 1958-1973*, ed. John Little (Boston: Charles E. Tuttle, 1997), 119.
3. Ibid., 128.
4. Robert Lee, *Orientals: Asian Americans in Popular Culture* (Philadelphia: Temple University Press, 1999), 35-36.
5. Bruce Lee was very aware of this, as in his 1966 letter to William Dozier, executive producer of the series (reproduced in *Words of the Dragon*, 76-77).
6. Bruce Thomas, *Bruce Lee. Fighting Spirit* (Berkeley: Frog, 1994), 143. This is a frequent theme in Bruce's interviews, as in his 1966 statement to *The Washington Post* on *The Green Hornet*. "It sounded like typical houseboy stuff," Bruce told the Post, and he told his producer that "if you sign me up with all that pigtail and hopping around jazz, forget it," *Words of the Dragon*, 60. In 1970, Bruce announced that "it's about time we had an Oriental hero. Never mind some guy bouncing around the country in a pigtail or something. I have to be a real human being. No cook. No laundryman," Little, *Words of the Dragon*, 98. This is not to say that cooks and laundrymen are not "real human beings," but that the stereotype itself effaced the real cooks and real laundrymen.
7. Thomas, *Bruce Lee*, 78-79.
8. "Kung Fu: A Sweet Poison," *Getting Together* (October 22-November 4, 1972), 4.
9. Jim Kelly with David W. Clary, "Whatever Happened to Jim Kelly?" *Black Belt Magazine* (May 1992).
10. dead prez, "Psychology," *Let's Get Free*.
11. Toshio Whelchel, *From Pearl Harbor to Saigon. Japanese American Soldiers and the Vietnam War* (London: Verso, 1999), 104.
12. Ibid., 46.
13. In 1966 of U.S. troop casualties, black soldiers comprised twenty-two percent even though they only made up 11 percent of the force. Daniel Patrick Moynihan's racist report on the black family was written in the service of mobilization for the war. "Given the strains of disorganized and matrifocal family life in which so many Negro youth come of age," wrote Moynihan in 1964, "the armed forces are a dramatic and desperately needed change; a world away from women, a world run by strong men and unquestioned authority." Christian G. Appy, *Working Class War. American Combat Soldiers and Vietnam* (Chapel Hill: University of North Carolina Press, 1993), 31.
14. Jon Shirota, "I'm Not a Militant. Equal Opportunity Sensei," *Black Belt Magazine* (January 1973).
15. Mike Marqusee, *Redemption Song. Muhammad Ali and the Spirit of the Sixties* (London: Verso, 1999), 162.
16. "The Fort Hood Three," pamphlet from 1966 collected in *Highlights of a Fighting History. 60 Years of the Communist Party USA* (New York: International Publishers, 1979), 374-375.
17. In 1965, during the Watts Rebellion, Minister John Shabazz compared the Vietnam War with Watts as he went after King for his ambivalence on both counts. He argued against the "black man being an Asiatic, fighting an Asiatic war." Gerald Horne, *Fire This Time*, 144.
18. Martin Luther King Jr., "A Time to Break Silence," in *The Essential Writings and Speeches of Martin Luther King, Jr.* Ed. James M. Washington (San Francisco: Harper,1986), 233-34.
19. Peter Matthiessen, *Sal Si Puedes (Escape if you can). Cesar Chavez and the New American Revolution* (Berkeley: University of California Press, 2000), 22.
20. Alice Echols, *Daring to be Bad: Radical Feminism in America*, 1967-1975 (Minneapolis: University of Minnesota Press, 1990), 54.
21. Connie Matthews, "The Struggle is a World Struggle," *The Black Panthers Speak*, ed. Philip S. Foner (New York: Da Capo, 1995), 158.
22. In late 1974, *The Man with the Golden Gun* tore through the world's cinema halls, making $13 million despite its rather slipshod production and strained plot. Set in Asia, the film pits British agent James Bond against international scoundrel Scaramanga in a battle of titans. In the midst of the movie, Bond is imprisoned at a Bangkok kung fu school where he takes on all the students and teachers by himself. Bond makes his escape with a furloughed Texan policeman (J. W. Pepper) who yells at the martial arts aficionados who try to catch Bond: "now if you pointy heads would get out of them p-jamas, you wouldn't be late for work." Ian Fleming's 1965 book of the same name (with a similar plot) is not set in Asia, but in the Caribbean. Bond, in 1965, was to take on the Cuban Revolution, while Bond, in 1974, was to be imperialism's adversary against Vietnam. Perhaps this is what the lawman meant by "pointy heads," a reference to the hats worn by the Vietnamese peasantry.

23. Robert Brenner, "The Economics of Global Turbulence," *New Left Review* 229 (May/June 1998) and Peter Gowan, *The Global Gamble. Washington's Faustian Bid for World Dominance* (London: Verso, 1999).

24. Walden Bello, *Dark Victory. The United States, Structural Adjustment and Global Poverty* (Penang: Third World Network, 1994).

25. Fred Halliday, *The Making of the Second Cold War* (London: Verso, 1983), 86-92.

26. Koushik Banerjea, "Ni-Ten-Ichi-Ryu: Enter the World of the Smart Stepper," *in Travel Worlds: Journals in Contemporary Cultural Politics*, eds. Raminder Kaur and John Hutnyk (London: Zed Press, 1999), 22 and May Joseph, Nomadic Identities. *The Performance of Citizenship* (Minneapolis: University of Minnesota, 1999), 54.

27. Little, *Words of the Dragon*, 70.

28. Bruce Lee, *The Tao of Gung Fu* (Boston: Charles E. Tuttle, 1997), 166 and Thomas, Bruce Lee, 64.

29. Lee, *The Tao*, 176-7.

30. Ibid., 179-80.

31. Little, Wor*ds of the Dragon*, 120.

32. Shirota, "I'm Not a Militant."

33. Ibid.

34. Flyers for such tournaments are collected at the Schomburg Research Center in Black Culture.

35. John Corcoran and Emil Farkas, *The Original Martial Arts Encyclopedia* (Los Angeles: Pro-Action, 1993), 309.

36. To reach Moses Powell, call 212-673-0899 or else visit him on the web at http://espytv.com/sanuces.htm.

37. To reach Tayari Casel, send an E-mail message to TwoNaRow@ix.netcom.com.

38. Where the BKF and the martial artists of the 1970s seem to have changed is that their critique of imperialism has been lost in the service of a 1990s New Age drive to help "a person to gain inner peace and maintain focus." For more information on BKF, see http://www.bkf-international.com/.

39. Little, *Words of the Dragon*, p. 136, and pp. 88-90. Bruce's views found reflection in his movies. In *Enter the Dragon*, he brought in Angela Mao Ying to play his brave and noble kung fu warrior sister. When she is cornered by a gang, she kills herself in a suicide, an act that is at odds with the bravery displayed by Angela Mao Ying's characters in *Hap Ki Do* (1970) and *Lady Whirlwind* (1971).

40. Echols, *Daring to be Bad*, 64. Martha McCaughey, *Real Knockouts: The Physical Feminism of Women's Self-Defense* (New York: New York University Press, 1997).

41. Cedric Robinson argues that the 1970s black cinema took the image of the Communist feminist Angela Davis and reduced it to the ultra-sexual body of Pam Grier. Grier was not so one-dimensional, for her roles transformed the image of the black woman from the servile mammy (as with Hattie McDaniel in the 1939 *Gone with the Wind*) and from the tragically lifeless (as with Lena Horne in the 1943 *Stormy Weather*) to the tough and street-wise Cleopatra Jones and Foxy Brown. But, yes, Robinson is right that the black woman was, in Grier especially, the epitome of uncontrolled sexuality ("she's black and she's stacked," as in *Coffy*), this despite the story line about the rebellious ghetto. The world of black kung fu did not go along the grain of Shaft and Coffy. Tamara Dobson in Cleopatra Jones (1973) acts as a secret agent who can kick ass and look good while at it. Cleo does not flail around or resort to a gun, but she reserves her energy to trounce her enemy with Kung Fu skill. Cedric J. Robinson, "Blaxploitation and the Misrepresentation of Liberation," *Race & Class* 40. 1 (July-September 1998): 1-12

42. Thomas, *Bruce Lee*, 276.

43. David Walker, "Jim Kelly and Me," *Giant Robot* 11 (Summer 1998); www.giantrobot.com/issues/issrell/kelly/index.html

44. Donald Bogle misses all this when he writes, in passing, of the "stolid and wooden Jim Kelly." *Toms, Coons, Mulattoes, Mammies and Bucks. An Interpretive History of Blacks in American Films* (New York: Continuum, 1989), 245.

45. *Black Belt Jones*, 1974, produced by Warner Brothers and the Shaw Brothers.

46. While Yvonne Tasker makes several good points in her section on black action films, she misses the contradictions in the films with her suggestion that Gloria Hendry's role as Sidney has "a certain novelty value." Yvonne Tasker, *Spectacular Bodies. Gender, Genre and the Action Cinema* (London: Comedia/Routledge, 1993), 21-26.

47. Stokely Carmichael and Charles V. Hamilton, *Black Power. The Politics of Liberation* (New York: Random House, 1967), 44. My analysis parallels that of Jeffrey Ogbar, "Yellow Power: The Formation of Asian American Nationalism in the Age of Black Power, 1966-1975" (Talk at the "Blacks and Asians: Revisiting Racial Formations" conference at Columbia University, November 10, 2000).

48. Carmichael and Hamilton, *Black Power*, 77-81.

49. On the Brown Berets, Carlos Munoz, Jr., *Youth , Identity, Power. The Chicano Movement* (London: Verso, 1989), 85-86 and Tony Castro, *Chicano Power. The Emergence of Mexican America* (New York: Dutton, 1974), 134-136. On the American Indian Movement, Paul Chaat Smith and Robert Allen Warrior, *Like a Hurricane: The Indian Movement from Alcatraz to Wounded Knee* (New York: The New Press, 1996), 127-148.

50. Ron Jacobs, *The Way the Wind Blew. A History of the Weather Underground* (London: Verso, 1997), 13.

51. Echols, *Daring to be Bad*, 44.

52. For the full extent of the relationship, see Robin D. G. Kelley and Betsy Esch, "Black Like Mao: Red China and Black Revolution," *Souls* 1. 4 (Fall 1999), 6-41.

53. Mao Zedong, "The United Front in Cultural Work," *Selected Works* vol. 3 (Peking: Foreign Languages Press, 1965), 236.

54. Rod Bush, *We Are Not What We Seem. Black Nationalism and Class Struggle in the American Century* (New York: NYU Press, 1999), 211 and Komozi Woodard, *A Nation Within a Nation. Amiri Baraka (LeRoi Jones) and Black Power Politics* (Chapel Hill: University of North Carolina Press, 1999), 74.

55. "Young Lords Party Will Visit Chinatown," *Getting Together 2*. no.8 (November 1971), 4; "YLP Leader Convicted," *Getting Together* (3-17 March 1972), 3; "Young Lords Step Forward," *Getting Together* (5-19 August 1972), 3; Palante, "Letter From Prison," *Getting Together* (2-15 September 1972), 7.

56. Marlene Tanioka and Aileen Yamaguchi, "Asians Make Waves," *Gidra* (March 1970), 6-7.

57. There is a PLO statement in *West River Times, East River Echo* 1. 1 (August 1975), 2; Stokely Carmichael's

speech of August 31, 1968 is available in the Social Protest Project, Bancroft Library, University of California, Berkeley; at the Bancroft, as well, there is a collection of Black Panther telegrams to the Iranian consulate, flyers for a July 16, 1970 rally in support of the "Iranian 41" and a statement from the BPP; finally, "Ethiopian Students Speak Out," *Wei Min* 3. 9 (September 1974), 8.

58. "Bobby (DeAnna Lee interviews Bobby Seale in San Francisco County Jail)" *Gidra* (June-July 1970), 14.

59. Amy Uyematsu, "The Emergence of Yellow Power," *Gidra* (October 1969), 10.

60. "Moritsugu 'Mo' Nishida interviewed by Fred Ho," in *Legacy to Liberation: Politics and Culture of Revolutionary Asian Pacific America*, ed. Fred Ho et al. (San Francisco: AK Press, 2000, 300 and Eric Nakamura, "Hardcore Asian American," Giant Robot 10 (Spring 1998), 74-75.

61. Bobby Seale, *Seize the Time* (Baltimore: Black Classic Press, 1991), 72.

62. *Giant Robot* magazine's no. 10 issue in Spring 1998 carried a series of interviews with these men done by Martin Wong: "A Gang of Four," 70-71 [Aoki]; "Yellow Panther: By Any Means," 66-69 [Lee]; "Panther and Beyond," 76-78 [Kurose].

63. Ho, *Legacy to Liberation*, 330-331.

64. Alex Hing acknowledged to Fred Ho, (*Legacy to Liberation*, 284 and 290), as well as in an interview with me) that "women were the backup and did most of the work," but at the same time they did not get leadership positions until the Red Guard merged with I Wor Kuen in 1971, when most of the leadership was female. In 1970 Frances Beale of SNCC wrote that although the black militant men rejected white cultural values, "when it comes to women he seems to take his guidelines from the pages of *Ladies Home Journal*." Echols, *Daring to be Bad*, 107. There is much to what Beale says of the Red Guards and of other nationalist formations, but it should also be pointed out that the Red Guards and the I Wor Kuen worked with the contradictions of sexism, unlike other groups that tried to deny the role of feminism within the struggle. For an introduction, see Miya Iwataki, "The Asian Women's Movement: A Retrospective," East Wind 2. 1 (Spring/Summer 1983), 35-41.

65. The membership in the Red Guard Party was not restricted to Chinese Americans, as illustrated by the presence of Japanese Americans such as Stan Kadani and Neil Gotanda.

66. The Hardcore, according to Mo Nishida "openly identified ourselves with the Panthers." Ho, *Legacy to Liberation*, 301.

67. The Asian American Community Action Research Program is well covered by Marge Taniwaki, and its polycultural heritage may be seen in the Chicano anti-poverty movement (of Corky Gonzalez and others) alongside the veterans of the internment camps from the 1940s. Ibid., 65-73.

68. Most of my information comes from the *Red Guard Community News*, 1969 onwards, and an interview with Alex Hing as well as Steve Louie.

69. Laura Ho, "Red Guard Party," *Gidra* (May 1969), 4.

70. Duane Kubo and Russell Kubota, "Alex Hing at UCLA," *Gidra* (June-July 1970), 2.

71. "Over 300 at Meeting on Situation at State College," *Nichi Bei Times* 8 December 1968, 4 and H. M. Imazeki,

"Local Open Forum Views Dr. Hayakawa as 'Puppet,'" *Hokubei Mainichi* 9 December 1968.

72. *Black Panthers Speak*, 124-127.

73. The frustration with quietism traversed the political and class spectrum, as in the 1972 words of W. K. Wong (advisor to the Six Companies in San Francisco's Chinatown) that "if you're politically strong, like the blacks or the Mexicans, you can go up and demand this and that. Chinatown has never really demanded anything because, up to now, there just aren't enough of us with political muscles." Victor G. Nee and Brett de Bary Nee, *Longtime Californ'. A Documentary Study of an American Chinatown*. (Stanford: Stanford University Press, 1986), 247. This is not to minimize the role of the Chinese American Left, documented by Him Mark Lai, "To Bring Forth a New China, To Build a Better America: The Chinese Marxist Left in America to the 1960s," in *Chinese America. History and Perspectives* (San Francisco: Chinese Historical Society, 1992), 3-82.

74. "People of the World Unite! Interview with Alex Hing and Pat Sumi," *Gidra* (October 1970); Alex Hing's two "Dear Comrades" letters in *Gidra* (August 1970): 17 and (October 1970), 6; "Glad They're Back," *Gidra* (October 1970): 4.

75. Junot Diaz deserves all credit for this formulation.

76. Van Troi Pang, "To Commemorate My Grandfather," in *Moving the Image: Independent Asian PacificAmerican Media Arts*, ed. Russell Leong (Los Angeles: UCLA Asian American Studies Center, 1991). When Alex Hing was asked many years later what he thought of Bruce Lee, he had this to offer: "When he was alive, I was very critical of him because he played Kato. Being an ultra-leftist, I felt, 'Oh here's Bruce Lee playing the servile role and fighting for this white guy. We've got to get off of that.' It wasn't till he passed away until I began to appreciate his contributions. He played a major role in having a more positive view of Asians out there. To be that good of a martial artist, you've got to put in a lot of work. Maybe it's easier to say let's break out of that and do something easier! If we had a home-grown Jet Li from the U.S., we'd all be flocking. We wouldn't put that down." Martin Wong, "Red Star in America," *Giant Robot* 10 (Spring 1998), 81. Of course, Bruce was home-grown, or at least, if we reassess the idea of "home" in this century!

77. Thomas, *Bruce Lee*, 146.

78. David Hilliard and Lewis Cole, *This Side of Glory* (Boston: Little Brown, 1993), 247.

79. Timothy B. Tyson, *Radio Free Dixie. Robert F. Williams and the Roots of Black Power* (Chapel Hill: University of North Carolina Press, 1999), 295; Mary Kochiyama, "Robert Williams," *Asian American Political Alliance Newspaper* 2. 1 (November 1969), 2. Ho's early journalism for *La Correspondence Internationale* is on antiblack racism in the USA, such as "Lynching" (no. 59, 1924) and "Ku Klux Klan" (no. 74, 1924). These pieces formed part of a pamphlet that Ho published in Moscow on the question of African American oppression. They are collected in *Ho Chi Minh on Revolution*, ed. Bernard Fall (New York: Signet, 1967), 51-58. There is a Japanese biography of Robert Williams by Yoriko Nakajima, written in the late 1960s.

80. Marika Sherwood, *Kwame Nkrumah: The years abroad*, 1935-1947 (Legon, Ghana: Freedom Publications, 1996).

81. V. I. Lenin, "Inflammable Material in World Politics," *Proletary 33* (July 23 or August 5, 1908), Collected Works 15, 182-188.

82. Pierre Queuille, *Histoire de L'Afro-Asiatime Jusquía Bandoung. La naissance du tiers-monde* (Paris: Payot, 1965), 50-56. Much of the Afro-Asian political trajectory drew from the Pan-Asianism of the 1920s (Association of Greater Asia, founded in 1924, and the conference on Asian peoples in Nagasaki in 1926) and the Pan-Africanism of an earlier period (the four congresses from 1919-1927, and then the 1945 Congress in Manchester).

83. Cedric Robinson, *Black Marxism. The Making of the Black Radical Tradition* (Chapel Hill: University of North Carolina Press, 2000) and the ongoing project by Aijaz Ahmed for Leftword Books in New Delhi on Asian Marxists.

84. Aimé Cesaire, *Letter to Maurice Thorez* (Paris: Editions Présence Africaine, 1957), 12. Down the page, Cesaire writes that "But it would also interest me, and still more so, to see the African brand of communism blossom forth and flourish. In all likelihood, it would offer us variants -- useful, valuable, original variants, and the wisdom in us that is our age old heritage would, I am certain, shade or complete a good many of the doctrine's points." Cesaire could not entirely cut himself off from the appeal of the Left to people of color. In 1952 a Morehouse professor wrote to Martin Luther King, Jr., that "I think there can be no doubt about it that the appeal of Communism to the Eastern nations today can be traceable to a large degree to the Soviet attitude toward race." Taylor Branch, *Parting The Waters. America in the King Years*, 1954-1962 (New York: Touchstone, 1988), 210. When Reverend C. T. Vivian was in Moscow in the 1950s he stayed with a group of Africans. They spent an evening being very critical of Moscow, and C. T. felt this had to do with their good feelings for the U. S. He was wrong. Late that night he realized that "the Africans did not agree entirely with the Soviets, but they could see no way to deal with Jim Crow U.S.A. They were willing to compromise on their politics, but they were not going to compromise on their dignity." Lecture at Trinity College, January 16, 2001.

85. Stuart Schram, ed. *Political Thought of Mao Tse-tung* (New York: Praeger, 1972), 412.

86. The Taiwanese government at this time adopted a more racialized notion of the people. In March 1957, for instance, the Taiwan government approved the formal establishment of the Yellow Emperor religion, a sect with grave racial undertones. In 1976, one of the teachers of the sect introduced martial arts, but his was not to be the barefoot arts of the people, since he founded his art on the ecstasy of *qigong*. Bruce would have found this distasteful, but so did the racialist leader of the sect, Wang Hansheng who ordered the Martial Way disbanded. Christian Joachim, "Flowers, fruit and incense only: Elite versus popular in Taiwan's religion of the Yellow Emperor," *Modern China* 16. 1 (January 1990), 3-38.

87. Jawaharlal Nehru, "India and Africa," *Selected Works of Jawaharlal Nehru* 1 (New Delhi: Oxford University Press, 1984), 453-453, and "A Gesture to Africa," Selected Works, 506.

88. Hari Sharan Chhabra, "India's Africa Policy," *India Quarterly* 41. 1 (1985), 68-73, but for a contrary view see Anirudha Gupta, "A Note on Indian Attitudes to Africa,"

89. Immanuel Wallerstein, *Africa. The Politics of Independence* (New York: Vintage, 1961), 146.

90. Alan Hutchison, *China's African Revolution* (London: Hutchinson, 1975), 56 and Udo Weiss, "China's Aid to and Trade with the Developing Countries of the Third World," *Asia Quarterly* 3 & 4 (1974), 203-314 & 263-309. There was tremendous depth to these exchanges, for, as Baker shows us, the Chinese low-cost, low-technology agricultural systems increased yields in Senegal. Kathleen Baker, "The Chinese Agricultural Model in West Africa: The Case of Market Gardening in the Region du Cap Vert, Senegal," *Pacific Viewpoint* 26. 2 (1985), 401-414. Emmanuel John Hevi's two books, one a memoir of his time in China (An African in China [New York: Praeger, 1963]) and the other an assessment of Chinese assistance in Africa (*The Dragon's Embrace. The Chinese Communists and Africa* [Washington: Praeger, 1966]), are good illustrations of Cold War scholarship. Hevi captures the attempt by the Chinese to move away from xenophobia, but he misses the heart of the PRC's experiments with Third World solidarity.

91. Julius K. Nyerere, "Tanzania's Long March is Economic (4 June 1965)," *Freedom and Socialism/Uhuru na Ujamaa; A Selection from Writings ans Speeches*, ed. Julius K. Nyerere (Dar es Salaam: Oxford University Press, 1968), 33-34.

92. Hutchison, *China's African Revolution*, 50.

93. Kwame Nkrumah, *I Speak of Freedom. A Statement of African Ideology* (New York: Praeger, 1961), 155. And besides, places like India and Tanzania used their place as part of the Third world strategically to garner resources from the other two worlds (which often included China). The Chinese helped the Tanzanians build the Tanzam Railroad, but the USA assisted the Tanzanians to build the Dar es Salaam-Tunduma road. As President Nyerere put it, Tanzania wanted to "compare the advantages of different offers before turning any of them down." Julius K. Nyerere, *Freedom and Socialism*, 203.

94. From Asia: Afghanistan, Burma, Cambodia, Ceylon, China, India, Indonesia, Iran, Iraq, Japan, Jordan, Laos, Lebanon, Nepal, Pakistan, the Philippines, Saudi Arabia, Syria, Thailand, Turkey, North Vietnam, South Vietnam and Yemen. From Africa: Egypt, Ethiopia, the Gold Coast, Liberia, Libya, and the Sudan.

95. "Speech by President Soekarno at the Opening of the Asian-African Conference, April 18, 1955," *The Asian-African Conference. Bandung, Indonesia*, April 1955, ed. G. M. Kahin (Ithaca: Cornell University Press, 1956), 43. On neocolonialism, Sukarno said that "colonialism has also its modern dress, in the form of economic control, intellectual control, actual physical control by a small but alien community within the nation. It is a skillful and determined enemy, and it appears in many guises. It does not give up its loot easily," 44.

96. David Kimche, *The Afro-Asian Movement* (New Brunswick: Transaction Books, 1973).

97. Kahin, *The Asian-African Conference*, 75.

98. The most comprehensive account of the destruction of solidarity is Penny M. Von Eschen, *Race Against Empire. Black Americans and Anticolonialism, 1937-1957* (Ithaca: Cornell University Press, 1997). Du Bois and the CPUSA attempted to keep the tradition alive, but their minority view was not to hold the day: "Negro Press in U. S. Hails Bandung Meet," *Daily Worker* (5 May 1955);

African Affairs 69. 275 (1970), 170-178.

"Bandung and the World Today," (a discussion held on 5 December 1955 at YMCA Auditorium in Harlem); "Robeson and DuBois at Rally Tomorrow," *Daily Worker* (29 April 1957); Abner Berry, "They're Great in a Crisis," *Daily Worker* (16 June 1955); "Newsman at Bandung Says Asia 'Knew All about U. S. Negroes,'" Daily Worker (8 June 1955).

99. In 1946, U. S. Secretary of State James Byrnes protested Soviet election policy in the Balkans. The Soviet foreign ministry replied that "the Negroes of Mr. Byrnes' own state of South Carolina were denied the same right." Frances Stonor Saunders, *The Cultural Cold War. The CIA and the World of Arts and Letters* (New York: The New Press, 1999), 291.

100. "Interview with Adam Clayton Powell, Jr.: Red China Exposed: Not dominant in Asia," *US News & World Report* (29 April 1955); "Capitol Stuff," *New York Daily News* (6 May 1955); "Interview with Max Yergan: Why There's No Colored Bloc," *US News & World Report* (3 June 1955); Abner Berry, "Foreign Policy for Patriotic Negroes," *Daily Worker (*29 May 1955); Wright, Color Curtain, 177-178. This response is also there from the National Urban League, but they did adjudge the confer-ence important enough to warrant a pamphlet: Louis Lautier, *Bandung. A Common Ground* (Washington, DC: National Urban League, 1955).

101. Wright, *Color Curtain*, 140 and 157. For more on the book, see Herbert Aptheker, "Richard Wright Gives Views on Bandung," *Daily Worker* (26 April 1955); Tillman Durdin, "Richard Wright Examines the Meaning of Bandung," *New York Times* (18 March 1956).

102. George Plimpton, *Shadow Box* (New York: Berkeley Publishing, 1977), says that the line comes from Ali's friend Bundini,

103. Marqusee, *Redemption Song*, 267-279.

104. Thomas, *Bruce Lee*, 97.

105. Ibid., 278.

106. Nadya Labi, "Tae-Bo or Not Tae-Bo?" *Time* (15 March 1999), 77. What is forgotten now is that Billy Blanks was a leading karateka. In November 1980 he won silver (openweight) and bronze (80-kg division) medals in Spain at the fifth WUKO championships.

107. Kilinidi Iyi, "African Roots in Asian Martial Arts," *African Presence in Early Asia*, ed. Ivan Van Sertima and Runoko Rashidi (New Brunswick: Transaction Books, 1985) 142.

108. J. Lowell Lewis, *Ring of Liberation: Deceptive Discourse in Brazilian Capoeira* (Chicago: University of Chicago Press, 1992). Capoeira also resembles other American self-defense forms such as the Cuban manì, the Venezuelan broma, and the Martiniquean ladj·.

109. Phillip Zarrilli, *When the Body Becomes All Eyes: Paradigms, Discourses, and Practices of Power in Kalanppayattu* " (New York: Oxford Press, 1998).

110. Shifu Nagaboshi Tomio (Terence Dukes), *The Bodhisattva Warriors* (York Beach, Maine: Samuel Weiser, 1994), 342-343.

111. Another story that is often left out of the mix is that of Kali, the martial arts traditions of the Filipinos. Legend has it that the art came to the archipelago in the late 13th century from Borneo. Their sword was called the *kali*, but there is also a suggestion that this itself came from Bengal, where the goddess Kali carries a sword in her hand. In numerous African languages the word Kali refers to fierceness.

112. Wayne Chandler, "The Jewel in the Lotus: The Ethiopian Presence in the Indus Valley Civilization," and Graham W. Irwin, "African Bondage in Asian Lands, *African Presence*. We get some of this from hip-hop artist Nas who raps that he is "like the Afrocentric Asian, half man, half amazin," and that "I exhale the yellow smoke of Buddha through righteous steps," the mix of Nation of Islam and the Afrocentric claim on Buddha. This is on his "Ain't Hard to Tell" track from Illmatic, 1994.

113. Kamau Ryu, System of Self-Defense, www.kamau-ryu.com/intro.htm.

114. W. E. B. Du Bois, "Egypt and India," *The Crisis* 18. 2 (June 1919), 62.

115. W. E. B. Du Bois, *Dark Princess* (Jackson: Banner Books, 1995), 249 and 311.

116. Tre' Boogie, "The Arsonists: The Art of Jeet Kune Flow," *The Iron Fist Magazine* (30 December 1999).

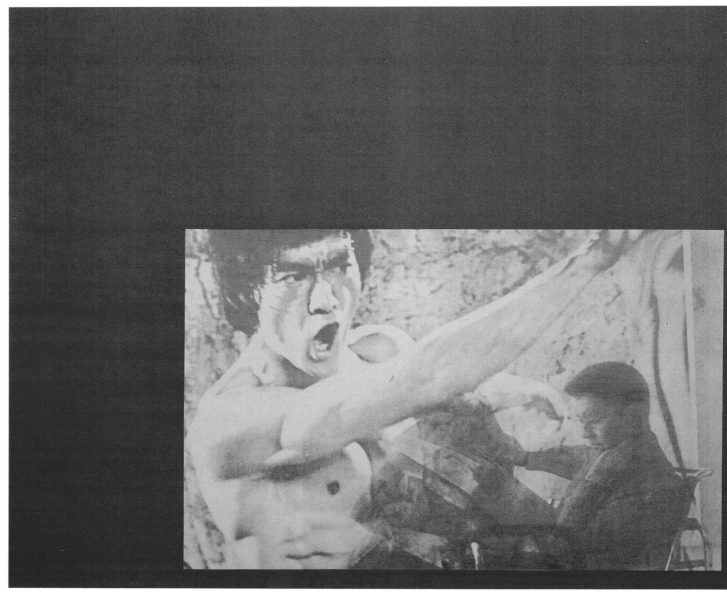

David Diao, *Reading*, 1999

"We are the subconscious of the Western mind..." —Ntozake Shange

Enter

I like Asian boys. Think they're kinda cute. Sexy if the body is doing justice. They're different than the black male I also dearly lust for. Different than my in-bred notion of Asian men. That notion has been transformed by kung fu into a down-for-whatever desire for some sweet-and-sour-rib-on-my-chocolate-ham-hock. In a phallic and nonpolitically correct mode I am an Asianphile who has only gone there through Hong Kong films, Anime, and Asian fiction. I am a black girl with an Asian male fetish. There lurks within me the desire to converse with the Asian penis.

Game One: The Quiz

"Don't think! Feeeeel. It is like a finger pointing away to the moon...Don't concentrate on the finger or you will miss all that heavenly glory..."
 —Bruce Lee from *Enter the Dragon* (1973)

What in my previous life made the Asian equation arousing? When is the exact moment I began to wonder if Asian dick was for me?

Was it: When I was twelve years of age and the Chinese spot between 115th and 116th on Seventh Avenue was the nastiest place to get some pork fried rice? I liked the food but there was something else I liked as much: the Chinese boy (or was he Korean?) who worked there was a cutie. He always smiled and said hello and must have given me something free at one point. Or did he accept the food stamps?

Or: When I met Tommy, a fine arts major at my high school, I thought he looked like Officer H. T. Ioki (Dustin Nguyen) from *21 Jump Street* (who's now on VIP) or one of the thugs from Mickey Rourke's *Year of the Dragon*.[1] He wore tight acid-washed jeans that made a crease in his balls. Had short and spiky hair on top, long in the back, and a little peach fuzz going on in the face. Umm.

Or: Shaolin Executioner a.k.a. *Executioners from Shaolin* a.k.a. *Executioners of Death* (1977). The Shaolin are attacked by Manchurians. The remaining students "take refuge" on red ships used by the Peking Opera.[2] They travel the southern waterways as theater actors and acrobats with a political statement. The leader, Hung Hsi Kuan (played by Chen Kuan Tai), hooks up with this chick (Lily Li) in a nearby village. He knows tiger style. She knows crane. She flips his whole shit on their wedding night by simply keeping her legs closed. Honestly, I would have given it up. Those lips were just too plump.

Or: Ricky "Data" Wang in *The Goonies* (1985), John Lone in *The Last Emperor* (1987), and those anonymous bad guys in *Big Trouble in Little China* (1986). Something about those three storms—Thunder, Rain, and Lightning—in that corny-ass (but entertaining) Kurt Russell flick. (Like Chinese girls really have jade eyes! The nerve!)

Or: An uptown summer jam. A Taste of Honey's *"Sukiyaki"*.

Game Two: Baby Names

There was always a brother sporting a karate suit and Chinese slippers on the block. Now whether or not bro could actually do something in the suit was a complete mystery. He wore it to ensure mofos left him the fuck alone.

Bruce Leroy (Tiamak) had changed everything with *The Last Dragon* (1985). Oh. My. GOD. A brother does something with kung fu (which was really nothing at all) but Jesus he was cute. Had good hair and a chest thing going—a pretty boy who could kick ass. Only . . . why was he in Janet Jackson's "Let's Wait a While" video?

"My interest in martial arts began at the age of four while watching Kato on television in The Green Hornet." [3] —Tiamak

"'Cause I like it," said the thick young bro with the newly stitched tattoo down his forearm. The Chinese characters read: "Only God can judge me."

I noted the gel smoothed across the raised skin. The tattoo looked like a good four to five hours of needle poking at flesh.

I take the answer for what it is.

I know what it is to have a simple answer.

I like it.

No deep thirty-page dialogue to validate choosing Chinese characters over English.

Hell, it looks better than standard English anyway.

The number of boys and girls with foreign words scrolled down their arms and across their waists is increasing.

Only God Can Judge Me.

Money, Power, Respect.

Yadayadayada.

Yeah I like it too but I'm not on the hype machine.

Folks are not giving much thought to things these days. They're either spoon-fed or joining the nation of cannibals. Be like him or eat of him, no questions asked.

Here's a *true* story. One day a young couple visited their favorite Japanese steak house. After going so many times, they came to see this steak house as more than an eat-out specialty. You see, they were expecting a child. It would be a son and they soon decided, in the old ghetto-Negro custom, the child's name would be one to live forever after this steak house was closed. The couple loved each meal they had there and thought this the right thing to do. The child would go on to be a shining light in the world of slave entertainment. This child's name would be Kobe, after his parents' favorite steak house. [4]

When Wu-Tang Clan came out with *Enter the Wu Tang (36 Chambers)*, I worshiped them. Of course, the Fu-Schnickens were there before them. And yes, Chip Fu was tight along with his clan brothers, Moc and Poc. But for some reason, the Wu seized me. They sampled from the movies I loved to watch on Channel 5 Saturday mornings. They somehow found a way to mention martial arts stars and the various characters without seeming to name-drop. (I am a contradiction.) The Wu were out-to-lunch as hell but I could relate because I was fixated on the same things.

I wanted to study kung fu but resigned myself to just beating up my baby sister. When I was young I had been restricted from jump rope and hand-clap games. When finally allowed to go outside, I suffered the torment of not having the money to afford Red Devils (the ghetto version of Sassoon for all y'all middle-class Negroes). Therefore I had to hone my self-defense tactics. Doing karate chops in kids' throats on the block became an all-time favorite. I made many a four-foot, jawbreaker-eating asshole lose his breath with a swift dart to the Adam's apple.

At that point my interest in martial arts film went a little further than fighting. Due to how they unrepressed my violent instincts, I came to look at them lustfully. Bruce Lee was the first Asian male sex symbol in the New World, but it was Chen Kuan Tai (*Shaolin Executioners, Challenge of the Masters*) who got me wet in junior high school.

When Hollywood began to feature more Asian men in the eighties, the roles let me down while still holding me controlled supernaturally. The heroes were always white boys. The Asian

dudes always had mushrooms for a haircut and they always looked like little boys. The only sexy ones were the evil-doers or the idiots.

Hollywood made a mockery of the culture: Always mysterious. Always honorable. Always in need of Western guidance. Their culture too archaic to maintain or dissect. I ate up every idea and assumed it to be true. I studied the stereotypes. There was no problem with the type-casting of buffoonery, only attraction. I watched *Year of the Dragon* and Michael Douglas's *Black Rain* every time they aired. While Andy Garcia getting his head chopped off hurt me, I wanted the young Japanese counterfeiter to reign supreme. I seriously contemplated pursuing the call-girl business at a Japanese men's club. Here I bestow to you my ignorance.

Game Three: Silk Cotton Shirts and Still Lacking a Zen-Mind State...

The latest Asian knockoff in the hood: fake Versace silk shirts cascaded with Japanese/Chinese gun-slinging, sword-fisting Euro-Asian Anime characters (dragons, tigers, and snow-capped mountains!) down the front and back. Sold outside the storefronts of 125th, the fish-eating pigeon gutters of Canal Street, and in front of Mt. Sinai Hospital, these shirts are everywhere. The marketing of part silk, part cotton, part polyester oversized men's shirts proved that East Asia is in urban style. I am pleased that an interest is brewing among my Harlem countrymen in Asian couture, though I question how genuine it is. Are blacks making a fetish out of Japanese and Chinese fashion or is it capitalism that's making folks believe that what they are wearing is actually something of an import? I am at fault too. I've hunted for the perfect peasant-style straw hat and dreamed of having the figure that could fit into the Shanghai–Suzie Wong–Dragon Lady dress—the cheongsam.[5] There was a time I went to Chinatown every weekend in hopes of finding the perfect martial arts suit. I wanted the getup David Chiang had in *Shaolin Mantis* (1978). Then again, I wanted one of Chiang's in-laws, John Chang, to have me.

I have been as shallow as all you mofos dangling those damn ying-yang pendants from your necks. I have bought into all the commercialized notions and hyphenated stigmas of "the "Orient," making me no different from a number of those *kente*-cloth–wearing, Tibetan silk wrap skirt–chasing, Native American silver bracelets–jangling white women who haunt nomadic, third-world novelty stores in the West Village. Hoping to feel like they're of another world and reality. Dreaming to look "cultured."

Then I look at my bookshelves. If I'm only about a sexual and material attraction to Asian culture, what's with all the Taoist and Zen books? And all the works by Yukio Mishima, Bei Dao, Kazuko Shiraishi (woman poet), Lu Hsun, Richard E. Kim, Yosano Akiko (another girl), Junichiro Tanizaki, etc.? Why is it that I have yet become a calm little Buddha-monk, absent of the temper tantrums from my youth?

As a New World Afrikan I once wanted to believe Asians (including South Asians) had a history and a philosophy not in need of being re-created for the sake of gaining identity, one that was ancient and untouched by white hands, the oldest civilization around. Rock stars and academia alike seemed to embrace this notion too. This being the case meant Asian culture would be modernized and capitalized upon. That it would come to us via Amazon.com as feng shui coffee table books, Shambhala pocket wisdom, and Le Chateau hot shorts made of red Chinese silk. Buddhism can accompany me everywhere in my life. I can read *The Art of War*, go see the Dalai Lama in Central Park, and sport my Sisqo "Unleash the Dragon" baby tee with no ridicule. It is more readily adaptable to my comings and goings than the symbols and garb of Afrocentricity. Kwanzaa is cool. But it's a black thing. Everyone, on the other hand, has an idea about what Zen is and what "karma" does. Kwanzaa is still disputed. It may be Hallmark marketable but it is not the *Tao Te Ching*. It's not even authentically African.

Dogon cosmology is as deep as Buddhism but the word "Dogon" is not at all street lingo like

"karma" is to the Dees, Travina's, and Daminen's on Malcolm X Boulevard. It is also not entirely accepted by the Western big willies as authentically African. The *minds* dispute it, tagging it as something probably influenced by Europeans. We can't even sully it. You can find a Chinese horoscope mug but when have you seen a My First Dogon™ planetary location kit at your local crystal and astronomy shop on Broadway? I will be long dead before it is referenced in a Sprite commercial.

Game Four: The Myth of the Dick

"The significance of curvature when length & circumference fall short"
—Wanda Coleman, "Dangerous Subjects"[6]

More movies are made and the characters continue to annoy or entice me. The Van Dammes and Seagals showed us more Asian bad guys, still dumb, rough, and lacking sufficient ass-kicking skills. Actor Cary-Hiroyuki Tagawa, seen in *Mortal Combat* (1995) and *Rising Sun* (1993), may be sly and sexy, but he is always the guy who loses.
Hollywood absurdly wants you to believe the white star can really do kung fu. As if their dicks were even bigger than a black man's. Okay, we're going into genitalia, but this is what it's all about. Penis size.

Hollywood attempted to make you believe that Sean Connery's dick was bigger than Wesley Snipes's in *Rising Sun*. Connery was all-knowing, more knowledgeable of the master-student relationship than the Japanese he intricately mocked. The Japanese were depicted as extreme in their habits and doings but dick/less despite a reversal of power roles at the end of the flick. Wesley was made even smaller when he tried to get in the pants of Tia Carrere's character—a half-black/half-Japanese outcast with a horrible accent (can you believe they crimped her hair to give it a "nappy" look?), who is Connery's lover. "Just like a black man" and "just *LIKE* a black man." All in all, the idea of the small-dicked Asian man remains intact with Wesley as a stand-in for the black male myth (now chopped down to size) and the already foreshortened Asian phallus.

Despite Hollywood's feeble attempts at making white dicks look bigger, I remain attracted to something of proposed less volume. Some logic for this can be found in Asian-American homosexual texts on rice queens and gay porno. Richard Fung's essay "Looking for My Penis"[7] reveals that, surprisingly, Asian men were seen as a sexual threat during the twenties in Hollywood. The image of the Asian male as egghead/wimp, the clumsy personage jerking off while in hiding as they watch girls undress came later. Nothing sexy about these boys. Yet, according to Fung, once upon a time my Asian crushes were oversexed. Whoa! Once they were *mythologically* half black and half Japanese too?!

In the porn/horror genre of Anime flicks which I love, black men, I argue, are being metamorphed into Japanese monsters. This can be seen in characters depicted in *Legend of the Overfiend* (1989), *Legend of the Demon Womb* (1991), *Wicked City* (1989, 1992), and *Guyver*. In one scene of *Overfiend*, the monster known as the Chojin relishes having some "delicious pussy after three thousand years . . ." The size of the monster, the voice in English dub, suggests a pseudo black and even pimpish character. Were the animators using *Mack* and *Superfly* to model their monster after? Or are they apprising the viewer with details that may suggest a libido equal to the mythical hypersexual black man?

According to Freud, as examined in David Eng's *Racial Castration*, one creates a fetish that disavows the lack of something and thus circumvents a paternal threat. One finds a substitute that is projected in place of that which is absent. The existence of such both denies and attests.[8]

Non-Asian men love to maintain the myth of Asian men in the genital area. They pass it on to non-Asian women. Confessing my interest in Asian dick to my girlfriends provokes comments like "Girrrlll, now you know they ain't got no dick!" The peer pressure repels me from seeking out the truth. Thus, I am back at reexamining Eng's psychoanalysis of repressed Asian-American sexuality and homosexuality, I substitute the mystery dick with Anime flicks, Hong Kong

flicks, Japanese-as-a-second language books.

Though the Asian man may be clinically defined by the "striking absence" of a penis, Bruce Lee had other means of projecting sex than waving his dick around. He was erotic by way of sexualizing his craft and his persona. Those fight scenes where his latissimus dorsi was spread wide and glistening with sweat. That sharp flick of the nose with his thumb implied that he'd be perfectly able to perform if the opportunity arose. He never had to grab his testicles to make sure they were still there.

Game Five: Why I Hated Romeo Must Die

"Your wife's a nigger huh? You're very liberal. Blacks are beautiful. Color doesn't matter, does it? You really look like a couple." —Hoi, from the movie Fallen Angels

Upon seeing the previews and ads for Romeo Must Die (2000), I expected some incredible magic to be happening on screen between the cast members. I was given the impression that my fantasy of Asian penetration was going to be executed by Jet Li (who's far more cute bald in Once Upon a Time in China and The Legend) via the late Aaliyah. I had my doubts about her acting ability, but beggars can't be choosy. What I didn't expect was the complete idiocy of the project. Maybe I'm being harsh, but needless to say I take Asian and black intermingling on screen pretty damn seriously. Romeo was a bad joke. Blacks fighting Asians over the right to sell property being sold to junior Mafioso. The film's moral was that the Chinese are smarter than African Americans but Whitey will watch both of you kill each other and pay for the privilege. Almost every black man in the movie is a fool, some repeatedly referring to Jet's character as "dim sum" to make the audience laugh (they wish!) before he symbolically castrates them. Worst of all, what I wanted most from Aaliyah and Jet never went down. They were obviously attracted to each other but things stayed dry. I wanted a kiss. I wanted the dream.

Journalist Hyun Kim suggested that "audiences weren't ready to see one of hip-hop's prized young kittens getting it on with an Asian kung-fu master sixteen years her senior." But where he sees a Dorothy Dandridge–like prized kitten I see a slight hint of Xica, the oversexed African slave girl any virtuous man needs to be wary of. In this scenario, it is Jet Li who must be protected from the evils of miscegenation, not Aaliyah. (Small wonder that her next and last role was as an Egyptian vampire so blood-lusty all the white vampires became appalled and destroyed her for it.)

Perhaps Aaliyah kissing or having a nipple in Li's mouth would have disturbed a number of black penises. Perhaps these would be the same brothers we see sporting a fetish for Asian women in current hip-hop videos and on the streets. Perhaps Aaliyah and Jet embracing would have disturbed Asians, blacks, and whites.

Game Six: Who's Kissing Who?

"Race cannot be narrowly defined in terms of race hatred. Race is a factor in even our most intimate relationships." —Richard Fung, "Looking for My Penis"

From Eng's analysis of Kaijou Silverman's Threshold of the Visible World:

Silverman delineates a social structure in which the black penis works to disturb the sexual relations between white man and white woman. The differentiation of the white man from the black man, on the basis of the black man's hyperbolic penis, consequently reverberates in disturbing ways within the domain of gender. It places the white man on the side of the "less" rather than "more," and so threatens to erase the distinction between him and the white woman. The hyperbolic black male penis threatens the unity of the white male ego by placing him in the position of being less masculine, thereby endangering the structural distinction between him and the white woman.[9]

If Asians are thought of as being sexually lesser, they cannot disturb white superiority. This may explain why Japanese-Taiwanese pop star and actor Takeshi Kaneshiro (*Fallen Angels*, 1995; *Chunking Express*, 1994) was allowed to play opposite Mira Sorvino in *Too Tired to Die* (1998) and she with Chow Yun-Fat in the *Replacement Killers* (1998). It may explain why Tony Leung Ka Fai's (not to be confused with Tony Leung Chiu-Wai from *Bullet in the Head*) thirty-two-year-old character could make continuous love to an eighteen-year-old English girl in the movie adaptation of Marguerite Duras's *The Lover* (1992)[10] and why Jodie Foster could befriend Chow Yun-Fat in *Anna and the King* (1999) or Jet Li could be heroin-addicted screen prostitute Bridget Fonda's white knight in *Kiss of the Dragon* (2001). The Asian superheroes are presumed to be no threat to either white or black men.

Quoting Earl Jackson, Jr.—as quoted from Eng's book—white men occupy a peculiar position in a heterosexist society. I would argue that white women hold a fair share of this society also. They too contain an adequate (but not equal to gay white men) amount of access to the very power mechanisms that bridle them. More important, the white male mind believes she will come back because the Asian dick is not a black dick.

Her gender counterpart who cannot pass is the black woman. Because black women are also framed in the hyperbolic sex category, Aaliyah, the kitten, may have no chance with an Asian dude because she, like Zezé Motta in the movie *Xica* (1976), is "in heat." She will be the one who will disturb the equilibrium of ethnicity. Black people, as Fung suggests, "are endowed with a threatening hypersexuality" while Asians are "collectively seen as undersexed."[11] Jet Li, in keeping within the stereotype of "sexless" (he the "oriental" is not perceived as being completely masculine), may have not returned home if he got a taste. Then again, Jet Li, in keeping within "honor," may have dumped her after the first night for fear of being excommunicated from Beijing and Hong Kong.

Game Seven: Exit

I sit in a Korean restaurant dining on *bi bim bab*. Eggs and rice and vegetables and a taste of tofu. There's this man sitting at a table beside me. Asian. Older. Handsome. He groans sensually from his meal of pork and things I can't recognize. The groaning is causing me to sneak at his facial details. I hesitate to look directly. I fumble with the chopsticks. I am consumed with placing them down the correct way. Never have them sticking out of your rice like totem poles. Honestly, I want to impress him with these sticks; with the usual stupidity I've come to admit is Western fascination. Keep my eyes lowered, use my sticks the right way. Maintain a type of submissive, subordinate presence that is part Asian woman, part lily Southern-belle white girl. Eat slowly and neatly. Maybe get his attention.

Flashback. A cute Japanese boy tries to grind me on the dance floor with his processed locks. Why is he trying to grab my hips? He's being too aggressive. I've seen the MTV specials of tanning salons, the nappy hair machines, the many efforts to look "black." Who told him he could put on a Rasta tam, some baggy jeans, take some hip-hop house dance lessons from Ejoe, Stretch, Voodoo Ray, and Majorie, and get some black ass?[12] I would like him to be one of those men I served at the coffee bar while working at the World Trade Center back in '96. I want him to be that A-typical Japanese male—the one who does not look directly at me, attempts to traffic in sneaks, knows no English, wears a tight black suit (sometimes Banana Republic khaki), and orders a medium black with a raisin bun. He's the one. Not this kid.

Reading the late Joe Wood's essay "The Yellow Negro" in *Transition*, I become annoyed all over again with the recent obsession to go blackface in Japan. I am bored of the yellow fever trend among black boys. Especially with so many Japanese girls in New York trying to look like Britney Spears and breaking their ankles with ten-foot-high platform boots. I'm even more annoyed that Mr. Wood was able to see what I've only read about. I am impotent for lack of Wood's journey.

I continue renting videos. I continue reading and mumbling small phrases I've remembered since befriending a handful of Japanese folks. I continue to watch Janet's "If" video; not for the dancing but for the Asian boys reclining in the background. I'll get there, I suppose.

This essay was reprinted from Everything But The Burden, *edited by Greg Tate (New York: Broadway Books, 2003). Reprinted by permission of Latasha Natasha Diggs and Broadway Books, a division of Random House, Inc.*

1. Pretty cool website dedicated to the eighties television series about cops with baby faces who go undercover in high schools, *21 Jump Street*, Johnny Depp's road to fame (and self-proclaimed Cherokee-ness) started here. Has a neat trivia. *www.angelfire.com/ak/penhall*
2. Bey Logan, *Hong Kong Action Cinema* (Woodstock: Overlook Press, 1996), 48. Personally, the "for dummies" guide for any action cinema head that wants to know who's who in the history of martial arts flicks.
3. Here's another website dedicated to the eighties cult classic *The Last Dragon*, starring Vanity and Tiamak, a.k.a. Bruce Leroy. Heads who lived for this movie will get a brief synopsis of the flick and a few press release pics. *www.fast-rewind.com/dragon/*
4. During the NBA playoff of 2001, one of the announcers spoke of how Kobe Bryant got his name. Now whether or not it was a joke or straight from Kobe's parents, one will never know. Still, the idea itself is inherently ghetto enough to be mentioned. Other examples of baby names include Asia, China, Mercedes and Alizé.
5. For those who may not be familiar with the actual name "cheongsam," the dress is usually comprised of a high collar, crossover and side fastening, a slit in the skirt, which (depending on the decade) is either worn long or short in length. The material from which it is made has changed becoming a sort of East-means-West fashion. White girls can rock them. For a little more about how the dress became popular, *China Chic: A Visual Memoir of Chinese Style and Culture* (Regan Books, 2000) by Vivienne Tan is pretty good.
6. Wanda Coleman, *Bath Water Wine* (Santa Rosa, California: Black Sparrow Press, 1998).

7. Richard Fung, "Looking for My Penis," in *Q & A: Queer in Asia America*, ed. David Eng and Alice Y. Hom (Temple University Press, 1998), 115.
8. David Eng, *Racial Castration; Managing Masculinity in Asian America* (Durham: Duke University Press, 2001), 146.
9. Eng, 150.
10. In the movie *The Lover*, the actor has one of the most amazing lines. When Tony Leung's character is confronted by the girl's older brother—who sees him as dirt despite his wealth—he replies, "You have no idea how weak I am." Having not read the book I perceived it as an acknowledgement and reversal of what the Western mind assumes, making it sexual and dominant. However, I can't be held fully to this statement ten years from now. Marguerite Duras did write the book and I did need read it.
11. Fung, 116.
12. The four individuals I've mentioned are some of the top hip-house dancers for the past fifteen or so years. Since the rise of gangsta rap, dancers were—at one point—considered unnecessary for the stage. Since being resurfaced, dancing has morphed into modern Frank Hatchett theater jazz, Janet-esque house moves, and Backstreet Boys/P. Diddy/burlesque hip-hop choreography. I mention these people because while dancing was viewed for a moment as "wack," Japan continued to employ them as instructors, seeing them as an important asset to hip-hop culture and black culture.

SANFORD BIGGERS

Born 1970, Los Angeles, CA
Lives and works in New York, NY

EDUCATION

1999 MFA, The School of the Art Institute of Chicago, IL

The Skowhegan School of Painting and Sculpture, Skowhegan, ME

Maryland Institute of College of Art, Baltimore, MD

1992 BA, Morehouse College, Atlanta, GA

SELECTED SOLO EXHIBITIONS

2002 *Creation Dissipation*, Trafo Gallery, Budapest, Hungary

Afro Temple, Contemporary Arts Museum, Houston, TX

Psychic Windows, Matrix Gallery, Berkeley Art Museum, CA

In the Mind's Eye, Wight Gallery, UCLA, CA

Gomi no Tendankai, Cabaret Mago, Nagoya, Japan

SELECTED GROUP EXHIBITIONS

2003 *Somewhere Better Than This Place*, The Contemporary Arts Center, Cincinnati, OH

Black President: The Art and Legacy of Fela Anikulapo Kuti, The New Museum, New York, NY

Shuffling the Deck, Princeton Museum of Art, NJ

Family Ties, Peabody Essex Museum, Salem, MA

The Commodification of Buddhism, Bronx Museum of the Arts, NY

Skin Deep, Numark Gallery, Washington DC

Little Triggers, Cohan Leslie Brown Gallery, New York, NY

2002 *New Wave*, Kravets/Wehby Gallery, NY

Art on Paper, Weatherspoon Museum, Greensboro, NC

Ecstasy Falls, G- Module, Paris, France

Family, Aldrich Museum of Contemporary Art, Ridgefield, CT

Not Quite Myself Today, Arizona State University Art Museum, Tempe, AZ

One Planet Under a Groove, Bronx Museum of the Arts, Bronx, NY

Group of Four, NFA Space, Chicago, IL

Zoning, The Project, New York, NY

Freestyle, Studio Museum in Harlem, NY

Rapper's Delight, Yerba Buena Center for the Arts, San Francisco, CA

Altoid's Curiously Strong Collection, New Museum for Contemporary Art, New York, NY

2000 *Full Service*, Kenny Schachter, New York, NY

The Third Dimension, Pelham Art Center, Westchester, NY

Artists-In-Residence 1999-2000, Studio Museum in Harlem, New York, NY

Clockwork 2000, P.S. 1 Clocktower Studios, New York, NY

Confluence, Five Myles Art Space, Brooklyn, NY

Altered Objects, Hyde Park Art Center, Chicago, IL

Lifers, Cordozo School of Law, New York, NY

New Talent II, Contemporary Art Workshop, Chicago IL

Dialog, Krasel Art Center, St. Jospeh's Harbor, MI

Bank Holiday, Skowhegan School of Painting and Sculpture, Skowhegan, ME

Black Alloy, Cornerstone Alliance Community Gallery, Benton Harbor, MI

Black Creativity, Chicago Museum of Science and Industry, Chicago, IL

Magical, Mythical, Monumental, Green Street Space, Baltimore, MD

Foreign Artist's Exhibition, International Center Nagoya, Japan

IONA ROZEAL BROWN

Born 1966, Washington, DC
Lives and works in Chillum, MD

EDUCATION

2002 MFA, Yale University School of Art, New Haven, CT

1999 Skowhegan School of Painting and Sculpture, Skowhegan, ME

BFA, Painting, San Francisco Art Institute, CA

1996 Pratt Institute, Brooklyn, NY

1995 Montgomery County Community College, Takoma Park, MD

1991 BS, University of Maryland, College Park, MD

SOLO EXHIBITIONS

2002 *a3... black on both sides*, Caren Golden Fine Art, New York, NY

a3... black on both sides, Sandroni Rey, Los Angeles, CA

2000 *Homecoming*, Pavilion of Fine Arts, Takoma Park, MD

1999 *many faces*, Diego Rivera Gallery, San Francisco, CA

1995 *iona 101*, Gallery Upstairs, Takoma Park, MD

soul tapping, St. Stephen and the Incarnation Episcopal Church, Washington, DC

GROUP EXHIBITIONS/ SCREENINGS

2003 *Skin Deep*, Numark Gallery, Washington, DC

International Paper, UCLA Hammer Museum, CA

2002 *New Wave*, Kravets/Wehby Gallery, New York, NY

Ritmo de Hoy, La Raza Galeria Posada, Sacramento, CA

Mass Appeal: The Art Object and Hip Hop Culture, Gallery 101, Ottawa, Canada

Zinc Gallery, Stockholm, Sweden

1999 *Frenzy*, Luggage Store Gallery, San Francisco, CA

Skowhegan Film Festival, Skowhegan, ME

Radical Performance Fest, Somart Gallery, San Francisco, CA

Zyzzyva in Black and White, Diego Rivera Gallery, San Francisco, CA

1998 *Ultra Down*, The Luggage Store Gallery, San Francisco, CA

Afro Solo, Z Space Studio, San Francisco, CA

Portraiture, The Abstract Zone, Emeryville, CA

Busted, Crucible Cell Gallery, San Francisco, CA

PATTY CHANG

Born 1972, San Francisco, CA
Lives and works in New York, NY

EDUCATION

1994 BA, University of California, San Diego

1993 L'Accademia di Belle Arti, Venice, Italy

SOLO EXHIBITIONS

2003 *Beauty Room 02*, Miss China, Project Space, Paris, France

2002 Galerie Gabrielle Maubrie, Paris, France

2001 Jack Tilton Anna Kustera Gallery, New York, NY

Entwistle Gallery, London, England

Fri-Art Centre d'Art Contemporain Kunsthalle, Fribourg, Switzerland

Baltic Art Center, Visby, Sweden

2000 *Ven conmigo, nada contigo. Fuente. Melones. Afeitada.*, Museo Nacional Centro de Arte Reina Sofia, Madrid, Spain

The Contemporary Museum, Video Gallery, Honolulu, HI

Let Down and Release, Yerba Buena Center for the Arts, San Francisco, CA

Sarah Cottier Gallery, Sydney, Australia

Galerie Gabrielle Maubrie, Paris, France

1999 Jack Tilton Gallery, New York, NY

Ace Gallery, Los Angeles, CA

GROUP EXHIBITIONS AND PERFORMANCES

2003 *Somewhere Better Than This Place: Alternative Social Experience in the Spaces of Contemporary Art*, The Contemporary Arts Center, Cincinnati, OH

Water, Water, The Rotunda Gallery, Brooklyn, NY

Feminine Persuasion, The Kinsey Institute and the School of Fine Arts Gallery, Bloomington, IN

Videos in Progress, The RISD Museum, Providence, RI

2002 *Mirror, Mirror on the Wall*, MASS MoCA, North Adams, MA

The Body Electric: Video Art and the Human Body, Cheekwod Museum of Art, Nashville, TN

Americas Remixed, La Fabbrica del Vapore, Milan, Italy

Extreme Existence, Pratt Manhattan Gallery, NY

Moving Pictures, Solomon R. Guggenheim Museum, New York, NY

Fusion Cuisine, Deste Foundation Centre for Contemporary Art, Athens, Greece

Time Share, Sara Meltzer Gallery, NY

Le Studio, Yvon Lambert, Paris, France

Oral Fixations, Center for Curatorial Studies, Bard College, Annandale-on-Hudson, NY

Superlounge, Gale Gates, Brooklyn, NY

About the Mind (Not Everything You Always Wanted to Know), Video Cafe, Queens Museum, NY

Mirror Image, UCLA Hammer Museum, CA

2001 *Circus Maximus*, BeganeGrond, Center for the Contemporary Arts, Utrecht, Holland

Casino 2001, 1st Quadrennial of Contemporary Art, Stedelijk Museum Voor Actuele Kunst and the Bijloke Museum, Gent, Belgium

Looking for Mr. Fluxus: In the Footsteps of George Maciumas, Art in General, NY

Las Hijas de la Tierra, IODAC Museum of Contemporary, Canary Islands, Spain

Panic, Julie Saul Gallery, New York, NY

Video Jam, Palm Beach Institute of Contemporary Art, Lake Worth, FL

WET, Luise Ross Gallery, New York, NY

Trans Sexual Express Barcelona, Centre d'Art Santa Monica, Barcelona, Spain

Smirk: Women, Art, and Humor, Firehouse Art Gallery, Nassau Community College, New York, NY

2000 *Uncomfortable Beauty*, Jack Tilton Anna Kustera Gallery, New York, NY

Cross Female, Kunstlerhaus Bethanien, Berlin, Germany

Soma, Soma, Soma, The Sculpture Center, New York, NY

The Standard Projection: 24/7, Standard Hotel, Los Angeles

Galerie Fons Welters, Amsterdam, Netherlands

ID/y2k, Identity At The Millennium, Castle Gallery, NY

Mug Shots, Center for Visual Art and Culture, University of Connecticut, Storrs, CT

1999 *IDENDITAT, hat man doch zu viel*, Ort Hälle für Kunst, Luneburg, Germany

Körperinszenierungen, Städtische Bühnen Frankfurt Oper, Frankfurt, Germany

1998 *Untitled (two women at tea)*, Jack Tilton Gallery, New York, NY

1997 *Likewise, Sacred Stiff*, Leslie Lohman Gallery, New York, NY

Repose, Art et Industrie, New York, NY

TKO: Better to Give than to Receive, Avant-gard-arama, P.S. 122, New York, NY

Alter Ergo, Terra Bomba, Exit Art The First World, New York, NY

1996 *xm, The Shape of Sound*, Exit Art The First World, New York,NY

Gong Li with the Wind, Millennial Identities, NYU Cantor Film Center, New York, NY

Isadora Duncan: Babtised Myth, Clit Club, New York, NY

Glacier, Sweat, Exit Art The First World, New York, NY

1995 *At a Loss*, P.S. 122, New York, NY

Fistwich, Avant-gard-arama, P.S. 122, New York, NY

Half-n-Half, The Deviant Playground, New York, NY

Y. DAVID CHUNG

Born 1959, Bonn, Germany
Lives and works in McLean, VA

EDUCATION

MFA, George Mason University, Fairfax, VA

BFA, Corcoran College of Art and Design, Washington, DC

SELECTED SOLO EXHIBITIONS

2002 Hand Workshop Art Center, Richmond, VA

Gallery K, Washington, DC

1998 Mary Lou Williams Center, Duke University, Durham, NC

1996 Project Rowhouses, Houston, TX

1993 Alternative Museum, New York, NY

1992 Whitney Museum of American Art at Philip Morris, New York, NY

SELECTED GROUP EXHIBITIONS

2002 *Gwangju Biennale*, Gwangju, Korea

Media/Metaphor, the 46th Corcoran Biennial, Corcoran Gallery of Art

2000 *The View from Here*, State Tretyakov Gallery, Moscow, Russia

1996 *Twentieth-Century Nomads*, Kasteev State Art Museum, Almaty Kazakhstan

1995 *Uncommon Ground*, Virginia Museum of Fine Arts, Richmond, VA

1994 *In and Out of Place*, Boston Museum of Fine Arts, Boston, MA

1993 *Across the Pacific*, Queens Museum of Art, New York, NY

In Transit, New Museum of Contemporary Art, New York, NY

Asia/America, Asia Society, New York, NY

Luxor, v 1.0, Corcoran Gallery of Art, Washington, DC

The Curio Shop, Artist's Space, New York, NY

1991 *Sites of Recollection*, William's College Museum of Art, Williamstown, MA

1990 *ANGULAS–Street of Gold*, Jamaica Arts Center, NY

The Decade Show, The Studio Museum in Harlem, New York, NY

1988 *Invented Selves*, Asian-American Arts Centre, New York, NY

SEOUL HOUSE (Korean Outpost), Washington Project for the Arts, Washington, DC

DAVID DIAO

Born 1943, Chengdu, Sichuan, China
Lives and works in New York, NY

EDUCATION

1964 BA, Kenyon College, Grambier, OH

SELECTED SOLO EXHIBITIONS

2000 Postmasters Gallery, New York, NY

1999 Cherng Piin Gallery, Taipei, Taiwan

1997 *Histories et Fictions, Peintures Recentes de David Diao*,
La Criée, Centre d'Art Contemporain, Rennes, France

1992 *Vendus*, Ecole National d'Art de Dijon, France

1990 *Het Kruithuis*, Museum voor Hedendaagse Kunst,
's-Hertogenbosch, Holland Provincial Museum voor
Moderne Kunst, Oostende, Belgium

1989 Musée d'Art Moderne, Saint Étienne, France

1979 Arts Club of Chicago, Chicago, IL
Tyler Gallery, Temple University, Elkins Park, PA

1974 Jared Sable Gallery, Toronto, Canada
Cuningham Ward Gallery, New York, NY

1969 Françoise Lambert Galleria, Milan, Italy
Paula Cooper Gallery, New York, NY

SELECTED GROUP EXHIBITIONS

2000 *Personal Space: the Domesticated Long Island Landscape*,
The Parrish Museum, South Hampton, New York, NY

1998 Museum of Contemporary Art, Los Angeles, CA

1999 *Le Consortium's Collection*, Pompidou Center, Paris, France
Brooklyn Museum of Art, Brooklyn, NY

1997 *After the Fall, Painting Since 1970*, Snug Harbor Center for
Art, Staten Island, NY

Landscape Regained, Aldrich Museum of Contemporary
Art, Ridgefield, CT

1996 *Thinking Print*, Museum of Modern Art, New York, NY

*Fractured Fairy Tales: Art in the Age off Categorical
Disintegration*, Duke University Museum of Art,
Durham, NC

1992 *Gegen den Strich*, Galerie Theuretzbacher, Vienna

C'est pas la fin du monde—une vue des annees 80, La
Cour d' Or—Musée de Metz, France

Generiques, le Visuel et L'Ecrit, Hotel des Arts, Fondation
Nationale des Arts, Paris, France

1990 *The Charade of Mastery*, Whitney Museum of American Art,
New York, NY

1973 *Maler, Pinters, Peintres, Prospect '73*, Stadtische
Kunsthalle, Dusseldorf, Germany

Biennial Exhibition, Whitney Museum of American Art,
New York, NY

1972 *New York Painters*, Berkeley Museum of Art, CA

David Diao and Cy Twombly, Hampshire College,
Northhampton, MA

1967 Park Place Gallery, New York, NY

SEAN DUFFY

Born 1966, San Diego, CA
Lives and works in Los Angeles, CA

EDUCATION

1992 MFA, University of California, Irvine

1988 BA, University of California, San Diego

SELECTED SOLO EXHIBITIONS

2003 *The Second Greatest Generation*, Susanne Vielmetter
Los Angeles Projects, CA

2001 *cream*, Susanne Vielmetter Los Angeles Projects, CA
mod2, Howard House, Seattle

2000 *Endless Sunday*, Santa Barbara Contemporary Arts Forum,
Miramar Artist Project Space, Santa Barbara, CA
Game Over, George's, Los Angeles, CA
Mod, Irvine Fine Arts Center, Irvine, CA

1999 *first wave*, Quotidian Gallery, San Francisco, CA

1998 *teach me to love*, Deep River, Los Angeles, CA

1995 *Living Plan B; Go Captain Baby Vol. 2*, Los Angeles
Contemporary Exhibitions, CA

1994 *The Real Captain Commander; Go Captain Baby Vol. I*,
Lemoyne Kennels, Los Angeles, CA

SELECTED GROUP EXHIBITIONS

2003 *21 Paintings from LA*, Robert V. Fullerton Art Museum,
Californa State University, San Bernadino, CA

2001 *Painting Beyond Painting*, Christinerose Gallery,
New York, NY

2000 *For Example*, Acuna-Hansen Gallery, Los Angeles, NY
Bestiary, Armory Center for the Arts, Pasadena, CA
The Spurgeon Experience 2, Raid Projects, Santa Ana, CA
Pleasure Seekers, Museum of Contemporary Art,
Denver, CO
One Night Stand, Park Plaza Lodge Hotel, Los Angeles, CA

1999 *for the kids?*, Quotidian Gallery, San Francisco
Game Show, Bellevue Art Museum, Washington
What On Earth, Nevada Institute for Contemporary Arts,
Las Vegas
Day Dreaming, George's, Los Angeles, CA
Happy Trails, College of Creative Studies, UC Santa
Barbara, CA
The Touch, Action Space, Los Angeles, CA
Real Deal, Guggenheim Gallery, Chapman University,
Orange, CA

1998 *More More More*, Action Space, Los Angeles , CA
Tweeners, Spanish Kitchen, Los Angeles, CA
Time Travel, While U Wait, DMV Hollywood, CA

1996 *Make a Move*, Lemoyne Kennels, Los Angeles, CA

1995 *Neotoma*, Otis Gallery, Los Angeles, CA

1994 *Second Anniversary Fashion Show*, Food House,
Santa Monica, CA
Playfield, Rio Hondo College Art Gallery, Whittier, CA

1993 *Germinal Notations*, Food House, Santa Monica, CA

1992 *Hands*, Venice Art Walk, Venice, CA
Diverse Discourses Converge, DA Gallery, Pamona, CA
Visual Exchange, Otis Parsons, Los Angeles, CA

ELLEN GALLAGHER

Born 1965, Providence RI
Lives and works in New York, NY and Rotterdam, Netherlands

EDUCATION

1993 Skowhegan School of Painting and Sculpture,
Skowhegan, ME

1992 School of the Museum of Fine Arts, Boston, MA

1984 Oberlin College, OH

SELECTED SOLO EXHIBITIONS

2003 Galerie Max Hetzler, Berlin

POMP-BANG, Saint Louis Art Museum, MO

2001 Watery Ecstatic, Institute of Contemporary Art, Boston, MA

Preserve, Des Moines Art Center, IA

Blubber, Gagosian Gallery, New York, NY

2000 Anthony d'Offay Gallery, London, England

1999 Mario Diacono Gallery, Boston, MA

Galerie Max Hetzler, Berlin, Germany

1998 Gagosian Gallery, New York, NY

IKON Gallery, Birmingham, England

1996 Anthony d'Offay Gallery, London

Mary Boone Gallery, New York, NY

1994 Mario Diacono Gallery, Boston, MA

1992 Akin Gallery, Boston, MA

SELECTED GROUP EXHIBITIONS

2003 Popstraction, Deitch Projects, New York, NY

Dreams and Conflicts–The Dictatorship of the Viewer,
50th Venice Biennial, Italy

2002 Cartoon Noir: Contemporary Investigations,
The Jack S. Blanton Museum, Austin, TX

2001 From Rembrandt to Rauschenberg: Building the Collection,
Jack S. Blanton Museum of art, University of Texas at
Austin, TX

The Mystery of Painting, Sammlung Goetz, Munich,
Germany

The Americans, Barbican Centre, London, England

2000 New Acquisitions, Solomon R. Guggenheim Museum,
New York

Kin, The Kerlin Gallery, Dublin, Ireland

Making Sense: Ellen Gallagher, Christian Marclay, Liliana
Porter, The Contemporary, Baltimore, MD

Strength and Diversity: A Celebration of African-American
Artists, Carpenter Center for the Visual Arts, Harvard
University, Cambridge, MA

Greater New York: New Art in New York Now, P.S.1.
Contemporary Art Center, Long Island City, New York

Visual Memoirs: Selected Paintings and Drawings,
The Rose Museum, Brandeis University, Waltham, MA

1999 Corps Social, École Nationale Supérieure des Beaux-Arts,
Paris, France

Negotiating Small Truths, Jack S. Blanton Museum of Art,
University of Texas at Austin, TX

Collectors Collect Contemporary: 1990-99, Institute of
Contemporary Art, Boston, MA

1998 Cinco Continentes y una Ciudad, Museo de la Ciudad de
Mexico, Mexico City, Mexico

Piecing Together the Puzzle: Recent Acquisitions,
The Museum of Modern Art, New York, NY

Postcards from Black America, De Beyerd Centre for
Contemporary Art, Breda, Netherlands

1997 Project Painting, Basilico Fine Arts and Lehmann
Maupin Gallery, New York, NY

Projects, Irish Museum of Modern Art, Dublin, Ireland

The Body of Painting, Mario Diacono Gallery, Boston, MA

T-Race, Randolph Street Gallery, Chicago, IL

1996 Art at the End of the 20th Century: Selections from the
Whitney Museum of American Art, National Gallery,
Alexandros Soutzos Museum, Athens, CO

Inside the Visible, Institute of Contemporary Art, Boston,
Massachusetts and Whitechapel Art Gallery,
London, England

1995 Whitney Biennial, Whitney Museum of American Art,
New York, NY

Altered States, Forum for Contemporary Art, St. Louis, GA

Degrees of Abstraction, Museum of Fine Arts, Boston, MA

1994 Airborne/Earthbound, Mario Diacono Gallery Boston, MA

In Context, Institute of Contemporary Art, Boston, MA

1993 Artists Select, Artist Space, New York, NY

Traveling Scholars' Exhibit, Museum of Fine Arts,
Boston, MA

1992 Autopia, Akin Gallery, Boston, MA

Faces, Clark Gallery, Lincoln, MA

Ion, Akin Gallery, Boston, MA

Symphony of Prosperity, Akin Gallery, Boston, MA

World and Image, Boston Public Library, MA

RICO GATSON

Born 1966, Augusta, GA
Lives and works in Brooklyn, NY

EDUCATION

1989 BA, Bethel College, St. Paul, MN

1991 MFA, Yale School of Art, New Haven, CT

SELECTED SOLO EXHIBITIONS

2001 Ronald Feldman Fine Arts, New York, NY

Masking: Rico Gatson (Kindred), The Atlanta Contemporary Art Center, GA

Serge Ziegler Galerie, Zurich, Switzerland

2000 *Fire*, Ronald Feldman Fine Arts, New York, NY

1999 *Home Sweet Home*, Pierogi 2000, Brooklyn, NY

1996 *Project Room*, Momenta Art, Brooklyn, NY

SELECTED GROUP EXHIBITIONS

2003 *Living Inside the Grid*, New Museum of Contemporary Art, New York, NY

2002 *Vini Vidi Video*, The Studio Museum in Harlem, New York, NY

Spinning, MIT List Visual Arts Center, Cambridge, MA

Knockout Fairground, Washington Square East Galleries, New York, NY

Americas Remixed, Comune di Milano, Milan, Italy

Season Review, Ronald Feldman Fine Arts, New York, NY

Paris Exchange, Momenta Art, Brooklyn, NY

Enough About Me, Momenta Art, Brooklyn, NY

Race in Digital Space, The Studio Museum in Harlem, New York, NY

A Painting for Over the Sofa (that's not necessarily a painting), Bernice Steinbaum Gallery, Miami, FL

Brooklyn!, Palm Beach Institute of Contemporary Art, Lake Worth, FL

In Cold Blood, Samuel Dorsky Museum of Art, SUNY New Paltz, NY

Race in Digital Space, MIT List Visual Arts Center, Boston, MA

Freestyle, The Studio Museum in Harlem, New York, NY

2000 *Light x Eight: The Hanukkah Project 2000*, The Jewish Museum, New York, NY

Videotheque Kunst Zurich 2000, Serge Ziegler Galerie, Zurich, Switzerland

Never Never Land, University Galleries, Florida Atlantic University, Boca Raton, FL

The Light Show, Gale Gates, Brooklyn, NY

1999 *Working In Brooklyn: Beyond Technology*, Brooklyn Museum of Art, Brooklyn, NY

Rage for Art, Pierogi 2000, Brooklyn, NY

Video Program, Cynthia Broan Gallery, New York, NY

1998 *Hybro Video*, Exit Art, New York, NY

1997 *Current Undercurrent: Working in Brooklyn*, Brooklyn Museum of Art, Brooklyn, NY

Artists Respond to 2001: Space Odyssey, Williamsburg Art & Historical Society, Brooklyn, NY

The View from Denver, Museum Moderner Kunst Stiftung Wien, Austria

1996 *Video Faz*, FARCO, International Art Fair, Guadalajara & Mexico City, Mexico

Video Faz, Art and Idea, Mexico City, Mexico

Cadmium-Cathode, Sauce, Brooklyn, NY

1995 *Presence*, Real Art Ways, Hartford, CT

On the Lam, Thicket Gallery, New York, NY

Other Rooms, Ronald Feldman Fine Arts, New York, NY

Options 2, The Denver Art Museum, Denver, CO

1994 *Faux*, Ronald Feldman Fine Arts, New York, NY

FIRED – A Late-Nite Comedy Show, No Bias Space, North Bennington, VT

FIRED – A Late-Nite Comedy Show, Thicket Gallery, New York, NY

1993 Art Space, New Haven, CT

LUIS GISPERT

Born 1972, Jersey City, NJ
Lives and works in Brooklyn, NY

EDUCATION

2001 MFA, Yale University School of Art, New Haven, CT

1996 BFA, Film, The School of the Art Institute of Chicago, IL

1992 Miami-Dade Community College, Miami, FL

SELECTED EXHIBITIONS

2003 *Influnce, Anxiety, and Gratitude*, MIT List Visual Arts Center, Cambridge, MA

Youngstars, Galerie Krinzinger, Vienna, Austria

Fucking Trendy, Kunsthalle Nurnberg, Germany

New Wave, Kravets/Wehby Galley, New York, NY

2002 *Interplay*, Moore Building, Miami, FL

Mass Appeal, Galerie 101, Ottawa, Canada

Owens Art Gallery, Sackville, Canada

Monitor 2, Gagosian Gallery, New York, NY

Bystander, Andrea Rosen Gallery, New York, NY

10 Seconds 2 Love, Mullerdechiara Gallery, Berlin, Germany

Whitney Biennial, Whitney Museum of American Art, New York, NY

New Additions To The Altoids Curiously Strong Collection, New Museum of Contemporary Art, New York, NY

Officina America, Galleria D'Arte Moderna Villa Delle Rose Museo Morandi, Bologna, Italy

2001 *One Planet Under A Groove*, The Bronx Museum of the Arts, Bronx, NY and Walker Art Center, Minneapolis, MN

Border Stories, IX International Biennial of Photography Palazzo Brocherasio, Torino, Italy

Optic Nerve III, Return of Optic Nerve, Museum of Contemporary Art, Miami, Florida

Bling Bling, Audelio Fine Art, New York, NY

Pause, Mark Fox Gallery, Los Angles, CA

2000 *Travels In Hyperreality, Making Art In Miami*, Museum of Contemporary Art, Miami, FL

Publikulture, Museum of Art Fort Lauderdale, FL

Effects, Audelio Fine Art, New York, NY

Mount Miami, American Artists In Tel Aviv, Tel Aviv Artists Studios, FL

1999 *The Present Absent*, Eight Artists From Miami, Paco Imperial, Rio de Janeiro, Brazil

Booty Bass, Centre Gallery, Miami-Dade Community College, Miami, FL

University of North Carolina, Greensboro, Pittsburgh Center for the Arts

DAVID HAMMONS

Born 1943, Springfield, IL
Lives and works in New York, NY

SELECTED SOLO EXHIBITIONS

2002 Ace Gallery, New York, NY

White Cube, London, England

2001 Gallery Shimada, Yamaguchi, Japan

2000 Museo Reina Maria Sofia, Madrid, Spain

1998 *Blues and the Abstract Truth*, Kunsthalle Bern, Switzerland

Gallery Shimada, Yamaguchi, Japan

1995 Salzburger Kunstverein, Salzburg, Austria

1994 Veratagioia, Milan, Italy

Sara Penn-Knobkerry, New York, NY

1993 *Hometown*, Illinois State Museum, Springfield, IL

Williams College Art Center, Williamstown, MA

1992 American Academy in Rome, Italy

1991 Jack Tilton Gallery, New York, NY

1990 P.S.1 Museum, Long Island City, New York, NY

Jack Tilton Gallery, New York, NY

1989 Exit Art, New York, NY

1986 Just Above Midtown Gallery, Inc. New York, NY

1980 *The Window*, New Museum of Contemporary Art, New York, NY

1977 *Nap Tapestry: Wire and Wiry Hair*, Neighborhood Art Center, Atlanta, GA

1976 *Dreadlock Series*, Just Above Midtown Gallery, Inc. New York, NY

1975 *Greasy Bags and Barbecue Bones*, Just Above Midtown Gallery, Inc. New York, NY

1974 Fine Arts Gallery, Los Angeles, CA

1971 Brockman Gallery, Los Angeles, CA

SELECTED GROUP EXHIBITIONS

2003 *Work Ethic*, The Baltimore Museum of Art, Baltimore, MD

2002 *Crisis Response*, Museum of Art, Rhode Island School of Design, Providence, RI

2001 *One Planet Under a Groove*, The Bronx Museum of the Arts, NY

Red, Black, and Green, The Studio Museum in Harlem, NY

About Objects: Selection from the Permanent Collection, The Rhode Island School of Design Museum, Providence, RI

2000 *Material and Matter*, The Studio Museum in Harlem, NY

Parkett Editions, Museum of Modern Art, NY

1999 *MoMA 2000: Open Ends*, Museum of Modern Art, NY

The Age of Influence, Museum of Contemporary Art, Chicago, IL

Exit Art, New York, NY

1998 *Group Show 4*, Xavier LaBoulbenne, New York, NY

1997 *Installations and Projects*, P.S.1 Museum, Long Island City, NY

1996 *Flight in August*, Tribes Gallery, New York, NY

Art at the End of the Twentieth Century: Selections from the Whitney Museum, Soutzos Museum, Athens, Greece

1995 *Ripple Across The Water*, Watari Museum, Tokyo, Japan

Thinking in Print, Museum of Modern Art, New York, NY

1994 *Black Male*, The Whitney Museum of American Art, New York, NY

L'Hiver de l'amour, Musee d'Art Moderne de la Ville, Paris, France

Face-Off: The Portrait in Recent Art, Institute of Contemporary Art, Philadelphia, PA

Old Glory, Cleveland Contemporary Arts Center, Cleveland, OH

1993 *Reflections of King*, National Civil Rights Museum, Memphis, TN

The Abject, The Whitney Museum of American Art, New York, NY

American Art in the 20th Century, Royal Academy of Art, London

1992 *Documenta IX*, Kassel, Germany

Carnegie International, Carnegie Institute, Pittsburgh, PA

Re/Visions, Wexner Center for the Arts, Columbus, OH

Malcolm X: Man, Ideal, Icon, Walker Arts Center, Minneapolis, MN

Assemblage, Southeastern Center for Contemporary Art, Winston-Salem, NC

1991 *Dislocations*, Museum of Modern Art, New York, NY

Places with a Past, Spoleto Festival, Charleston, SC

Flying Colors: Military Flags of Africa and African America, Museum of Afro-American History, Boston, MA

Heimat, Wewerka and Weiss, Berlin, Germany

Discarded, Rockland Center for the Arts, Nyack, NY

Social Structure, Vrej Baghoomian, New York, NY

Counter Media, Key Gallery, Richmond, VA

1990 *The Decade Show*, Studio Museum in Harlem, New York, NY

Just Pathetic, Rosamund Felsen, Los Angeles, CA

Annual Exhibition, American Academy in Rome, Italy

Ponton Temse, Museum van Hedensdaagse Kunst Gent, Belgium

Who Counts: Assessing the 1990 Census, Randolph Street Gallery, Chicago, IL

1989 *Strange Attractions, Signs of Chaos*, New Museum of Contemporary Art, New York, NY

Awards in the Visual Arts, High Museum, Atlanta, GA

The Blues Aesthetic, The Washington Project for the Arts, Washington, DC

The City/The Spirit, Paula Allen Gallery, New York, NY

19 Sixties: A Cultural Awakening Re-evaluated 1965-75, California

Afro-American Museum, Los Angeles, CA

Art as a Verb, Studio Museum in Harlem and Met Life Gallery, New York, NY

1988 *Out of the Studio: Art in the Community*, P.S.1 Museum, Long Island City, NY

1987 Arts Festival of Atlanta, Atlanta, GA

1986 *Higher Goals*, Public Art Fund, Cadman Park, New York, NY

Kenkeleba House, New York, NY

1985 Ronald Feldman Fine Arts, New York, NY

Art on the Beach, Battery Park, New York, NY

1983 *Message to the Public*, Spectacolor Billboard, New York, NY

1982 *Higher Goals*, Public Art Fund, Harlem, New York, NY

1980 *Times Square Show*, New York, NY

Betty Parsons Gallery, New York, NY

Franklin Furnace, New York, NY

1976 *Printmaking New Forms*, The Whitney Museum of American Art, New York, NY

1974 Just Above Midtown Gallery, Inc. New York, NY

1972 Los Angeles County Museum of Art, Los Angeles, CA

1971 Santa Barbara Museum, Santa Barbara, CA

1970 La Jolla Museum of Art, La Jolla, CA

Oakland Museum of Art, Oakland, CA

Fine Arts Gallery, San Diego, CA

California State University, Los Angeles, CA

DAVID HUFFMAN

Born 1963, Berkeley, CA
Lives and works in Oakland, CA

EDUCATION

1998 MFA, California College of Arts and Crafts, Oakland, CA

1986 California College of arts and Crafts, CA

1985 Alliance of Independent Colleges of Art, New York
Studio School, New York, NY

SELECTED SOLO EXHIBITIONS

2003 De Saisset Museum, Santa Clara University, Santa Clara, CA

2001 *Trauma Travel*, Patricia Sweetow Gallery, San Francisco, CA

2000 Patricia Sweetow Gallery, San Francisco, CA

1998 Patricia Sweetow Gallery, San Francisco, CA

1997 San Francisco Museum of Modern Art Rental Gallery,
San Francisco, CA

1995 *History Lesson #52*, Watts Tower Art Center,
Los Angeles, CA

 Broadside, Jan Baum Gallery, Los Angeles, CA

 David Huffman Selected Paintings, The Renaissance,
Santa Monica, CA

1994 *Lucid*, Julie Ricco Gallery, Santa Monica, CA

SELECTED GROUP EXHIBITIONS

2003 *Black Belt*, The Studio Museum in Harlem, New York, NY

2002 *Three person show*, Elizabeth Oliveria Gallery,
San Francisco, CA

 Patricia Sweetow Gallery, San Francisco, CA

 Institute of Contemporary Art (ICA), San Jose, CA

 Retrofuturest, New Langton Art, San Francisco, CA

 Institute of Contemporary Art, San Jose, CA

2001 *Freestyle*, The Studio Museum in Harlem, New York, NY,

 Patricia Sweetow Gallery, San Francisco, CA

2000 *Renditions 2000*, Yerba Buena Center for the Arts,
San Francisco, CA

 Hybrid, Southern Exposure, San Francisco, CA

 Second Bay Area Now, Yerba Buena Center for the Arts,
San Francisco, CA

1999 Heritage Bank, San Jose, CA

 Patricia Sweetow Gallery, San Francisco, CA

1998 MFA Exhibition, CCAC, Oakland, CA

1997 *Over and Under*, Southern Exposure, San Francisco, CA

 Introducing..., Patricia Sweetow Gallery, San Francisco, CA

1996 *Southern Exposure 6th Annual Juried Works by Northern
California Artists*, Whitney Museum of American Art,
New York, NY

 Sixth Biennial National Drawing Invitational, Arkansas
Art Center, Little Rock, AK

1995 *Social Engagements: Observations and Personal
Narratives*, The Municipal Art Gallery, Los Angeles, CA

 Impure Painting, Jan Baum Gallery, Los Angeles, CA

 Drops Another One, La Luz de Jesus Gallery,
Los Angeles, CA

 The Gallery Group, Jan Baum Gallery, Los Angeles, CA

1993 *Two Person Exhibition*, Walton Gallery, Los Angeles, CA

ARTHUR JAFA

Born 1960, Tupelo, MS
Lives and works in New York, NY

SELECTED SOLO EXHIBITIONS

2002 *Arthur Jafa: My Black Death*, ArtPace, A Foundation for
Contemporary Art, San Antonio, TX

SELECTED GROUP EXHIBITIONS

2002 *Formal Social*, Westfälischer Kunstverein, Münster,
Germany

2001 *Bitstreams*, Whitney Museum of American Art,
New York, NY

2000 Biennial Exhibition, Whitney Museum of American Art,
New York, NY

 Media_City, Seoul, Korea

 Black Box, California College of Arts and Crafts,
Oakland, CA

1999 *Dexter Buell, Arthur Jafa, Judy Stevens*, Artists Space,
New York, NY

 Mirror's Edge, Bildmuseet, Umeå Universitet, Sweden

MICHAEL JOO

Born 1966, Ithaca, NY
Lives and works in New York, NY

EDUCATION

1991 MFA, Yale School of Art, New Haven, CT

1989 BFA, Washington University, St. Louis, MO

 Wesleyan University, Middletown, CT

SELECTED SOLO EXHIBITIONS

2003 List Art Center, Boston, MA

2002 Paolo Curti, Milano, Italy

 Anton Kern Gallery, New York, NY

2001 Venice Biennale, Korean Pavilion, with Do-Ho Suh, Venice, Italy

1999 Anton Kern Gallery, New York, NY

1998 White Cube, London, England

1997 Anton Kern Gallery, New York, NY

1996 Thomas Nordanstad Gallery, New York, NY

1995 *Crash*, Anthony D'Offay Gallery, London, England

 Galerie Anne de Villepoix, Paris, France

 Thomas Nordanstad Gallery, New York, NY

 Nature vs. Nature at the Glass Ceiling, Bureau Amsterdam, Stedelijk Museum, Amsterdam

1994 *Salt Transfer Cycle*, Thomas Nordanstad Gallery, in collaboration with Petzel/Borgmann, 80 Mercer Street, New York, NY

1992 *The Artifice of Expenditure*, Nordanstad-Skarstedt, New York, NY

SELECTED GROUP EXHIBITIONS

2002 *Manifeste, oder: Ergriffenheit–was ist das?*, Galerie Daniel Blau, Munich, Germany

2001 *Selections from the Collection of Vicki and Kent Logan*, California College of Arts & Crafts, Oakland, CA

 Translated Acts, Haus der Kulturen der Welt, Berlin and Queens Museum, NY

 I Love NY, Benefit show, Anton Kern Gallery, New York, NY

2000 Whitney Biennial, Whitney Museum, New York, NY

 Koreamericakorea, Artsonje Center, Seoul; Sonje Museum, Kyung-ju, Tokoyo

 Psycho, Art and Anatomy, curated by Danny Moynihan, Anne Faggionato, London, England

 Drawings 2000, Barbara Gladstone Gallery, New York, NY

 Group Show, Korean Embassy, New York, NY

 Media_City Seoul 2000, National Historical Museum, Seoul, Korea

 The Korean War and American Art: Fifty Years Later, Guild Hall Museum, East Hampton, NY

 Juvenilia, Yerba Buena Center for the Arts, San Francisco

1998 *Selections from the Permanent Collection*, Walker Art Center, Minneapolis, MN

 Matthew McCaslin, Susan Etkin, Michael Joo, P.S. 1, Long Island City, New York

 Nine International Artists at Wanås, Wanås Foundation, Knislinge, Sweden

1997 L'École des Beaux Arts Galerie, Paris, France

 Art Club Berlin, Messe Berlin, Russia

Group Show: Painting, Photography, Drawing, Anton Kern Gallery, New York, NY

Art in the Anchorage, Brooklyn Bridge Anchorage, Brooklyn, NY

Johannesburg Biennial 1997, Museum of Africa, Johannesburg, South Africa

Techno-Seduction, The Cooper Union, School of Art, New York, NY

Selections from the Permanent Collection, Walker Art Center, Minneapolis, MN

1996 *Joo, Sheward & White, Wigram*, The Post Office, London, England

 The Damien Hirst Collection, Quo Vadis, London, England

 Against, Anthony D'Offay Gallery, London, England

 Urban Structures, Kunsthalle, Munich, Germany

 Patrick Painter Editions, Bloom Gallery, Amsterdam

1995 *La Belle et la Bête*, Musée d'Art Moderne de la Ville de Paris (ARC), Paris, France

 Kwangju Biennale, Kwangju Contemporary Museum, South Korea

 Museum of Contemporary Art, Chicago, IL

 Configura 2, Erfurt, Germany

 Thomas Nordanstad Gallery, New York, NY

 Better Living Through Chemistry, Randolph Street Gallery, Chicago, IL

 Chicago Institute of Cultural Anxiety, Institute of Contemporary Art, London Portalen, Copenhagen, Denmark

1994 *Some Went Mad, Some Ran Away*, Serpentine Gallery London

 Nordic Art Center, Helsinki

 Kunstverein Hannover, Hannover, Germany

 Museum of Contemporary Art, Chicago, IL

 Portalen, Copenhagen, Denmark

 Sandra Gering Gallery, New York, NY

 Drawing on Sculpture, Cohen Gallery, New York, NY

 Crash, Thread Waxing Space, New York, NY

 Kumho Museum, Seoul, Tokyo

 I, Myself and Me, The Interart Center, New York, NY

 What is in your mind?, Tekniska Museet, Stockholm, England

1993 *Recent Acquisitions*, Moderna Museet, Stockholm, England

 Künstlerhaus Bethanien, Berlin, Russia

 Aperto–93, Venice Biennale, Venice

 Nordanstad Gallery, New York, NY

 Galerie Max Hetzler, Cologne, France

 Changing I: Dense Cities, Shedhalle, Zurich, Germany

 The Final Frontier, New Museum for Contemporary Art, New York, NY

 Across the Pacific, Queens Museum of Art, Queens, NY

 In Out of the Cold, Center for the Arts at Yerba Buena, San Francisco, CA

1992 *Unfair*, Nordanstad Gallery at Balloni Halle, Cologne, France

 Galerie Metropol, Vienna, Italy

 Mimique, Bard College, Annandale-on-Hudson, NY

1988 Demolition Daze, exhibition/auction, Rifle Sport Gallery, Minneapolis, MN

GLENN AKIRA KAINO

Born 1972, Los Angeles, CA
Lives and works in Los Angeles, CA

EDUCATION

1996 MFA, University of California, San Diego

1993 BA, University of California, Irvine

SELECTED SOLO EXHIBITIONS

2003 The Project, New York, NY

2001 *Style Telegraphie*, Rosamund Felsen Gallery,
Santa Monica, CA

2000 *Blue*, Venetia Kapernekas Fine Art Inc., New York, NY

 Chasing Perfect, Three Rivers Gallery, Pittsburgh, PA

1999 *Stratch*, Rosamund Felsen Galery, Santa Monica, CA

SELECTED GROUP EXHIBITIONS

2001 *One Planet Under a Groove*, Bronx Museum of the Arts, NY

2000 *Surf Trip*, Track 16 Gallery, Santa Monica, CA

1999 International Film Festival Rotterdam, Rotterdam,
Netherlands

1998 *Xtrascape*, Los Angeles Municipal Art Gallery, Los
Angeles, CA

 i Candy, Rosamund Felsen Gallery, Santa Monica, CA

 Access All Areas, Fellows of Contemporary Art, Japanese
American Cultural and Community Center, Los Angeles, CA

1995 *Finding Family Stories*, Japanese American National
Museum, Legacy Center, Los Angeles, CA

CLARENCE LIN

Born 1974, Lincoln, Nebraska
Lives and works in Los Angeles and New York

EDUCATION

2002 MFA, Contemporary Art and Visual Culture, Columbia
University, New York, NY

2001 Skowhegan School of Sculpture and Painting,
Skowhegan, ME

1998 BA/BFA, University of California, Berkeley

SELECTED EXHIBITIONS

2003 *Artists in the Marketplace: Twenty-third Annual Exhibition*,
Bronx Museum of the Arts, Bronx, NY,

2002 MFA Thesis Show, The Mink Building, New York, NY.

2001 *Recent*, Leroy Neiman Center, New York, NY.

 MFA, First-Year Show, The Wallach Gallery, Columbia
University, New York, NY

KORI NEWKIRK

Born 1970, Bronx, NY
Lives and works in Los Angeles, CA

EDUCATION

1997 Skowhegan School of Painting and Sculpture,
Skowhegan, ME

1997 MFA, University of California, Irvine

1993 BFA, The School of the Art Institute of Chicago, IL

SELECTED SOLO EXHIBITIONS

2003 The Project, New York, NY

To See It All, Henry Art Gallery, Seattle, WA

Galleria francesca kaufmann, Milan, Italy

2002 Finesilver Gallery, San Antonio, TX

James Van Damme Gallery, Brussels, Belgium

Johnson County Community College, Overland Park, KS

2001 Rosamund Felsen Gallery, Santa Monica, CA

Galleria Francesca Kaufmann, Milan, Italy

2000 The Project, New York, NY

1999 *Midnight Son*, Rosamund Felsen Gallery, Santa Monica, CA

Legacy, Deep River, Los Angeles, CA

1998 *Higher Standard*, Project Room, Rosamund Felsen Gallery,
Santa Monica, CA

1997 *BLOWOUT*, Fine Arts Gallery, University of California,
Irvine, CA

SELECTED GROUP EXHIBITIONS

2003 *Hair Stories*, Scottsdale Museum of Contemporary Art,
Scottsdale, AZ

Kori Newkirk and Peter Rostovsky, The Project,
Los Angeles, CA

2002 *Majestic Sprawl*, Pasadena Museum Of California Art,
Pasadena, CA

Maximum Art, International Curatorial Space, New York, NY

Harlem Postcards, Studio Museum in Harlem, New York, NY

Wallow, The Project, New York, NY

Storefront–LIVE!, Korean American Museum,
Los Angeles, CA

Loop, Gallery 400, Chicago, IL

Beyond Stereotype, Dowd Fine Arts Gallery, SUNY
Cortland, NY

Drive By, Reynolds Gallery, Richmond, VA

Short Stories – To See It All, Henry Art Gallery, Seattle, WA

Gene(sis): Contemporary Art Explores Human Genomics,
Henry Art Gallery, Seattle, WA

2001 *Boomerang: Collectors' Choice*, Exit Art, New York, NY

One Planet Under A Groove: Hip Hop and Contemporary Art,
Bronx Museum of the Arts, NY

Whippersnapper III, Vedanta Gallery, Chicago, IL

New Work: L.A. Painting, Hosfelt Gallery, San Francisco, CA

Snapshot, UCLA/Armand Hammer Museum, Los Angeles
and The Museum of Contemporary Art, Miami, FL

Freestyle, The Studio Museum in Harlem, New York

Capital Art, Track 16 Gallery, Santa Monica, CA

Painting 2001, Victoria Miro Gallery, London, England

2000 *Fresh Cut Afros*, Watts Towers Arts Center, Los Angeles, CA

1999 *Southern California Car Culture*, Irvine Fine Arts
Center, Irvine, CA

Homeless in Los Angeles, The Mota Gallery, London

After the Gold Rush, Thread Waxing Space, New York, NY

1998 *I'm Still in Love with You*, Women's 20th Century Club,
Eagle Rock, CA

Same Difference, Guggenheim Gallery, Chapman
University, Orange, CA

Disaster, part of the WhileUWait series, Hollywood DMV,
Los Angeles, CA

The Comestible Compost, Gallery 207 & Pavilion's,
West Hollywood, CA

1997 *PROP*, Korean Cultural Center, Los Angeles, CA

Re:Bates, L.C. Bates Museum, Hinckley, ME

Black is a Verb! WORKS/San Jose, San Jose, CA

Five Emerging Artists, Dan Bernier Gallery,
Santa Monica, CA

1996 *Just a Taste*, Fine Arts Gallery, University of California,
Irvine, CA

Finding Family Stories, Watts Tower Arts Center and Plaza
de la Raza, Los Angeles, CA

Self Satisfy, Robert Berman Gallery, Santa Monica, CA

1995 *Custom Complex*, Helen Lindhurst Gallery, USC,
Los Angeles, CA

PAUL PFEIFFER

Born 1966, Honolulu, HI
Lives and works in New York, NY

EDUCATION

1997-98 Whitney Museum of American Art Independent Study Program
1994 MFA, Hunter College, New York, NY
1987 BFA, San Francisco Art Institute, CA

SELECTED SOLO EXHIBITIONS AND PROJECTS

2003 Museum of Contemporary Art, Chicago, IL
List Visual Art Centre, MIT, Cambridge, MA
SITE Santa Fe, New Mexico, Mexico
2001 *Sex Machine*, The Project, Los Angeles, CA
Orpheus Descending, Public Art Fund, World Trade & Financial Centers, New York, NY
Kunsthaus Glarus, Glarus, Switzerland
Barbican Art Centre, London, UK
UCLA Hammer, Los Angeles, CA
Whitney Museum of American Art, New York, NY
2000 Project, New York, NY
Kunst-Werke, Berlin, Germany
Duke University Museum of Art, Raleigh-Durham, NC
1998 *The Pure Products Go Crazy*, The Project, New York, NY
1997 *The Pure Products Go Crazy*, Cendrillon, New York, NY
1994 *Santo Niño Incarnate*, Colonial House Inn, New York, NY
1993 *Survival of the Innocents*, Art In General, New York, NY

SELECTED GROUP EXHIBITIONS

2003 *The Moderns Castello di Rivoli*, Torino, Italy
100 Artists See God, Independent Curators International *Graz 2003 As Heavy as the Heavens Graz*, Austria
2002 *Out of Place*, Museum of Contemporary Art, Chicago, IL
Pictures, Greene Naftali, New York, NY
Model World, Aldrich Museum, Richfield, CT
Tempo Museum of Modern Art, New York, NY
K21, Dusseldorf, Germany
Special Effects (2002 Media Art), Daejeon Municipal Museum of Art, Korea
2001 *49th Venice Biennale*, Venice, Italy
Bitstreams, The Whitney Museum, New York, NY
Gio Marconi, Milan, Italy
Maze Gallery, Torino, Italy
Sala Uno, Rome, Italy
Casino 2001, SMAK, Gent, Belgium
Zero Gravity Gallery, Rome, Italy
The Americans, Barbican Arts Centre, London
Subject Plural, Museum of Contemporary Art, Houston, TX
Refresh, Cantor Centre for the Visual Arts, Houston, TX
Loop, Kunsthalle der Hypo-kultursiftung, Munich, Germany
Metropolis 2002, Istanbul, Turkey
List Visual Arts Center, MIT, Cambridge, MA

False Start, Center for Curatorial Studies, Bard College, New York, NY
Cheekwood, Nashville, TN
2000 *The Whitney Biennial*, The Whitney Museum, New York, NY
Greater New York, P.S.1/MoMA, New York, NY
Hypermental, Kunsthaus, Zurich, Switzerland
City Visions, media city_seoul 2000, Seoul, Korea
Extraordinary Realities, Columbus Museum of Art, OH
Scanner, Oliver Art Center, California College of Art & Culture, Oakland, CA
1999 *Tete de Turkois*, The Project, New York, NY
Surface Tension, Art in General, New York, NY
A Place Called Lovely, Greene Naftali, New York, NY
Hocus Focus: New Video, Rare Gallery, New York, NY
1998 *warming*, The Project, New York, NY
At Home and Abroad: 21 Contemporary Filipino Artists, Asian Art Museum, San Francisco, CA
1997 *Memories of Over-development: Philippine Diaspora in Contemporary Art*, Plug In Gallery, Winnipeg, Canada
Travel Size, City College, New York, NY
Fermented, Parsons School of Design, New York, NY
1996 *Memories of Overdevelopment: Philippine Diaspora in Contemporary Art*, UC Irvine Art Gallery, CA
Neighbors, Boom Gallery, Honolulu, HI
1995 *In a Different Light*, UC Berkeley Museum, CA
Pervert, UC Irvine Art Gallery, CA
14 Artist: Sugod sa Katapusan, End House Art Center, Dumaguete City, Philippines
1994 *Extreme Unction*, Market Gallery, London
Reframing a Heritage, University Of Hawaii, Manoa, Hawaii
Stonewalls, 494 Gallery, New York
Picturing Asia America: Communities, Cultures, Difference, Houston Center for Photography, Texas
Kayumanggi Presence, Skyline College, San Francisco, CA
1993 *DisMantling Invisibility*, A Space, Toronto, Canada
Kayumanggi, Presence Academy of Art, Honolulu, HI
1992 *Altars, Divinations and Icons*, Painted Bride Art Center, Philadelphia, PA
Altars, Divinations and Icons, Guadalupe Cultural Center, San Antonio, Texas
(en)Gendered Visions: Race, Gender and Sexuality in Asian American Art Injustice, Guadalupe Cultural Center, San Antonio, TX
Made in America: Remembering Vincent Chin, Art In General, New York, NY
Day Without Art, Lehman College Art Gallery, New York, NY
1991 *Dismantling Invisibility: Asian Americans Respond to the AIDS Crisis*, Art In General, New York, NY

CYNTHIA WIGGINS

Born 1968, USA
Lives and works in New York, NY

EDUCATION

1999 Independent Study Program, Whitney Museum of
American Art, New York, NY

1995 MFA, California Institute of the Arts, Valencia, CA

BA, Princeton University, Princeton, NJ

SELECTED EXHIBITIONS

2003 *Hair Stories*, Scottsdale Museum of Contemporary Art, AZ

2001 *Committed to the Image*, Brooklyn Museum of Art,
Brooklyn, NY

Material & Matter, Studio Museum in Harlem, New York, NY

2000 *Imaging the Wunderboard*, London Biennale, Centre for
Freudian Research & Analysis, London

Twentieth Anniversary Exhibition, Artist in the
Marketplace, Bronx Museum of the Arts, NY

Reflections in Black, Smithsonian Institution,
Washington, DC

1999 *Xmas*, Kent Gallery, New York, NY

Artist in the Marketplace, Bronx Museum of the Arts, NY

Supermarket, Slop Art, Kansas City, MO

ROY WILLIAMS

Born 1969, Hartford, CT
Lives and works in Brooklyn, NY

EDUCATION

1989 Cleveland Institute of Art, Ohio

Foundation Program

SELECTED EXHIBITIONS/ PROJECTS

2002 Charles Dunn Studio, Brooklyn, NY

Reality Allstars, Noise Experiment, New York, NY

2001 *Being and Becoming*, Detective Series, New York, NY

2000 Rome Arts Gallery, Brooklyn, NY

1992 Art Without Walls, Cleveland, OH

Blake DuBois Bradford is Education Coordinator at The Fabric Workshop and Museum in Philadelphia. He has written broadly on education, art and culture for publications such as *SchoolsArts*, *Museum News*, *Triple-Bypass*, and The Stranger, and has contributed to monographs on Philadelphia-based artists such as Humbert Howard. An African-American educator and visionary, Bradford is currently developing Philadelphia Partners, a multidisciplinary collaboration between teen arts programs. Among his interests are muay Thai kickboxing and mixed martial arts.

Writer and vocalist, **Latasha N. Nevada Diggs'** literary and sound works have been published and recorded in various publications and for music projects ranging from rock to house. She is the author of two chap-books, *Ichi-Ban: from the files of negríta muñeca linda* and *Ni-ban: Villa Misería* and the producer and writer for an experimental audio project called "Television". A fellow of the Cave Canem Workshop for African American Poets, she is 2002 artist in residence at Harvestworks Digital Media Arts Center and a 2003 New York Foundation for the Arts recipient. She is also the lead electronic vocalist for the Zappa-esque jam band, Yohimbe Brothers, fronted by Vernon Reid and DJ Logic.

Deborah Grant was born in Toronto, Canada, and grew up in Coney Island and in Harlem. She received her BA from Columbia College in Chicago, IL in 1996, and her MFA from Tyler School of Art, Temple University, in Elkins Park, PA in 1999. She was a 2002-03 Artist-in-Residence at The Studio Museum in Harlem, and participated in *Freestyle* in 2001. Grant has lectured at numerous art schools and universities including Hunter College, Tyler School of Art, and The New School University. She is presently working on a photo journal.

Glenn Kaino is a Los Angeles-based artist whose work is featured in "Black Belt" (see the Artists' Biographies section of this catalogue).

Peter Kang is president of Ill Tongue Music Management and a former A & R executive for Relativity Records. A hip hop visionary, he put world-famous Relativity Records on the map and launched the careers of such superstars as Common, The Beatnuts, and The X-Ecutioners. In addition to his work with The X-Ecutioners, Kang is committed to working with Korean-American and Asian-American youths. He is currently producing *AfroEurAsian Eclipse*, a joint CD and film documentary project chronicling many of the most talented Asian-American emcees, deejays, and spoken word poets today.

Christine Y. Kim is Assistant Curator at The Studio Museum in Harlem where she has organized exhibitions such as "Africaine: Candice Breitz, Wangechi Mutu, Tracey Rose and Fatimah Tuggar" (2002) and "For the Record: Julie Mehretu, Senam Okudzeto and Nadine Robinson" (2001). Kim also co-organized "Freestyle" (2001) with SMH Deputy Director Thelma Golden. Prior to her post at The Studio Museum, Kim received her MA from New York University and worked at The Whitney Museum of American Art. She is a visiting professor at Bard Center for Curatorial Studies and a 2002 recipient of the Fund for Arts Research Grant from the American Center Foundation.

Dominic Molon is Associate Curator at the Museum of Contemporary Art, Chicago, where he has curated numerous projects including major exhibitions of Paul Pfeiffer (2003), Gillian Wearing (2002), Sharon Lockhart (2001) and Mariko Mori (1998); solo projects with Tobias Rehberger, (2000), Eija-Liisa Ahtila (1999), Steve McQueen (1996), Pipilotti Rist (1996), and Jack Pierson (1995); and the group exhibition, "Out of Place: Contemporary Art and the Architectural Uncanny" (2002). He also organized "HUMID," a large-scale exhibition of new work by young and emerging artists from around the world in the Miami Design District in 2001. Molon is currently coorganizing a major re-hang of the MCA Collection titled "Strange Days" with MCA Associate Curator Staci Boris. He has contributed to numerous publications including *Trans*, *Flash Art Italia*, *Tate: the Art Magazine*, and the *New Art Examiner*.

Vijay Prashad is Director of the International Studies Program at Trinity College. He is on the Board of the Center for Third World Organizing, Oakland, a co-founder of Forum of Indian Leftists (FOIL), an editor of *Amerasia Journal*, a monthly columnist for Little India and ZNET, a weekly contributor to www.outlookindia.com, and a frequent contributor to *Frontline*, *Chennai*, *ColorLines*, *Oakland*, and *Himal South Asia, Kathmandu*.

Sanford Biggers
Black Belt Jones, 2003
Black Indonesian rice and acrylic on paper
44 x 33 inches
Courtesy the artist

Nanchakus, 2003
Acrylic, plastic, light bulbs, and steel
Dimensions variable
Courtesy the artist

Untitled I, 2003
Fake gold, metal, plastic chains, string, and
designer kung fu slippers
Dimensions variable
Courtesy the artist

Untitled II, 2003
Fake gold, metal, plastic chains, string, and
designer kung fu slippers
Dimensions variable
Courtesy the artist

Iona Rozeal Brown
a3 #10 (down-ass emperor Qianlong), 2003
Acrylic on handmade Korean rice paper
84 x 58.75 inches
Courtesy the artist

a3 blackface #0.50, 2001
Acrylic on paper
28 x 21 inches
Collection of Calum Stephenson, New
York, NY

a3 blackface # 0.75, 2001
Acrylic on paper
29 x 22 inches
Private Collection, New York, NY

a3 blackface #3, 2002
Acrylic on paper
50 x 38 inches
Collection of The Studio Museum in Harlem
Funds provided by Anne Ehrenkranz 02.10.10

a3 blackface # 55, 2003
Acrylic on paper
50 x 38 inches
Courtesy the artist

a3 blackface # 56, 2003
Acrylic on paper
50 x 38 inches
Courtesy the artist

a3 blackface # 57, 2003
Acrylic on paper
50 x 38 inches
Courtesy the artist

Patty Chang
Death of Game, 2000
Video projection
TRT 02:20
Courtesy Jack Tilton/Anna Kustera, New
York, NY

Death of Game (frame I), 2002
Watercolor and pencil on paper
9.5 x 13 inches
Courtesy Jack Tilton/Anna Kustera, New
York, NY

Death of Game (frame 2), 2002
Watercolor and pencil on paper
9.5 x 13 inches
Collection of Larry Sanitsky, Los Angeles, CA

Death of Game (frame 3), 2002
Watercolor and pencil on paper
9.5 x 13 inches
Courtesy Jack Tilton/Anna Kustera, New
York, NY

Death of Game (frame 4), 2002
Watercolor and pencil on paper
9.5 x 13 inches
Courtesy Jack Tilton/Anna Kustera, New
York, NY

Y. David Chung
Black Belt Jones, 2003
Oil stick and graphite on paper on wall
Dimensions variable
Courtesy the artist

Bruce, 2003
Video projection
TRT 03:20
Video assistant Emily Lee
Animation assistant Mark Schumaker
Sound by Pooh Johnston
Courtesy the artist

David Diao
Hiding, 2000
Acrylic and silkscreen on canvas
72 x 48 inches
Courtesy the artist and Postmasters
Gallery, New York, NY

Reading, 1999
Acrylic and silkscreen on canvas
66 x 85 inches
Courtesy the artist and Postmasters
Gallery, New York, NY

Twin Dragons 2, 2000
Acrylic and silkscreen on canvas
Triptych 72 x 154.5 inches
Courtesy of the artist and Postmasters
Gallery, New York, NY

Sean Duffy
Thank You, Ernest, JoJo and Leslie, 2003
Turntables, 12" records, speakers, album
covers, bamboo furniture, and mixed media
Dimensions variable
Courtesy the artist

Ellen Gallagher
bling bling, 2001
Rubber, paper, and enamel on linen
96 x 120 inches
Collection of The Broad Art Foundation,
Santa Monica, CA

Psychoalphadiscobetabioaquadooloop, 2001
Paper, cut rubber and enamel on canvas
96 x 120 inches
Courtesy the artist and Gagosian Gallery,
New York, NY

Ellen Gallagher
Edgar Cleijne
*Murmur: Watery Ecstatic, Kabuki Death
Dance, Blizzard of White, For a while it may
be Necessary to Look like You, Super Boo*,
2003
5 16mm film projections
TRT 06:00
Courtesy the artist

Rico Gatson
The Art of Battle, 2003
9 monitors, DVDs, plywood and mixed media
TRT 10:00
Courtesy Ronald Feldman Fine Arts,
New York, NY

Luis Gispert
Enter My 37th Chamber, 2002
Steel, wood, mirror, subwoofer, infrared
sensors, and mixed media
Sound by Jeff Reed
Dimensions variable
Courtesy the artist

David Hammons
Untitled, 2003
Mixed media
Courtesy the artist and Jeanne Greenberg,
New York, NY

David Huffman
Darkmatter, 2003
Acrylic on mixed ground
48 x 48 inches
Courtesy the artist and Patricia Sweetow
Gallery, San Francisco, CA

Endothelium, 2003
Acrylic on mixed ground
48 x 48 inches
Courtesy the artist and Patricia Sweetow
Gallery, San Francisco, CA

Evolution, 2003
Acrylic on mixed ground
Diptych 60 x 88 inches
Courtesy the artist and Patricia Sweetow
Gallery, San Francisco, CA

Arthur Jafa
Untitled, 2003
Collage, metal, glass and mixed media
Dimensions variable
Courtesy the artist

Michael Joo
Chasing Dragons, 2003
Video projection
TRT 05:00
Courtesy the artist and Anton Kern
Gallery, New York, NY

Glenn Kaino
Society II Menace, 2003
Video projection
TRT 03:34
Produced/Directed by Glenn Kaino
Featuring Tommy Capistrano,
Jack Yang, Shawnda Thomas Faveau
Associate Producers Luke Lizalde,
Daniel Sakai, Micah McKinney
Courtesy the artist and The Project,
New York, NY

Bruce Leroy's Kung Fu Theater, 2000
Metal, light bulbs, paint
32 x 72 x 7 inches
Courtesy the artist and The Project,
New York, NY

Glenn Kaino
Mark Bradford
Game of Death (Reprise), 2003
Video game: projectors, computers,
hand controls
Dimensions variable
Engineering by Brian Kaino,
Geoff Schriber, and David Kwong
Models and animation by
Miguel Guerrero, Karl Forlander
Courtesy the artist and The Project,
New York, NY

Clarence Lin
*Housing Project: The Prison
Industrial Complex*, 2000-2003
Wood, metal, fiberglass, foam,
resin and mixed media
96 x 96 x 180 inches
Courtesy the artist

Kori Newkirk
Untitled (Neon Throwing Star I), 2003
Neon light fixture
Dimensions variable
Courtesy the artist and The Project,
New York, NY

Untitled (Neon Throwing Star II), 2003
Neon light fixture
Dimensions variable
Courtesy the artist and The Project,
New York, NY

Paul Pfeiffer
Live Evil, 2003
Miniature monitor, DVD, metal
and plastic armature
TRT 00:20 loop
Courtesy the artist and The Project,
New York, NY

Cynthia Wiggins
*Plays Well with Others/ Bruce Lee
Saved My Life*, 1999
Calligraphy on rice paper, throwing stars,
nanchakus, mask, kung fu slippers, exten-
sion cord, plaques, wisdom boards and altar
Courtesy the artist

Roy Williams
Losing Small Battles, 2002
Books, concrete brick, amplifier
Dimensions variable
Courtesy the artist

Appiah, K. Anthony, and Henry Louis Gates, Jr., eds. *The White Issue: A Special Issue of Transition.* Durham: Duke University Press, 1997.

Baruch, Ruth-Marion, and Pirkle Jones. *Black Panthers: 1968.* Los Angeles: Greybull Press, 2002.

Bhabba, Homi K. *The Location of Culture.* London: Routledge, 1994.

Block, Alex B. *The Legend of Bruce Lee.* New York: Dell, 1974.

Bogle, Donald. *Toms, Coons, Mulattoes, Mammies and Bucks: An Interpretive History of Blacks in American Films.* New York: Continuum, 1989.

Bordwell, David. *Planet Hong Kong: Popular Cinema and the Art of Entertainment.* Cambridge: Harvard University Press, 2000.

Campbell, Joseph and Bill Moyers. *The Power of Myth.* Ed. Betty Sue Flowers. New York: Doubleday, 1988.

Carmichael, Stokely, and Charles V. Hamilton. *Black Power: The Politics of Liberation.* New York: Random House, 1967.

Chari, Madhav. "Pundit Coltrane Shows the Way," *Journal of Asian American Studies* 4.3, October 2001.

Clegg, Claude A. *An Original Man: The Life and Times of Elijah Muhammad.* New York: St. Martins Press, 1997.

Clifford, James. *The Predicament of Culture.* Cambridge: Cambridge University Press, 1998.

Coleman, Wanda. *Bath Water Wine.* Santa Rosa, Calif.: Black Sparrow Press, 1998.

Deutch, Nathaniel, "The Asiatic Black Man': An African American Orientalism?," *Journal of Asian American Studies* 4.3, October 2001.

Dresser, David and Poshek Fu, eds. *The Cinema of Hong Kong: History, Arts, Identity.* Cambridge: Cambridge University Press, 1998.

Eng, David. *Racial Castration: Managing Masculinity in Asian America.* Durham, N.C.: Duke University Press, 2001.

Eng, David and Alice Y. Horn, eds. *Q & A: Queer in Asian America.* Temple University Press, 1998.

Essien-Udom, E., *Black Nationalism: A Search for Identity in America.* Chicago: University of Chicago Press, 1962.

Eubel, Michael and Harry Stecopoulos, eds. *Race and the Subject of Masculinities.* Durham, N.C.: Duke University Press, 1997.

Freidman, Lester, ed. *Unspeakable Images: Ethnicity and the American Cinema.* Urbana, Ill.: Illinois University Press, 1991.

Hisama, Ellie M. "Afro-Asian Crosscurrents in Contemporary Hip Hop." *ISAM Newsletter*, Fall 2002.

Ho, Fred, et al., eds. *Legacy to Liberation: Politics and Culture of Revolutionary Asian Pacific America.* San Francisco: AK Press, 2000.

Kelley, Robin D.G. *Freedom Dreams: The Black Radical Imagination.* Boston: Beacon Press, 2002.

Kim, Claire Jean. *Bitter Fruit: The Politics of Black Korean Conflict in New York City.* New Haven: Yale University Press, 2000.

Kim, Myung Ja. "Across Races: Towards a New Cultural Politics of Difference, An Interview with Dr. Cornel West," *The Korea Society Quarterly*, Spring 2000, 8-9.

Kingston, Maxine Hong. *Tripmaster Monkey.* New York: Vintage, 1990.

Kurutz, Steven. "Kung Who? How a 34th Generation Shaolin Master Fell Into Hip-Hop History." *Shout Magazine*, December 2002/January 2003, 55.

Lee, Robert. *Orientals: Asian Americans in Popular Culture.* Philadelphia: Temple University Press, 1999.

Little, John, ed. *Words of the Dragon: Interviews, 1958-1973.* Boston: Charles E. Tuttle, 1997.

Logan, Bey. *Hong Kong Action Cinema.* Woodstock: Overlook Press, 1996.

Machida, Margo. *Asia/America: Identities in Contemporary Asian-American Art.* New York: Asia Society and The New Press, 1994.

Marqusee, Mike. *Redemption Song: Muhammad Ali and the Spirit of the Sixties.* London: Verso, 1999.

McLuhan, Marshall. *Understanding Media: Extensions of Man.* Cambridge, Mass: MIT Press, 1994.

Munoz, Carlos Jr. *Youth, Identity, Power: The Chicano Movement.* London: Verso, 1989.

Olsen, Jack. *Black is Best: The Riddle of Cassius Clay.* New York: Dell, 1967.

Ongiri, Amy Abugo, "He Wanted to be Just Like Bruce Lee: African Americans, Kung Fu Theater and Cultural Exchange at the Margins," *Journal of Asian American Studies* 5.1, February 2002.

Powell, Richard J. *Black Art and Culture in the 20th Century.* London: Thames and Hudson Ltd., 1997.

Prashad, Vijay, *Everybody was Kung Fu Fighting: Afro-Asian Connections and the Myth of Cultural Purity.* Boston: Beacon Press, 2001.

Prashad, Vijay, "Bruce Lee and the Anti-imperialism of Kung Fu: A Polycultural Adventure," *Positions: East Asia Cultures Critique*, v. 11, #1, Spring 2003.

Remnick, David. *King of the World: Muhammad Ali and the Rise of an American Hero.* New York: Alfred A. Knopf, 1998.

Said, Edward, *Orientalism.* New York: Pantheon, 1979.

Schram, Stuart, ed. *Political Thought of Mao Tse-tung.* New York: Praeger, 1972.

Sprinker, Michael, ed. *Edward Said: A Critical Reader.* Oxford: Blackwells, 1993.

Stokes, Lisa O. and Michael Hoover. *City on Fire: Hong Kong Cinema.* London: Verso,1999.

Takaki, Ronald. *Strangers from a Different Shore: A History of Asian Americans.* New York: Penguin, 1989.

Tan, Vivienne with Judith Regan. *China Chic: A Visual Memoir of Chinese Style and Culture.* New York: Harper Trade, 2000.

Tannen, Mary. "Martial Lore." *The New York Times Magazine*, Spring 2003.

Tasker, Yvonne. *Spectacular Bodies: Gender, Genre and the Action Cinema.* London: Comedia/Routledge, 1993.

Tate, Greg, ed. *Everything But The Burden.* New York: Broadway Books, 2003.

Teo, Stephen. *Asian/American: Historical Crossings of a Racial Frontier.* Stanford, Calif.: Stanford University Press, 1999.

Thomas, Bruce. *Bruce Lee: Fighting Spirit.* Berkeley, Calif.: Frog, 1994.

Tsu, Sun. *Art of War.* Trans. Ralph D. Sawyer. Boulder: Colorado: Westview Press, 1994.

Tzara, Tristan. *Seven Dada Manifestos and Lampisteries.* TK: Riverrun Press, 1988.

Whelchel, Toshio. *From Pearl Harbor to Saigon: Japanese American Soldiers and the Vietnam War.* London: Verso, 1999.

Williams, Angela Kyodo. *Zen and the Art of Living with Fearlessness and Grace.* New York: Viking Compass Penguin Group, 2000.

Yang, Jeff, et al., eds. *Eastern Standard Time: A Guide to Asian Influence on American Culture from Astroboy to Zen Buddhism.* Boston: Houghton Mifflin, 1997.

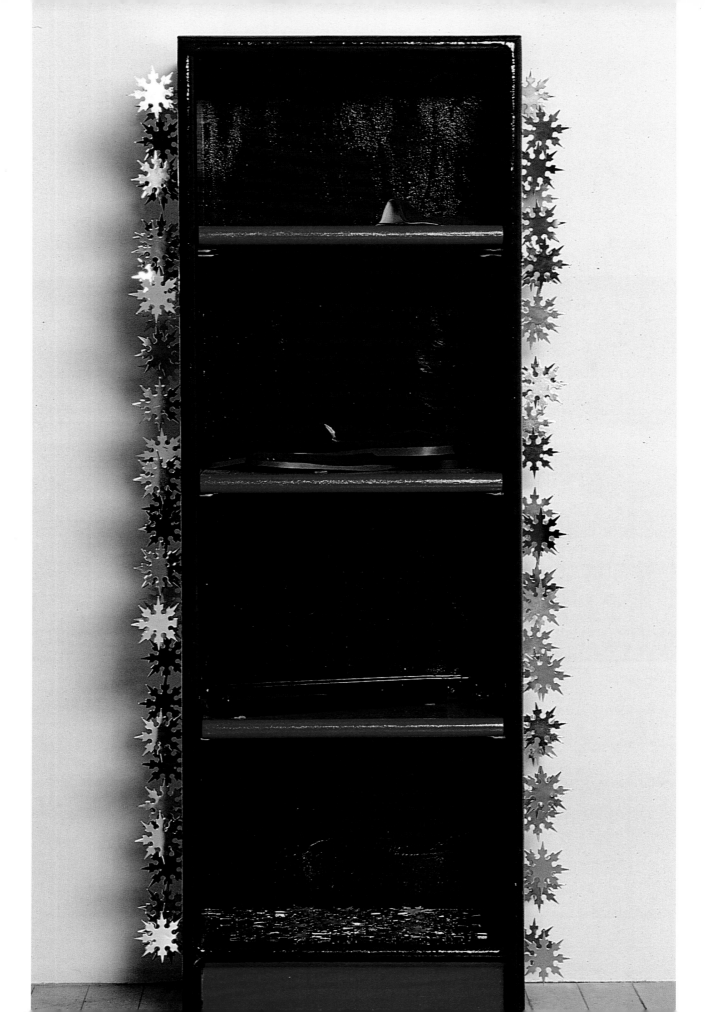

Designed by **Brian Hodge** and **Kelly Schwartz**
Printed by **Snoeck-Ducaju & Zoon**

Edited by **Franklin Sirmans**
Roundtable conversation transcribed by **Naima Keith,**
 Dalila Scruggs and **Alexandra Whitney**
Copyedited by **Matthew Cowan**

Printed in Belgium

Photo Credits
27: Catherine Serrano
38, 39: Tom Powel Imaging
11-22: Gineen Glenn

Front cover: Sandford Biggers, Study for *Black Belt Jones*, 2003; Inside front cover: Iona Rozeal Brown, *a3 blackface #3*, 2003; p.2: Y. David Chung, *Study*, 2003; p.6: Clarence Lin, *Housing Project: The Prison Industrial Complex*, 2002-2003; p.8: Ellen Gallagher and Edgar Cleijne, *Super Boo*, 2003; p.10: Sandford Biggers, *Kung Fu Shoes*, 2003; p.25: Iona Rozeal Brown, *a3 blackface #2*, 2001; p.26: Ellen Gallager, Detail of *Preserve* (Karate), 2001; p.65: Sean Duffy, *Thank You, Ernest, JoJo and Leslie*, 2003; p.68: Michael Joo, *Chasing Dragons*, 2003; p.115: Glenn Kaino, *Society 2 Menace*, 2003; p.116: Cynthia Wiggins, *Plays Well with Others/Bruce Lee Saved my Life* (detail), 1999; p.117: Kori Newkirk, *Studies for Untitled (Neon Throwing Stars)*, 2003; Glenn Kaino, *Dojo*, 2003; Patty Chang, *Death of Game*, 2000; Inside back cover: David Huffman, *Evolution*, 2003; Back cover: Glenn Kaino, *Bruce Leroy's Kung Fu Theater*, 2000